Drawing
FOR
DUMMIES®

by Brenda Hoddinott

WILEY

Wiley Publishing, Inc.

Drawing For Dummies®

Published by
Wiley Publishing, Inc.
111 River Street
Hoboken, NJ 07030
www.wiley.com

Copyright © 2003 by Wiley Publishing, Inc., Indianapolis, Indiana

Drawings copyright © 2003 Brenda Hoddinott

Published by Wiley Publishing, Inc., Indianapolis, Indiana

Published simultaneously in Canada

For general information on our other products and services or to obtain technical support, please contact our Customer Care Department within the U.S. at 800-762-2974, outside the U.S. at 317-572-3993, or fax 317-572-4002.

Wiley also publishes its books in a variety of electronic formats. Some content that appears in print may not be available in electronic books.

Library of Congress Control Number: 2002114851

ISBN: 0-7645-5476-X

1O/QV/QT/QT/IN

Manufactured in the United States of America

20 19 18 17 16 15 14 13 12 11

 is a trademark of Wiley Publishing, Inc.

About the Author

Brenda Hoddinott is a self-educated visual artist, forensic artist, and illustrator. Her favorite drawing subjects are people, and her styles include hyperrealism, surrealism, and fantasy.

Born in St. John's, Newfoundland, Brenda grew up in the small town of Corner Brook. Every spare hour during her adolescence was spent reading and developing her drawing skills. Thankfully, nobody ever told her that she couldn't draw. As an introverted child, Brenda was oblivious to the meaning of the word "talent." By the time she discovered that many people believed drawing to be very difficult or required a special talent, she was already well on her way to becoming an artist. With the aid of various books, she developed a strong level of technical competence. Learning to draw provided Brenda with endless hours of productive entertainment that called for only a few inexpensive materials. At the age of 16, Brenda moved back to St. John's to study Commercial Art. After graduation, she worked as a graphic designer with various advertising agencies.

By the late 70's, married with two small children (Heidi and Benjamin), she chose to become a stay-at-home mom. Brenda started a home-based business as a freelance artist and accepted numerous graphic design contracts with various businesses and advertising agencies. Brenda became well known throughout her home province as a portrait artist and was featured in several newspaper and magazine articles. She completed over 1,100 private and corporate commissions, including over 100 celebrity commissions for the covers of a provincial magazine.

She accepted a position with her local recreation department to design curriculum and teach a pre-school program, a children's art class, and an adult class in drawing portraits. Brenda enjoyed this challenging opportunity to teach and enhance the skills of students from all age groups.

Brenda's skillful rendering of facial anatomy was recognized by municipal and federal police departments, and she was invited to become their forensic artist. As a forensic artist, Brenda worked with the Royal Canadian Mounted Police and Royal Newfoundland Constabulary in Newfoundland from 1976 to 1982. In 1982 she was presented with a commendation for her contribution to criminal identification departments.

In 1982 Brenda moved to Halifax, Nova Scotia, with her family, and she re-established her forensic art and graphic design business and resumed teaching recreational drawing classes. She designed innovative curriculum, and within two years had an extensive waiting list for her programs. She accepted a position as supervisor of her community's recreational art department and hired and trained teachers and designed curriculum for several children's art programs. During this time she began teaching advanced students, from age

ten through adult in her home studio. By 1987, she also made time to learn to paint in oils and by 1989 had expanded her teaching portfolio to include painting classes.

From 1988 to 1994, Brenda began exhibiting her paintings and drawings in art exhibitions and provincial and regional art competitions. She was honored with more than twenty prestigious awards for her paintings and drawings during these six years.

In 1992, Brenda was honored with a commendation from the Royal Canadian Mounted Police. She became a member of The Association of Forensic Artists, based in Scottsdale, Arizona, in 1992. In September 1993, an article on her work as a forensic artist was featured in their official publication, *The State of the Art*. Through this organization, she accessed many articles and educational resources to further enhance her forensic art skills. She also learned cognitive interview techniques and adapted them to her specific needs in working with victims of and witnesses to crimes. In 1994, Brenda was awarded a Certificate of Membership from Forensic Artists International. During Brenda's twenty-five year career as a civilian forensic artist, she has interviewed over one thousand victims of and witnesses to crimes. She has completed more than twelve hundred composite drawings resulting in hundreds of successful identification matches.

In 1998, Brenda chose to end her eighteen-year career as an art educator in order to devote more time to her own art. On occasion, she continues to exhibit her work and has been honored with more awards. Drawing, painting, writing, developing Web sites and forensic art are Brenda's current career priorities. In 1998, she established an art publishing company called Hoddinott Fine Art and in January 1999, developed and launched www.hoddinott.com to supplement her company. In addition to showcasing her paintings and drawings, it has a gift shop featuring prints of her work.

By September 2000, Brenda was missing her teaching career, and she decided to launch a second Web site, Fine Art Education, www.finearteducation.com. This site offers free downloadable and printable drawing classes featuring Brenda's unique style of drawing. Students of all ages, levels, and abilities have praised the simple step-by-step instructional approach. This site has been recognized as a resource for fine art educators, home schooling programs, and educational facilities throughout the world. It includes an art gallery with several of her original drawings.

Dedication

This book is dedicated to my "bestest" friend, Rob Roughley, for his infinite encouragement and support throughout this book project. Thank you for turning yourself upside down in the interest of modeling, and for allowing me to transform your handsome young face into a wrinkled, balding, 85-year-old. Thank you Rob, for listening to me whine when I felt discouraged, for putting up with my endless enthusiastic outbursts, and for patiently helping me with editing!

Author's Acknowledgments

Warmest thanks to Mary Goodwin, my amazing project editor, and the entire team at Wiley.

Big hugs of appreciation are extended to my family: husband, Ed Thomson; parents, Pam and Granville Hoddinott; brother, Peter Hoddinott; sister, Karen Unicomb; Mom-in-law, Klara Thomson; children, Heidi and Benjamin Thomson; and grandson, Brandon Porter. Extra big dog cookies go to Shadow and Chewy for their love and an endless supply of dog fur in my keyboard.

My deepest thanks are extended to Jessica Faust, my phenomenal literary agent at Bookends. A big bouquet of gratitude goes to my manager, John McKeage for always believing in me. Thank you to my friend Bruce Poole, for his incredible photography skills. Thank you to all my friends who helped make this book a reality: Brian Church, Sherri Flemings, Kathleen McCleave, Wilma and Maggie Ross, Jesse Wilts, Maxene Webb, Jason Brown, Jackson Bishop, Susan Fulton-Kaiser, William O. McCormick, Teddy Bono, Carolyn Bedford, and all my friends at Paint-L.

Hugs go out to all my former students, who constantly challenged me, provided nonstop "interesting" giggles, and taught me how to teach.

Last but not least, thank you to all my extraordinary family and friends who loaned me their faces (or arms, hands, and legs) as models for drawings: Rob Roughley, Heidi and Ben Thomson; Brandon Porter; Anne Sawney, Ben Fong, Chris Church, Claudette Germain, Phil Power, Mike Lemoine, Colin, Adam, and Amy Unicomb, Daniel Shouse, and Kay Wilson. God bless yer cotton socks!

Publisher's Acknowledgments

We're proud of this book; please send us your comments through our Dummies online registration form located at www.dummies.com/register/.

Some of the people who helped bring this book to market include the following:

Acquisitions, Editorial, and Media Development

Project Editor: Mary Goodwin

Acquisitions Editor: Natasha Graf

Technical Editor: Mike Applegate

Editorial Manager: Michelle Hacker

Illustrations: Brenda Hoddinott

Cartoons: Rich Tennant, www.the5thwave.com

Production

Project Coordinator: Nancee Reeves

Layout and Graphics: Seth Conley, Michael Kruzil, Gabriele McCann, Tiffany Muth, Barry Offringa, Jeremy Unger

Proofreaders: John Tyler Connoley, John Greenough, Carl Pierce, Dwight Ramsey, TECHBOOKS Production Services

Indexer: TECHBOOKS Production Services

Publishing and Editorial for Consumer Dummies

Diane Graves Steele, Vice President and Publisher, Consumer Dummies
Joyce Pepple, Acquisitions Director, Consumer Dummies
Kristin A. Cocks, Product Development Director, Consumer Dummies
Michael Spring, Vice President and Publisher, Travel
Brice Gosnell, Associate Publisher, Travel
Suzanne Jannetta, Editorial Director, Travel

Publishing for Technology Dummies

Richard Swadley, Vice President and Executive Group Publisher
Andy Cummings, Vice President and Publisher

Composition Services

Gerry Fahey, Vice President of Production Services
Debbie Stailey, Director of Composition Services

Contents at a Glance

Table of Contents

Introduction

*W*elcome to *Drawing For Dummies.* This book focuses on the basics of drawing for beginning artists, with plenty of challenges for more-experienced artists. Whether you are 9 or 90, this book includes something of interest for you by introducing the pleasures of drawing within an informal and enjoyable format.

For some individuals, a passion for drawing begins in childhood and ends as young adults. A few dedicated individuals carry their love of drawing into adulthood. Some persons discover drawing later in their lives, sometimes much later. *Drawing For Dummies* is the one book I would have loved to have had when I was first attempting to decipher the technical skills of drawing.

My philosophy is simple. I believe that you can master drawing yourself, as I did. If you are dedicated and committed, you can become very good at drawing. Your progress should be at a pace that is comfortable for you. There are no tests or deadlines, and you draw whatever you want at times that are convenient for you. And, in addition to having fun, you may even find a few giggles.

About This Book

You won't figure out how to draw by simply reading this book. Drawing is an action word. Tons of result-oriented exercises and projects throughout this book are designed to be fun, while instilling strong technical skills that are necessary to drawing. I share numerous tips, secrets, and helpful suggestions that I mostly learned the hard way, by making mistakes.

The subjects I cover are based on your needs as an aspiring artist and are designed to motivate, inspire independent thought, and enhance your creativity. You are your own teacher, and you are encouraged to find out about drawing by doing.

Take a quick peek through this book at all the illustrations — almost 300 of them. Each illustration is specific to the skill that I discuss. I use my zany sense of humor to create some unique slants on traditional subjects, by incorporating some rather untraditional drawings. When I first planned this book, I thought maybe a hundred or so illustrations would be plenty. However, I soon realized as I began writing that I felt inspired to illustrate almost everything. Can you tell that I love to draw?

As with anything new, you simply have to do some necessary, but less-desirable, stuff in order to develop strong skills. But, with fun illustrations, I attempt to make even mundane topics as interesting as possible. In the more than 300 pages of this book, you find many valuable drawing tools, whether you're drawing for the very first time, resuming a childhood interest in art, or wishing to expand your current skills.

In addition to this book and a few inexpensive drawing tools, you need some ability to see, a way to hold a pencil, a huge dose of motivation, a pinch of patience, a smidgeon of dedication, and a few dollops of determination. You also need to find some free time, maintain your sense of humor, make a personal commitment to have some fun, and you're on your way.

Foolish Assumptions

Do you have any preconceived assumptions about drawing? Read each of the following three statements and decide if they are true or false.

- ✔ You need to already be able to draw fairly well, in order to take up drawing.
- ✔ If you don't have an innate or natural "talent" for drawing, there's no point in wasting your time trying.
- ✔ Drawing is an elusive and magical ability available only to certain gifted individuals.

If you answered all three questions with a false, you agree with my philosophy about art. I believe everybody can draw. You can draw. And, if you're an individual who doesn't like to make mistakes, here's more good news: There's no "right" or "wrong" way to draw but rather an acceptance of your own unique individuality.

How This Book Is Organized

This book begins by helping you feel comfortable with drawing. From there, you discover the basics, from buying supplies to holding a pencil, and from drawing lines to rendering shading. The rest of the book is chock-full of various drawing subjects and topics, through which you can pop around in no particular order. Read a little, then draw a little, and then read and draw some more.

Part 1: YOU Can Draw!

The title of this part says it all. If you're not totally convinced that drawing is for you, by the time you finish reading and doing the exercises and projects in this part of the book, many of your concerns about taking up drawing are squelched.

Drawing is a perfectly natural human ability. As with anything new, taking that very first step is the most difficult. Once you begin to work through this book, you discover a whole new exciting, enjoyable, and productive activity.

Keep your drawing supplies handy as you read. Even in Chapter 1, you jump headfirst into a fun drawing project that I've used for beginner students, of all ages, for more than two decades.

No need to feel intimidated by my drawings. I've been drawing for lots and lots (and lots) of years. My drawing skills used to be quite weak (at least according to my current standards). I dug out some drawings I did as a beginner to show you what my stuff looked like during the first few years of my drawing journey (thanks, Mom and Dad, for saving them for me). We all have to start somewhere, and simply doing your best is something to be very proud of.

Part II: Exercising the Basic Skills

If you're a beginner to drawing, you can skip over some parts of this book, but you won't want to miss these six chapters. You need some basic skills in order to draw. Hey, even if you're a pro at drawing, in this part of the book, you may find some new slants on old skills.

I begin by taking you through a bunch of fun exercises and optical illusions to show you how to see as an artist. You discover and begin to respect lowly lines from new perspectives, and progress to seeing and drawing the lines in objects around you. From exploring the three-dimensional visual illusions of drawing, you advance to discovering how light creates the foundation of shading. You discover how to render shading with values and textures, and you uncover tons of tools for creating your own drawings. Even perspective becomes interesting with lots of fun exercises and crazy illustrations.

Whether you work your way through this part of the book in a few days or a few months doesn't matter. Just respect its importance and give yourself the gift of a solid foundation for drawing. You save yourself a ton of frustration down the road.

Part III: Time to Start Drawing

You're ready to jump out of the nest and choose a direction in which to fly. In this part, I show you how to plan your drawings, offer you tips on keeping a sketchbook diary, and encourage you to use your creative mind and inner eye. You even get a peek inside the world of forensic art, with a chance to play police artist, as you follow along with me and do a composite drawing.

Try your hand at several different drawing subjects, from well-behaved cooperative objects that stay still (still life) to appealing critters that fly, bark, meow, and swim. The ever-changing world outside is yours, as you explore drawing flowers, trees, skies, mountains, and bodies of water.

Your memory holds fascinating drawing subjects, and I share some tips on retrieving these images from your mind. You are also encouraged to explore the infinite boundaries of your mind's eye, where you can unveil some truly unique and exciting drawing subjects.

Part IV: Drawing People

If you believe that people are difficult to draw, you'll love this part of the book. I'm not into memorizing big, long names of muscles, or drawing boring bones and complicated anatomy. Drawing humans is easier and more fun by simply breaking down their parts into basic shapes and forms.

Babies are the easiest humans to draw, and one whole chapter explores their unique facial characteristics and easy-to-remember proportions. Children are favorite subjects for lots of artists, and with a few simple tips and skills, you are on your way to drawing portraits of adorable little munchkins. Adults present diverse challenges to portrait artists, but their faces also follow simple guidelines for accurately rendering likenesses.

Another of my favorite chapters in this book takes you inside the fun side of drawing people. You explore creative hairstyles, discover how to draw a vast selection of facial expressions, and enjoy cartooning with fun step-by-step instructions. I also share invaluable reference tools for understanding the anatomy of aging. I show you and tell you about the remarkable changes of one person's face as it progresses from age 14 to 85.

Keep your drawing supplies handy when you read these chapters, and try your hand at all of the exercises and projects. After you experience the joys of drawing people, you are hooked.

Part V: The Part of Tens

This part of the book includes a potpourri of tips, and several pages of other valuable artistic information. I also throw in a chapter that walks you step-by-step through creating a completely original drawing. You can impress the heck out of your family and friends with your unique masterpieces.

Last but by no means least, you won't be able to resist the chapter with ten extra fun projects, of different skill levels. Enjoyable subjects range from a cat, dog, and sheep, to a dragon egg, a mug on a mug, and a couple of fun cartoons.

Icons Used in This Book

In the margins of almost every page of this book, you find tons of adorable little circular drawings called icons. There's a method to the madness of these icon thingies. They serve the purpose of directing you to some really cool information.

This icon saves you time and energy by letting you know an easier method for doing something, or where to look to find more information on the topic being discussed.

Important information is presented wherever you see this icon. Sometimes, it may be a reminder of something already covered elsewhere in the book, and at other times it lets you know that you need to remember this informative tidbit for later.

Some really important stuff is hiding behind this icon. However, feel free to skip over these sections if you prefer to ignore some really cool information that will help enrich your artistic journey. Some of the info beside these icons even helps you to become literate in the language of art, known in some circles as "Artspeak."

When you see this icon, you need to dig out your drawing materials, open your sketchbook, put the cat out, feed the dog, and get ready to spend some quality time drawing. Plan on doing lots of these exercises and projects because your drawing skills improve every time you draw.

Something visual is waiting to be explored wherever you see this icon. Drawing is all about seeing. Sometimes, you are guided through some valuable information in one of my drawings, and other times you are asked to observe specific details in objects around you.

Where to Go from Here

You don't have to go through this book in sequence. You can poke through the Table of Contents and jump right into those topics that excite you. Lots of reference material is scattered throughout this book. For example, if you're having difficulty getting Great Uncle Ignatius to look old enough in a portrait, go to "Watching a Face Travel through Time," in Chapter 20, to find out how to draw the sequential elements that define the aging process.

If you're a beginner to drawing, you may prefer to start at the very beginning of Part I and work your way through each chapter in sequence. I strongly recommend that you totally inhale all the information, and work through each and every project and exercise, in Part II.

Once you have the basics, you can randomly wander through the rest of this book and read and enjoy whichever sections you prefer. Even though this is a reference book, it is also designed for those of you who like to work from beginning to end. You discover that the degree of difficulty, especially with the projects, increases as you get closer to the end of the book.

If you can already draw well, you can pop around this book any way you want. Take a quick flip through the pages. Take note of which illustrations catch your eye. Start reading wherever you feel inspired. Read some sections, draw a little, read a little while longer, and then do more drawings.

Part I
YOU Can Draw!

The 5th Wave By Rich Tennant

©RICHTENNANT

"Oh those? I thought drawing might help relieve the tension around here a little. I did those while you were napping. I'm particularly fond of the Red Cross ship. What do you think?"

In this part . . .

So, you don't know what a Wooly Woo is? Well, in that case, you really need to read this part of the book! Not only do you find out what a Wooly Woo is, but you discover that some may even live in your home. Oh, and did I mention that you also get to draw one?

Artists aren't born. They're made! Hmmm . . . maybe I should restate that and say self-made. I offer you a pep talk to motivate you and give you an appetite for drawing. I also let you in on some ways you can start making yourself into an artist, without dying your hair green or piercing your eyebrows.

Even if you're all revved up and ready to race ahead, take a few minutes to explore these first three short chapters. You find out what supplies you need and how to create a special little place in which to make your mark. And, while I'm on the subject of marks, I also show you some artsy little trinkets, like how artists hold their pencils to make marks, and how to mark your drawing style. I also let you know what to expect throughout this book, including a tiny sampling of some of the fun stuff.

Chapter 1

Discovering the Joys of Drawing

In This Chapter

▶ Adding drawing to your life

▶ Identifying, inspiring, and motivating the artist within you

▶ Starting your drawing journey

*O*n a simple sheet of paper, a magnificent eagle can soar over a snow-covered mountain, a small child can hug an adoring puppy, dewdrops on a rose can glisten in the morning sun, a mermaid can swim with dolphins under the ocean, or a lightning storm can illuminate a stormy sky.

Drawing can bring extraordinary and unexpected dimensions to your life. By adding drawing to your everyday experiences, you can change how you, and others, see the world. It's a powerful tool, one that you can spend a lifetime investigating.

Because of this power, some people find drawing a little intimidating at first. In this chapter, I demystify drawing by explaining the process of discovering how to draw. I tell you how you can implement drawing strategies and apply them to your own work.

Before you begin reading, find a pencil and some paper. You simply won't be able to resist following the ten simple steps towards designing and rendering your very own first drawing.

Drawing on the Possibilities

The joy and personal satisfaction of creating a drawing is both your incentive and your reward. The process of discovering this ability enriches all aspects of your life. Think about the following as you consider the possibilities inherent in drawing:

✔ **Your drawings illustrate your personal perceptions.** Drawing challenges you to communicate what you see in a nonnarrative language. Drawing allows you to speak without words.

✔ **Drawing adds a new and exciting activity to your life.** With only a few supplies and some basic skills, you soon find yourself taking pride in your new achievements.

✔ **You can decorate your surroundings with a personal touch.** Have some of your drawings framed and hang them in your home. Family and friends may become quite fascinated by your drawings. Don't be surprised if they soon request some of your work for their own homes. Of course, this is a good time to encourage them to take up drawing themselves.

✔ **Through the eyes of an artist, you appreciate everything around you from a whole new perspective.** Drawing is seeing. As an artist, you visually explore the world with a whole new purpose — to find drawing subjects!

✔ **The act of drawing produces a physical reward.** It really doesn't matter why you draw or who sees your drawings. Maybe you hope to one day publicly exhibit your drawings. Or you may choose to only share them with family and friends.

You also have the option of keeping them all for yourself. Your drawings serve as a journal of your artistic journey.

✔ **Drawing is relaxing, mentally challenging, and emotionally stimulating.** You CAN draw, and you can improve as much as your interest, patience, and commitment take you. The most important thing is that you are drawing. You are making art.

Discovering by Doing

Drawing is simply creating the illusion of depth and reality by making various marks on a piece of paper. But knowing how to skillfully make those marks is the key to achieving the results you want.

My philosophy on drawing is simple: You discover by doing! Simply reading this book from cover to cover won't help you to draw. Only *you* can teach you to draw!

This book provides you with all the necessary tools you need to explore the basics of drawing. Through self-directed learning, you become your own drawing guru. You should work at your own pace and develop your own schedule.

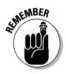

There's no "right" or "wrong" way to draw, but rather an acceptance of diversity and recognition that every drawing, no matter how much you dislike it, provides a chance for you to figure out something new (even if it's "I don't want to do *that* again!").

Pretty much every new skill requires practice. From picking up a musical instrument to playing a team sport, you don't progress very far without practice. However, the fun part of practicing drawing is that you can draw whatever you like, however you want, whenever you want, and your skills automatically improve. The three most important elements of discovering how to draw are practice, practice, and more practice!

The many projects throughout this book provide you with ample opportunities to practice the skills you need as you discover them. You may find some of the new skills are really easy. Others are more frustrating and need practice before you can do them well.

Some practice ideas to consider include:

- Draw everything and anything you love, every chance you have.
- When you find a skill you're not so great at, such as drawing circles or straight lines freehand, sketch lots and lots of them.
- Practice drawing perfect alphabet letters. Letters (and numbers) have all the types of lines you use in drawing.
- Choose what you consider to be the most challenging part of each project you do and redraw that section, or practice this technique over and over.
- Keep a pencil and some paper handy, and experiment with making marks, lines, and shading by drawing random doodles.

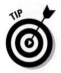

The key, to knowing when you've practiced a specific skill enough, is when you're happy with your results.

Finding Your Drawing Niche

As an individual, your art develops in its own time. You can look forward to many hours with your sketchpad in hand as you search for the style of drawing that is uniquely yours.

Nurture your natural creativity, and keep your mind open to new ideas. The broad range of subjects, styles, and media shown throughout this book encourages you to introspectively analyze your own personal preferences. The unique artist within you ultimately emerges with time.

Investigating the artist within you

I invested many years, and tried lots of different styles and media, before finally finding my current niche. Notice that I used the word *current*. I still love the challenge of experimenting with new techniques, and my current style is constantly evolving.

You can find the artist within you! Your drawings can look unbelievably realistic, inspirationally creative, or emotionally charged with energy. As you search for the drawing niche that best suits the kind of drawing you want to do, consider the following:

- ✔ **Challenge yourself by constantly experimenting with new media and different styles.** I describe various media in Chapter 24, and I introduce you to various styles of drawing throughout this book, including Chapter 2.

- ✔ **Stretch your mind and explore diverse drawing tools.** Drawing tools aren't limited to physical objects, such as paper, pencils, and pens. Methods of drawing and seeing, such as using a grid, are also considered tools.

 Use any tools, skills, or methods you can find to get the results you want in your drawings. I tell you about drawing tools in Chapter 10.

- ✔ **Take the time to practice numerous and diverse exercises as a foundation for developing basic drawing skills.** I discuss qualities of lines throughout this book and encourage you to follow along with me in exciting projects. I introduce you to all the basics of drawing in the six chapters of Part II.

Examining a diversity of drawing subjects

Giving some thought to what you enjoy most in your life can help you locate some excellent drawing subjects. You can investigate a vast range of drawing subjects throughout this book, including the following:

- ✔ **People:** If one of your current hobbies is people watching, lots of opportunities to explore drawing humans are in the four chapters of Part IV.

 I demystify drawing humans by revealing simple guidelines and fun techniques, for incorporating these most revered, but intimidating, subjects into drawings.

- ✔ **Animals:** In Chapter 16, you have a chance to try your hand at drawing various animals and critters, real and imaginary.

✔ **Mother Nature:** Maybe you love beautiful scenery and nature's splendid variety of flowers, trees, and earthly gifts.

I share lots of ideas for successfully capturing these subjects throughout this book (don't miss Chapters 14 and 15).

✔ **Things:** Many artists love the challenge of drawing still-life subjects, from toys to trinkets, from rocks to fruits and vegetables, and everything in between.

I offer you creative ideas for drawing textures (you explore textures in Chapter 8), setting up lighting, and creating moods in your drawings (don't miss Chapter 13).

You can find time in your hectic schedule for drawing, and somewhere in your home is a special place just waiting to be claimed as your personal drawing space. The artist inside you is waiting to emerge and claim ownership of the joys of drawing.

Project 1: Wooly Woo

You can't possibly make a mistake in this zany, fun project. Keep in mind that your dust bunny doesn't have to be a twin of mine. It can be a distant cousin (a *very* distant cousin)!

The instructions are supersimple, and your only goal is to have some fun. You need a pencil, some paper, and a sense of humor as you follow these steps:

1. **Draw a large square on your drawing paper.**

 This square provides a framework that helps you place everything in your drawing.

2. **Draw the outline of two eyes.**

 Look at the two ovals that I have drawn. Notice that they touch one another along their inside edges.

3. **Draw the nose.**

 The nose is the third circular shape, touching the two ovals. Make sure you leave a little triangular shape in the middle of your three circular shapes. In Step 8, you see why this triangle is important.

 The basic shapes are now in place, with plenty of space left for wool (fuzz, fur, fluff, hair, or whatever you wish to call it).

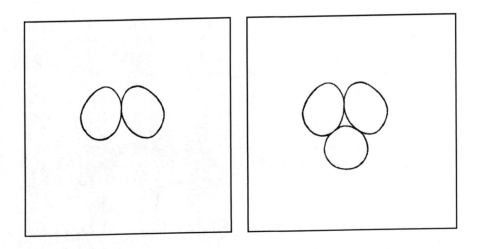

4. Use your pencil to fill in the triangular shape very darkly.

This little triangle is the center of your drawing. A 6B pencil works great to fill in an area darkly.

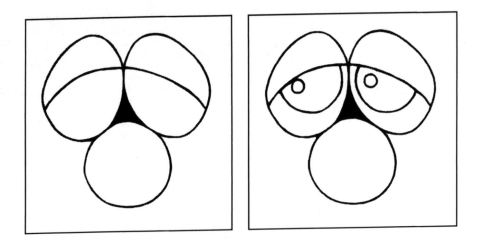

5. Draw curved lines through the eyes.

These lines represent the eyelids. Note that the lines begin in the same place in between the eyes. Then they curve outward and downward.

6. Draw two half circles under the eyelids, with a tiny circle inside each.

The two half circles with little circles inside them are the irises. The little circles inside the irises are the highlights of the eyes. They are off to the left and close to the lower edge of the eyelids.

7. Fill in the eyes, eyelids, and nose.

Use your 6B pencil to shade in the half circles in the eyes very darkly. With your HB pencil, shade in both the right and left ends of both eyelids and the nose very lightly.

Leave a small circular section of the nose white. This makes the nose look shiny.

8. Draw a few straight lines straight out from the triangular shaped center.

Pretend that the dark triangle in the center of the face is the center of a large circle. Think about how small children often draw the rays of light coming from the sun. These lines serve as guidelines to help you draw the "fur" in the next step.

I have given my dust bunny thick fur. You may choose to give yours thinner fur (or even curly fur). Remember, the only goal of this project is to have fun! You can draw the fur any way you wish.

9. Draw a whole bunch of straight (or curved) lines to represent the fur.

Make the fur a little thicker closer to the eyes and nose, by drawing a few extra shorter lines.

10. Sign your name and write today's date on the back of your drawing.

Congratulations! In this project you drew eyes similar to animal or human eyes and a three-dimensional sphere (his nose) with shading, and you rendered the texture used for drawing animal fur or human hair.

If these are the first things you have ever drawn, you have taken some great first steps.

Chapter 2

Nurturing the Artist within You

In This Chapter

▶ Exploring your inner artist

▶ Understand drawing from your own unique perspective

▶ Creating a drawing space of your very own

▶ Choosing your drawing supplies

*P*rodigies are often thought of as people who acquire a special ability with little effort. However, most prodigies, from a very young age, obsessively work to develop their skills. They continue to challenge themselves until their abilities transcend far beyond average to genius.

Everyone can develop superior skills in specific areas. With a better understanding of talent and ability, you begin to recognize that drawing can be one of your special skills. Be patient with yourself. Your drawing skills develop over time.

Many individuals, including people challenged by visual, physical, and mental limitations, enjoy drawing. Some individuals without vision draw with techniques such as embossing (or impressing). Persons without hands have become successful artists by accepting the challenge of using their mouth or feet to hold their drawing tools.

The drawing techniques presented in this book require only two abilities:

✔ **You must have some ability to see.**

✔ **You must have a way to hold a pencil.**

If you are among the majority of people with some vision and two hands, your only obstacle is making a commitment.

Exploring Your Drawing Preferences

Drawing is more than simply rendering a specific object. Drawing visually defines your choice of subjects from your own unique perspective.

No other person in the whole world is exactly like you, and, therefore, no one in the world draws exactly like you. Many factors influence how and what you draw, including the following:

- Your life experiences, philosophies, and perceptions
- Your understanding of and exposure to art and the history of drawing
- The styles you prefer and your approaches to implementing your preferences (in Chapter 24, I discuss personal drawing styles)
- The media with which you choose to draw
- The surfaces on which you draw and whether they are horizontal, at an angle, or vertical
- The ways you choose to hold your pencil and other drawing media

Marking your style

Making marks on a surface is the core of drawing. Diverse mark-making techniques and different drawing media lend themselves to various styles of drawing (I discuss several drawing styles in Chapter 24).

A huge variety of drawing media is available. Many are very similar to each other, and some are quite unique. A charcoal drawing looks completely different from a graphite or pen drawing. Colored pencils, conte crayons, and pastels bring the exciting world of color into drawings. (Explore different drawing options in Chapter 24).

Despite the vast variety of media and styles to choose from, most drawing styles fit into one of two basic categories:

- **Representational (sometimes called *realism*):** Refers to drawing objects and actual entities, such as trees or people, as they exist in reality. Some artists also consider imaginary subjects, such as angels or dragons, as representational.
- **Nonrepresentational (or *abstract*):** Focuses on shape, values, and form. Abstract art often has no recognizable subjects.

Traveling back in time

People have been drawing for a very long time. Throughout history, humans have used art to communicate and immortalize events and objects precious to their lives. For example, drawings discovered in the caves of prehistoric humans have provided us with insight into their way of life.

The early Egyptians used drawings to decorate many structures, including tombs. Native peoples all over the world have used natural materials, such as clay, to make drawings of their lives. And the drawings of such revered artists as Michelangelo and Leonardo Da Vinci explored science, human anatomy, and perspective.

Check out the Internet or your public library to find out more about the history of art. Be sure not to miss Renaissance art, romanticism, realism, and impressionism. The lifestyles and cultures of humans from prehistoric times to modern day have been illustrated in detail with drawings. Today's drawings document tomorrow's history.

Most drawing media lend themselves beautifully to either representational or nonrepresentational styles of drawing. Some artists even mix different media (sometimes called *mixed media*) and/or combine representational and nonrepresentational styles in the same drawing. So, basically, there are no rules. Experiment with the media and drawing styles you prefer.

Deciding which style applies to a specific drawing isn't easy. Many artists choose to not label their drawings at all. Your personal style unfolds each time you draw. Enjoy trying various methods of drawing. Keep an open mind while noting the types of drawings you prefer. Draw in a way you really love. Styles are neither right nor wrong — they just are. With time, your style develops all by itself.

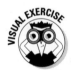

Figure 2-1 includes four drawings of a butterfly-like critter to show you a tiny sampling of different representational styles and the media used:

- ✔ The first is a line drawing done with an HB pencil in half an hour (check out Chapter 5 for lots of information on drawing with lines).

- ✔ A charcoal pencil gives the second drawing a nice soft look. This drawing took about 20 minutes (I tell you more about charcoal in Chapter 24).

- ✔ I shaded the third butterfly with 2H, HB, and 6B graphite pencils. This little critter took about four hours from start to finish.

- ✔ For the fourth butterfly, I decided to try my graphite drawing in a different medium. I used a pen to do an outline, scanned it, and then added the shading in Photoshop. It took three hours.

Figure 2-1:
Noting different drawing styles and media.

Different artists can take a shorter or longer time to achieve similar results. I tell you the times I spend on each so you have some idea of which styles and media are faster to work with than others. Keep in mind that I've been drawing a VERY long time, so don't expect to accomplish as much as I in the same amount of time.

Drawing is in the details

Every artist seems to have a unique approach to drawing. Some love big, bold, loose drawings. Others like tiny drawings with lots of intricate details.

The following sections feature three drawings to show you a small sampling of different ways to draw the same subject. Look closely at each drawing and make note of which drawing methods you initially prefer.

A rough sketch

A drawing usually begins with a rough sketch, as in Figure 2-2, which can be big or small. This sketch took me about five minutes.

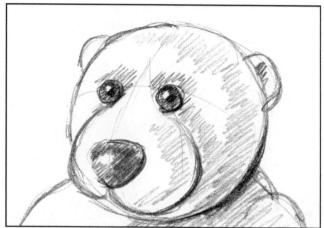

Figure 2-2:
Making a rough sketch, in 4B graphite, of Teddy Tink.

A detailed sketch

A detailed sketch (see Figure 2-3) can be either the beginning of a drawing or the final product. For Figure 2-3, I simply added more detail to the rough sketch (Figure 2-2). In the detailed sketch, Teddy's fur looks fuzzier, his eyes look brighter, and his nose seems more three-dimensional. This version of Teddy Tink took an additional ten minutes.

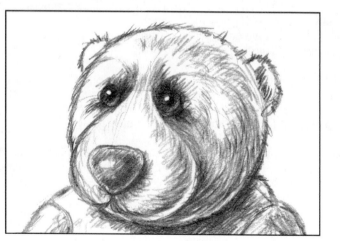

Figure 2-3:
Adding detail in 2B graphite to Teddy Tink.

A detailed drawing

This detailed drawing (Figure 2-4) is very precise and detailed. I started with a very light sketch and slowly added more detail and darker shading.

You need a lot of patience to draw this much detail. This small section of the full drawing took over three hours (I offer step-by-step instructions for drawing a full version of this adorable little bear in Chapter 11).

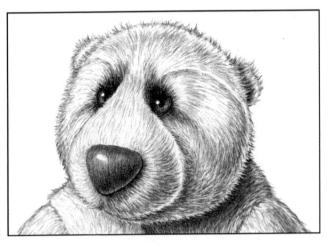

Figure 2-4:
Completing a detailed drawing in graphite of Teddy Tink.

Holding your drawing media

Your personal preference of how you hold your drawing media influences your individual style of drawing. Whatever you find most comfortable is right for you. You can move your pencil by moving only your fingers, or you can draw by moving your wrist, arm, and body.

Figure 2-5 illustrates how most people hold their pencil when first beginning to write and draw. Holding a pencil in this manner allows for better control over fine movement while rendering very intricate sections of a drawing. I use this method for most of my highly detailed drawings.

You simply grasp the pencil, or other drawing media, close to the tip with your thumb and index finger, and the end of the pencil rests comfortably on the curved area of your hand in between. Note that you can move your pencil with your fingers, wrist, or arm.

The second way of holding your pencil (as shown in Figure 2-6) is great for drawing on a slanted or vertical surface, and when you work on a large drawing. Sketching lends itself to this way of holding a pencil (check out Figures 2-2 and 2-3 to see what I mean by a sketch).

Figure 2-5:
Holding a
pencil in the
most
familiar and
traditional
manner.

Reach out to pick up your pencil from a flat surface and it should automatically be in its proper place in your hand. The farther the tip is extended away from your hand, the more loosely you can draw. This method requires movement from your arm, shoulder, and body.

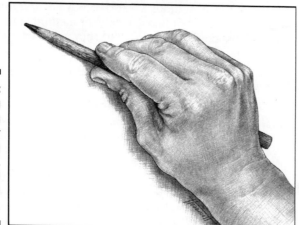

Figure 2-6:
Holding
drawing
media for
sketching
on large,
slanted, and
vertical
surfaces.

Try the method in Figure 2-7 when you stand to draw, or draw on a vertical or slanted surface. When I do loose sketches, this is how I hold short sticks or pencils of various media, such as charcoal, conte, or chalk pastel.

Simply rest the pencil comfortably in the palm of your hand (see Figure 2-7) with a large portion of the tip extended and pointed away from you. Slowly bring your thumb downward to gently hold it in place. This method requires movement from your wrist, arm, shoulder, body, or any combination.

Figure 2-7:
Holding
drawing
media for
sketching
on flat,
slanted, or
vertical
surfaces.

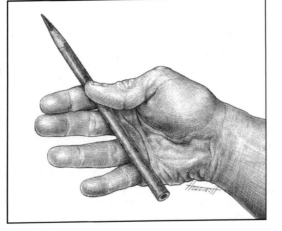

 You may find a couple of these methods a little awkward at first, but with practice you can get used to them. Choose whatever method of holding your drawing media that is most comfortable for you. Your personal preferences are influenced by:

✔ Your choice of medium (pencil, pen, charcoal, and so on)

✔ Whether your drawing surface is flat, vertical, or on an angle

✔ The size of your drawing paper

Finding Space and Time to Draw

In addition to making time for drawing, you need to find a comfortable place to draw and safely store your supplies. The favorite foods of one of my dogs are books, pencils, and erasers. Her name is Chewy!

You can create a personal drawing space in a small, busy home by sharing an area with others or by converting a corner of a room into a studio. If you have a spare room in your home, it can easily be converted into your very own studio, devoted exclusively to your art.

Working in a shared space

Your drawing place should be peaceful and free of distractions. This means compromises and careful planning if others use the same space. Choose a drawing time that provides minimum inconvenience for others and follow this list of suggestions:

- **Create a drawing surface:** Your kitchen or dining-room table or your computer desk can become an ideal drawing space. A portable, sloped drawing surface can be improvised by using books to prop up one end of a piece of plywood.

- **Find a comfortable chair:** Your back won't become tired and sore.

- **Find a good light source:** A window is ideal in the daytime. On overcast days and in the evenings, a flexible-neck study lamp can focus light directly on your drawing surface.

- **Locate a portable storage container:** Your drawing materials can stay organized, and safe from small children and pets, in some type of container, such as a large shoebox or a small fishing-tackle box. They are easily put away under a bed or in a closet. Maybe you even can free up a drawer or shelf for your supplies.

- **Create a portfolio:** Keep your drawing paper and completed drawings safe from being crumpled or damaged. No need to buy an expensive portfolio. You can easily make one from corrugated cardboard or matt board (see the sidebar "Making a portfolio" later in this chapter for instructions).

- **Play music:** I play my favorite music as I draw. A set of headphones connected to a source of your favorite music can block noisy distractions. This allows you to better concentrate on your drawing projects.

Setting aside a creative corner

You can design and individualize a personal home studio if you have a spare room or an unused corner of a room. Some suggestions for your studio space include the following:

- **Adjustable drawing table:** Check out stores, yard sales, or the classified ads of your local newspaper.

- **Comfortable, adjustable chair:** This becomes a necessity if you spend several hours a week drawing. A chair on wheels allows you to move easily.

- **Lighting options:** Natural light through a window is best, but you also need a flexible-neck lamp attached to your drawing table for overcast days and evenings.

- **Furniture:** A small table or storage cart (preferably on wheels) can hold your drawing materials as you work. A shelving unit would be ideal for storing your art books, drawing materials, and portfolios.

- **Bulletin or display boards:** Different types are relatively inexpensive and readily available. Display some of your drawings, inspirational images, photos, and articles in your studio.

- **Portfolio:** Whether you use it to simply store or to transport your paper and drawings, a portfolio is a must-have.

- **A sound system:** A collection of your favorite music is a wonderful addition to your studio.

Don't limit yourself to my suggestions. Be creative! Visit some furniture and art supply stores and look through some decorating books and magazines for more ideas.

Keep your color scheme as light as possible to ensure that your special drawing place is bright, welcoming, and enjoyable.

Finding time for drawing

With some creative planning, you too can discover several opportunities for adding the joys of drawing to your life. Consider the following:

- **Make a schedule of your daily commitments.** Include drawing time as high priority.

- **If you work outside your home, draw on the bus on your way to and from work (only if you're not the bus driver!) or during your lunch hour.**

- **Remember the evenings and weekends.** You can find lots of opportunities to draw during social events. Or why not take your drawing materials with you when you go visit Aunt Ivy?

- **Include family members or friends.** You could make arrangements to meet one night a week in each other's homes for a drawing party. Take turns bringing refreshments, motivating one another, and sharing ideas as you draw.

Making a portfolio

You can make your portfolio any size (I have two portfolios, one is 17 by 21 inches for small drawings, and the other is 23 by 31 inches for larger drawings). You need a large piece of matt board (or cardboard), wide packing or duct tape, a sharp knife, and a straight edge or long ruler (such as a T-square). Then follow these simple instructions for assembling your portfolio:

1. **Cut a large, rectangular piece of matt board to the size you want.**

 See the first drawing in the next set of two. You will eventually fold the matt board in half, so take this into account as you cut your piece of matt board.

 I highly recommend acid-free matt board, rather than cardboard, because the acid in cardboard may damage your drawings in time. You can buy large sheets of matt board at many stores that do custom framing.

2. **Reinforce both short ends with packing or duct tape (the wider the better).**

3. **Draw a straight line (slightly off center) parallel to the taped ends.**

4. **With your knife and straight edge, very lightly score along this line.**

 Cut only slightly through the board.

5. **Fold your board along the scored line towards the unscored side.**

 See the second drawing.

6. **Tape together both short sides of your portfolio, leaving the board open along the top.**

7. **Reinforce the bottom edge (the long side with the fold) with more tape.**

 If you wish to add handles, make two holes in the center section of each open side. Thread the ends of string or thin rope through the two holes, and tie it together on the inside.

If you want, you can nurture your creativity by using brightly colored shoelaces as handles and decorating your portfolio with drawings.

Choosing Your Drawing Supplies

Time to make your shopping list! The old expression "You get what you pay for" definitely applies to the better and generally more expensive brands of art supplies. For example, some inexpensive pencils may be scratchy instead of smooth to draw with, and this can be incredibly frustrating!

You're better off buying good-quality art materials from a reputable art store. Shop around. Sometimes the same brands of high-quality materials are available at several stores at different prices.

The supplies listed in the section "The necessities" take you through most of the projects in this book. To get serious about drawing, you also need the stuff I discuss in the section called "The wish list" later in this chapter.

Every artist needs a portfolio. Various sizes are available at most art supply stores, or if you prefer you can make your very own (refer to "Making a portfolio" earlier in this chapter for simple instructions).

The necessities

The following gives you a list of the very basic supplies. This list includes the most commonly used supplies for the projects in this book:

- **Sketchbook:** A hardcover, acid-free sketchbook is a must. The soft-covered ones get crumpled and dog-eared very quickly.

 Choose a size that you are comfortable with, but no smaller than 9 x 12 inches. Smaller than this can be frustrating when you want to draw nice, big, bold drawings!

 Look for a sticker or some sort of text written on the packaging to let you know the paper is acid-free, so that your drawing surface doesn't turn yellow after a few weeks and spoil your drawings.

- **Pencils:** The most important pencils for a beginner are 2H, HB, 2B, 4B, and 6B. The 2H is the lightest (hardest), and the 6B is the darkest (softest). Refer to the Cheat Sheet at the very beginning of this book to see the full range of marks made by each pencil. You can expect to use the HB, 2B, and 4B the most often.

 I prefer mechanical pencils instead of those that need sharpening so that my drawing isn't interrupted repeatedly during the process. I use 0.5 (available in lots of different stores) for regular drawings and 0.3 (check out an art supply store) for very detailed drawings. For sketching loosely or on a large surface (or both), try a 0.7 mechanical pencil.

✔ **Erasers:** You need two types of erasers, a vinyl and a kneaded. A vinyl eraser is usually white, longish, and rectangular, with a band of paper around it on which its name is written.

A kneaded eraser is gray, and its plastic packaging is usually clearly marked with the name of the eraser. You need two kneaded erasers, one exclusively for erasing graphite and one just for erasing charcoal.

If you aren't familiar with these items, have a salesperson help you choose which are best (I introduce you to various ways to use these erasers throughout this book).

✔ **Pencil sharpener:** You need a pencil sharpener for some drawing media (even if you're using mechanical pencils for graphite drawings).

Stay away from pretty or fancy sharpeners. Choose a basic, hand-held metal sharpener with two openings — one for regular and one for over-sized pencils. These sharpeners last forever, and you can buy replacement blades for them.

✔ **Rulers:** I prefer metal rather than plastic or wood. They last much longer, and are easier to use and clean. A regular 12-inch ruler works for most projects, but an 18-inch one also comes in quite handy.

✔ **Charcoal:** You need charcoal pencils and a couple of charcoal sticks for drawing. 2B (or 4B) creates a full value scale, and isn't as messy as the softer ones. You have a chance to test-drive your new charcoal in a couple of really fun projects in this book.

The wish list

You may soon want to experiment with other media (I tell you more about drawing media in Chapter 24). Here are some suggestions for enlarging your basic inventory of art supplies:

✔ **Colored pencils:** Stay away from the cheap ones. They're too waxy to blend properly, and they fade very quickly. Ask someone at an art supply store to recommend a good-quality set for a beginner.

✔ **Conte crayons and chalk pastels:** Choose from either sticks or pencils. A basic set of conte includes black, a couple of grays and sepias (browns), and a white. I prefer 2B. Pastels come in an infinite range of colors, but you should start with a beginner set of assorted colors.

If you choose the pencil type of conte or pastels, you need a special knife to sharpen them and a sandpaper block to sharpen the points (available at art supply stores).

- ✔ **Erasers:** Kneaded erasers get too dirty to erase after a while, especially when used with charcoal, conte, or chalk pastel. Pick up some extras.

- ✔ **Pencils:** A full selection of graphite pencils, from 8H to 8B, adds flexibility to your shading abilities (refer to the Cheat Sheet at the very beginning of this book to see the range of values a full set can make). Experiment with some other types of pencils, such as an Ebony pencil.

- ✔ **Drawing paper:** Special drawing papers are a lot of fun for your projects. Go nuts! Choose from hundreds of colors, textures, and types. My personal favorite drawing paper is 140 pound, hot-pressed, watercolor paper. Its surface is fairly smooth, but its tooth (texture) is adequate for most drawing media, and it is very forgiving of erasers.

Project 2: The Pupil of Iris

In this project, you get to play with the abilities of each of the drawing "toys" that I list in the section "The necessities" earlier in this chapter. Just follow these steps:

1. **Draw a square in your sketchbook any size you want.**

 This square is your drawing space for this project. Decide if you like drawing large or small objects before you choose a size. My drawing is quite small, only about 3 inches square.

2. **Use your charcoal pencil to draw the outline of a small circle inside your space, leaving a small section the shape of a backwards letter "C" missing. Then fill in the circle very darkly with your charcoal pencil.**

It should look as if someone took a bite out of the circle. Don't forget to leave the C-shaped section white; this will be the highlight of the eye.

3. **Use your 6B pencil to draw the outline of a large circle around your first circle.**

 You may choose to draw the larger circle freehand, but you can also use a compass or some other tool to help you.

4. **With your HB pencil, outline the other half of the highlight (the tiny circle partially created by the missing section of your first circle).**

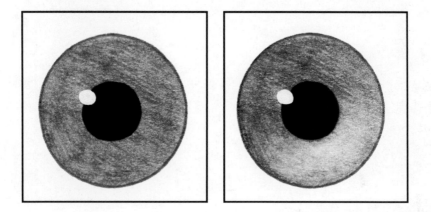

 Look closely at this tiny circle, called a highlight, in the first drawing. It helps to make an iris look realistic. The highlight stays the white of your drawing paper.

5. **Use your HB pencil to fill in the whole space inside the big circle.**

 Except for the highlight, of course!

6. **Pull and stretch your kneaded eraser until it becomes soft. Mold it to a point. Use the point of your kneaded eraser to gently pat the shading on the side of the circle opposite the highlight.**

 Keep patting until this small area becomes a little lighter than the rest of the shading. This little technique makes eyes look much more realistic.

7. **Use your vinyl eraser to clean up any smudges or fingerprints (or footprints, paw prints, or nose prints!) on your drawing paper.**

Chapter 3

Navigating Your Drawing Journey

* *

In This Chapter

▶ Exploring drawing landmarks along the way

▶ Keeping souvenirs of your journey

* *

"A journey of a thousand miles begins with a single step."

— *Ancient Chinese proverb*

Mastering the different components of drawing comes with time and practice. As you begin to draw, remember from the start that your efforts won't always look "perfect." You can look forward to a long and fulfilling journey as you discover and use all the skills you need to make a drawing look exactly as you envision it.

In this chapter, I post billboards to help you navigate toward important landmarks in your drawing journey. I give you just enough information so you have some idea of what to expect at your various destinations. You find out more about these landmarks in later chapters.

I include some of my early drawings to illustrate several stages of my artistic development. By sharing my beginnings as an artist with you, I hope that you feel less intimidated by the process of discovering your own drawing abilities.

My early drawings underscore another important point — drawing is an infinite quest. The day you are totally happy with everything you draw, that's the day to quit drawing. As long as you see problems in your drawings, you know there's room for improvement. You eventually discover solutions to the problem areas, and your skills advance. I hope to continue my drawing journey throughout the rest of my life. Thankfully, I'm rarely happy with anything I draw. I always find something that I can do better next time.

Keep your drawings, even if you don't like them at first. As you complete each one, write the date on the back of it. By seeing where your skills used to be, you can assess how far along you have come. Respect both your origin and your progress. As with any pleasurable journey, it isn't the destination that matters. Your joy in discovering new drawing landmarks is both the goal and the reward of your quest.

Looking for Lines

Most artists begin their drawing journeys with simple lines. In fact, most people get their first drawing experiences as children, by making lines with crayons, and coloring in coloring books.

Everything that you can see can be captured in a line drawing. Very few visible lines outline actual objects. But, with a little practice in looking for edges, you can adjust your vision to block the intricate details of a complex object and see only its lines. These lines become the foundation for more detailed drawings later on in your journey.

Find a mug or another simple object with a handle. Place it in front of you and look closely at it. Focus your eyes on its edges. Try to visually simplify the object into lines like in a coloring-book drawing (see Figure 3-1).

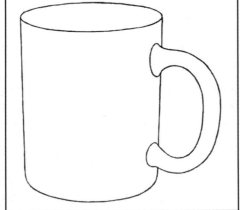

Figure 3-1:
You can draw any object when you see its edges as simple lines.

Like most people's, my early drawings were made almost entirely with lines. Figure 3-2 shows you a couple of my drawings before I discovered shading. I was around 14 when I did these. As you can tell, drawing faces already fascinated me.

Figure 3-2: Two of my early drawings show how even complex subjects, such as people, can be rendered using only lines.

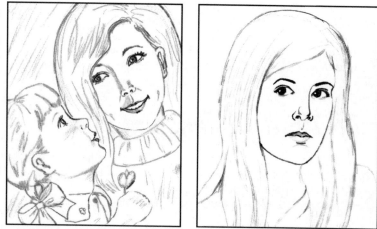

The next time you go shopping, treat yourself to a simple coloring book. Not to color, of course. Instead, look closely at the line drawings. Objects around you don't look like the line drawings in a coloring book, but those simple line drawings do look like real objects. Try some simple coloring-book-type drawings, such as a ball, house, or tree, in your sketchbook.

I tell you a lot more about drawing with lines in Chapter 5.

Going from Lines to Shapes

Young people have an uncanny knack for seeing simple shapes in objects. A house is a square, and its roof is a triangle. A tree is either a triangle or a long, thin rectangle with a circle on top. Close your eyes and imagine (or remember) how the world looks to a child — a world where objects are defined as simple shapes.

As you begin to reduce the objects you want to draw into lines (see the previous section), you start to notice that all objects are made up of such simple shapes as circles, squares, and triangles. Shapes are defined by looking at the outline (or edges) of an object. Circles, squares, and triangles can be varied and combined to create more-complex shapes.

Some objects look easy to draw, but they are actually quite difficult. Some subjects look really hard to draw, but they are in fact very easy. The degree of difficulty of a drawing subject is determined by the complexity of the various elements that define its shape.

Complex shapes can be very tedious and frustrating for a beginner to translate into a drawing. If you feel frustrated while drawing a certain subject, it's

probably a difficult and complex shape. Just do your best, and give yourself a pat on the back for accepting a challenge.

I show you some techniques for drawing complex subjects with lines in Chapter 5 and tell you more about shapes throughout Chapter 6.

Adding a Third Dimension: Form

You can put any subject down on paper by using lines to rough out its basic shapes (see the previous sections). In many cases, line and shape are all you need to make a complete drawing. However, if you want your subject to have the appearance of realism and weight, you need to give your drawing *form*.

I think of a form as a three-dimensional shape. Form is what turns a circle into a sphere and a triangle into a cone. Cubes and cylinders are examples of forms based on a square or rectangle. *Perspective* and *shading* are the tools you use to give your subjects form.

Drawing the form of an object with perspective and shading illustrates its structure. When you draw the light, shadows, and reflected light correctly, the form looks even more realistic. (I show you how to draw these elements throughout Chapter 6.) Figure 3-3 shows some of my early tries at adding form to my drawings.

Figure 3-3:
My early attempts at defining form in my subjects.

Getting a perspective on things

Perspective is the rendering of a three-dimensional object or space within a two-dimensional surface. Paying attention to and accurately portraying

perspective in your drawings gives your subject matter a sense of depth. When you understand perspective, your drawings become more realistic and visually correct. I discuss perspective in depth in Chapter 9. In Figure 3-5, you see how I attempted to use perspective to make the log cabin look three-dimensional.

Savoring shading

Shading refers to all the various shades of gray in a drawing. To draw an object realistically in black and white — to give the object form — you need to translate colors, light, and shadows into these shades of gray. Light and shadows in your subject determine where to draw the light and dark shading. *Contrast* (the difference between light values and dark values) is the primary ingredient of shading that makes your drawings look three-dimensional.

I use a range of grays for the shading in the first drawing in Figure 3-4. By choosing a dominant light source from the right, my shading is generally darker on the left, giving the figures form (especially the legs). Check out the styles of clothing! Have you seen any of them recently? I have. Today they're called "retro." I was a young teen (back in the '70s) when I did this drawing. Oh well, you know what they say about fashion — hang onto your clothes long enough and they come back into style!

Figure 3-4: Fashion drawings using a range of grays to create shading and form, and a portrait using high-contrast shading.

In the second drawing in Figure 3-4, I use high-contrast shading with very dark values and white. I drew this caricature (cartoon drawing) of one of my high school teachers during algebra class. But don't tell anyone, because the vice-principal at that time just happened to be my dad!

Discovering the Details: Textures

For many artists, the day they discover texture is a major milestone in their artistic journey. Textures are fun to draw and add a definite degree of realism to a subject. Think about the trunk of a tree, the surface of a mirror, the fur of a dog, or a thick wool sweater. See its texture in your mind and think about how it would look in a drawing.

In Figure 3-5, I show you how I drew textures when I was in junior high school. By attempting to create the illusion of a soft sky, solid mountains, uneven and jagged trees, and a rough roof, the drawing is more interesting and realistic.

Figure 3-5:
An early
attempt
to draw
textures.

You find lots of information on textures in Chapter 8.

Putting Things in Context: Composition

During the first few steps of your drawing journey, you may be entirely focused on just getting your subject down on paper any way you can. The essentials of seeing lines and shapes and adding form and texture may consume so much of your artistic energy that you end up placing all your subjects smack-dab in the middle of the page. Doing so tends to make your drawings look static. Eventually, you need to give the composition of your drawings some thought and planning.

Composition is the balanced and pleasing arrangement of your subject or sub-jects and the space surrounding them, within your drawing format. How you compose your drawing plays a big role in its final impact.

Notice the two key words used in the first sentence above — *balanced* and *pleasing*. These two words have different meanings for everyone. There are infinite compositional possibilities that you can employ to achieve the effects you want in your drawings. However, when you first start out, it can be help-ful to have a couple of guidelines and formulas to follow when creating a com-position, which I give you in Chapter 10.

Project 3: Sammy and Samantha

Drawing the Smiley twins, Sammy and Samantha, gives you a whirlwind tour of some of the drawing milestones I tell you about in this chapter. You get to use line, shape, composition, and even some texture. You can draw just one of these adorable little imps, or try drawing both on the same page (or on separate pages).

The instructions for this project are the same for both Sammy and Samantha until you get to the final step of drawing hair. Turn your sketchbook vertically and draw a rectangle 3 inches wide by 3¾ inches long (or 6 inches by 7½ inches if you want a larger drawing). Don't worry about making your drawing look exactly like mine. Just have a great time and follow these guidelines:

1. **Draw the outlines of two small circles below the halfway point on your drawing page.**

 These circles are the eyes. No big deal if yours are a little bigger or smaller than mine.

TIP

Imagine two diagonal lines from the opposite corners of your drawing space (forming a big X). The center of this X is the center of your drawing space, and your composition is stronger if you draw nothing important in this space. Note the position of the eyes in my drawing space. Neither eye is in the center of this imaginary X.

2. **Draw two tiny circles inside the circles you have drawn for the eyes.**

 These will be the highlights of the eyes and create the illusion that the eyes are shiny and round. These two tiny circles will stay white.

3. **Use your 6B pencil to fill in the two circles, leaving the highlights white.**

4. **Draw an egg shape around the eyes with the narrow section at the bottom.**

 If an egg had a tiny chin and chubby cheeks (and two eyes), it would look exactly like the shape of this figure's head. Make sure you draw the top of the head high enough so that the eyes are below the halfway point of your egg shape.

5. **Adjust your egg shape to include the cheeks and chin.**

 Small children usually have chubby cheeks and very tiny chins. Note that the cheeks in my drawing are a little wider than the lower section of an actual egg shape. The chin is just a little extension on the bottom of your egg shape.

6. **Add an oval shape for a nose and a curved line for the mouth.**

 You can make these features bigger or smaller if you wish.

7. **Draw the two ears.**

 Little kids often seem to have big ears because their faces are proportionately smaller than those of adults.

 Note the location of the ears in my drawing. The tops of the ears are slightly above the horizontal location of the eyes. The bottoms of the ears are a little below the bottom of the nose.

8. **Fill in the hair with your 6B pencil.**

 I created the texture of their hair with a supersimple fun technique I call squirkles. (Peek ahead to Chapter 8 to find out how to create the texture of curly hair.) Note how the little wiggly lines that extend outside the hair on the top, sides, and forehead create the illusion that this is curly hair and not a hat.

Part II
Exercising the Basic Skills

The 5th Wave By Rich Tennant

BRAD FINALLY COMES ACROSS
SOMETHING INTERESTING TO DRAW

In this part . . .

Eat your vegetables! They're good for you. Besides, if you don't, you can't have dessert! Okay, I confess, these chapters aren't the most delectable ones in this book, but they really are good for you. Some may even refer to the topics as bland. The way I see it, you have two choices:

First, you can choose to just line your bird cage with the pages from this part of the book, ignore all the fantastically exhilarating, and incredibly rewarding technical skills, and suffer miserably through all the stuff that you think should be fun. Get frustrated, feed your pencils to a woodchuck or beaver, let your dog eat your awful drawings, and give up your dream of drawing well.

Or, you can decide to have fun working your way through each and every page of these six chapters. Don't worry — I make this technical stuff appetizing. You can then take all your wonderful new skills and apply them to the really fun chapters. Your drawings turn out fantastic, your dog goes back to eating dog food, and everyone lives happily ever after!

In this part, you explore familiar surroundings with new visual perceptions. I also let you in on how to create the illusion of three-dimensional reality on a flat piece of paper. Knowing how to do shading, and draw textures, is an integral part of drawing. While composition and perspective are somewhat tedious, they are so very important that each has the power to make or break your drawings! Don't be surprised when you discover that the exercises and projects in these chapters are actually quite enjoyable.

Chapter 4

Seeing as an Artist

T he world looks totally different when you see it through the eyes of an artist. From this perspective, ordinary objects you've seen hundreds of times before suddenly teem with new angles, lines, and importance. When you adjust your eyes (and brain) to seeing in this way, you find that the world is jam packed with subjects for drawings.

In this chapter, you have an opportunity to explore your artistic visual abilities from your own unique perspective. With some simple and fun projects, you exercise both your brain and your vision. Keep your drawing supplies close by and draw along with me as I tell you about the artistic merits of each side of your brain.

Dissecting Your Brain

Many aspects of your brain need to work together with your vision when you draw. Although it's not critical that you understand how your brain functions as you draw, being aware of your brain's different capacities may help you realize some interesting characteristics about yourself that can impact your development as an artist.

Your brain is a magnificent possession! It has two sides: the right hemisphere (right brain) and the left hemisphere (left brain). Both sides of your brain play an equally important role in drawing.

Right-brain thinking is visual, perceptive, intuitive, insightful, and creative. This side of your brain is responsible for the following:

- ✔ Seeing relationships and likenesses between shapes and spaces
- ✔ Combining various visual elements to form a whole image
- ✔ Seeing composition instinctively

It may sound as if the right brain shoulders the bulk of the work of drawing. But the analytical left brain pitches in to carry its share of the artistic load by doing the following:

- ✔ Using mathematical logic to establish proportion
- ✔ Planning a composition according to the rules of composition
- ✔ Naming the parts of the object you are drawing
- ✔ Analyzing the step-by-step procedures of composing a drawing

As you can see, you need to activate both the creative Oscar-Madison and the analytical Felix-Unger sides of your brain in order to draw well.

Waking Up the Right Side of Your Brain

For most people, the left brain gets plenty of exercise in everyday life by making routine decisions, like writing a list of what to fix for dinner or adding up bills, or by attending school, which emphasizes the importance of left-brain functions. As a result, many persons end up being *left-brain dominant* by default; that is, the majority of people find that the analytical part of the brain takes over and silences the more creative right side.

Many of the perceptive skills needed for drawing are processed by the right brain. Exercising some dormant abilities of your right brain helps you to draw better in the long run. Time to give your right brain a wake-up call.

Flipping sides

This exercise ensures that both sides of your brain are up and running. In order to see both parts of the optical illusion in Figure 4-1, your brain must utilize both its right and left sides.

You start out seeing either a vase or two faces. At the moment that you perceive the second image, your brain has switched sides. By the way, those gorgeous facial profiles belong to my grandson, Brandon.

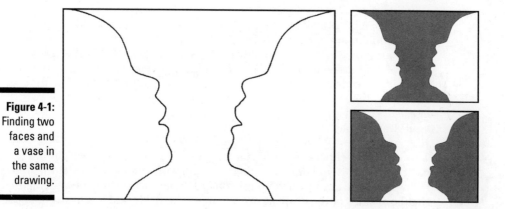

Figure 4-1:
Finding two faces and a vase in the same drawing.

Drawing the line

In this exercise, you call on the right side of your brain to recognize symmetry. *Symmetry* is a balanced arrangement of lines and shapes on opposite sides of an often-imaginary centerline. Many drawing subjects, including vases, frontal views of faces, wine glasses, flowerpots, and forms such as spheres, cones, and cylinders, are rendered using symmetry.

Imagine a line down the center of the left illustration in Figure 4-2. Each side is a mirror image of the other; both sides are symmetrical. Can you see the symmetry in the beautiful chalice? Can you also see the two old witches?

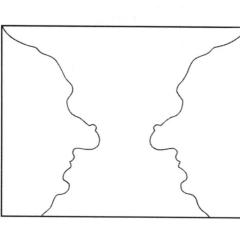

Figure 4-2:
Seeing symmetry in the chalice and old witches.

Giving your left brain a vacation

You don't have to stand on your head for this exercise, but if you should choose to, you can give your arms a workout as you stimulate your right brain.

Familiar objects often look very unfamiliar when viewed upside down. Visual information that is automatically verbally labeled by your left brain is no longer available. When your left brain can't name and identify the various parts of your drawing subject, it gets confused. Eventually it tires and gives up trying. This is where the right brain jumps in and takes over. The right brain sees the lines differently from the left brain. It focuses on the way the lines curve and how they create shapes and spaces within the boundaries of your drawing paper.

This exercise deliberately confuses your left brain so that your right brain can take over. As you draw upside down and with symmetry, resist the urge to sneak a peek at this object until you are done. No cheating now! Remember that both sides of the drawing are symmetrical. Each side is a mirror image of the other. You can use whichever pencils you prefer as you follow these steps:

1. **Draw a rectangle in your sketchbook 4 inches long by 2 inches high.**

 If you prefer a larger drawing surface, make the rectangle 8 inches by 4 inches.

2. **Very lightly draw a dotted line down the center of your rectangle to divide it into two 2-inch squares (or 4-inch if you use the larger format).**

 This line visually represents the imaginary line of symmetry. You draw it lightly because you erase it later.

3. **Draw the first set of three lines that you see in Figure 4-3.**

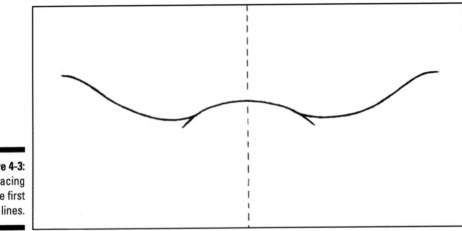

Figure 4-3:
Placing
the first
three lines.

Place this first set of curved lines almost halfway between the top and bottom of your rectangle. The line in the middle looks like a small section of the top of a circle. The other two curved lines touch the middle line, and then curve outwards and upwards.

4. Draw the second set of lines that you see in Figure 4-4.

Figure 4-4:
Placing the second set of lines.

Draw a slightly curved line directly above your first line. Note that this new line is almost at the top of your drawing space. Then draw a second line, curving up and then back down, below the first line, close to the bottom of your drawing space.

5. Put your pencil on one end of the top line. Draw a line that curves outward and downward, connecting to the end of the centerline (see Figure 4-5).

6. Do the same on the other side of the top line, completing the upper shape.

7. Put your pencil on one end of the centerline. Draw a line that curves outward and downward to join the very bottom line.

8. Do the same thing on the other side completing the lower shape (see Figure 4-5).

9. Erase the centerline running down the middle of the drawing.

There you have it. A symmetric, fully rendered, beautiful . . . what the heck is that? Your right brain can see the symmetry, but your left brain can't make out the object because it's upside down. Turn your sketchbook right side up and let your left brain come back from hiatus. Mick Jagger would be proud.

Figure 4-5:
Completing
the shape.

Exploring the World as an Artist

Look around you. As an artist, everything you see is a potential drawing sub-
ject. Your choices are endless. If you consider the possibility that even a tiny
section of an object can make a complete drawing, your options for choosing
drawing subjects become infinite.

In the next couple of sections, you are offered food for thought, literally and
philosophically, so you can give your drawing supplies a break. Your current
ideas about ideal subjects for drawing are about to be challenged.

Finding stuff to draw right in front of you

Subjects waiting to be captured in a drawing are right in front of you. Look
around you for interesting shapes, lines, and textures. Focus on small details
in familiar objects. You can transform anything into a valuable subject
worthy of your pencil.

Consider that palm-tree figurine that your Uncle Fred brought back from his
last trip to Florida. Study the delicate curve of its fronds and take note of its
proudly straight trunk.

Take a fresh look at that obnoxious (but really cute) talking codfish toy that your Aunt Daphne sent you from Newfoundland. Size up the gorgeous, intricate details of its texture, and its funny face.

The cup in Figure 4-6 was just quietly sitting on my desk. I drink coffee from it almost every morning, but only recently discovered its potential as a drawing subject. The funny face on the mug is what caught my eye.

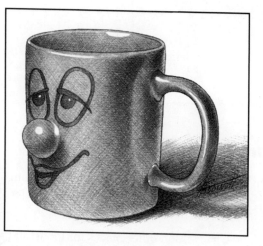

Figure 4-6:
Taking note
of the
possibilities
in everyday
objects.

Seeing your home for the first time

Take a walk around your home. See beyond your complex perceptions and look for drawing subjects. If a whole room seems overwhelming, find a smaller section that intrigues you. Maybe certain objects in a room have the potential to become fascinating drawing subjects.

In Chapter 10, I demonstrate how to make and use a *viewfinder frame,* which you may find very helpful for finding drawing subjects.

Figure 4-7 shows a partial view to the upstairs area of my home from my studio computer desk. The painting on the far wall of the dining room beyond the kitchen captured my attention. I drew it with shading, unlike the simple lines I used for the rest of this drawing. By making note of the lines in this scene, I found a dynamic subject for a drawing in a humdrum space I pass through many times during the course of a typical day.

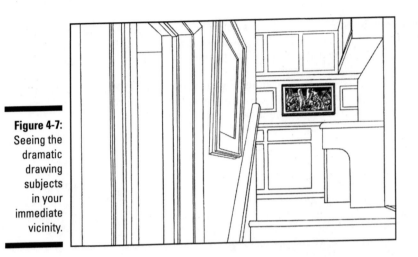

Figure 4-7:
Seeing the dramatic drawing subjects in your immediate vicinity.

From the fridge to your drawing

Food has always been a favorite drawing subject for artists. From fruit to vegetables, and from bread to fish, an eclectic menu of drawing subjects awaits your drawing appetite.

Check out your cupboards, fridge, and other places for foodstuff to use as drawing subjects. Figure 4-8 illustrates egg-axtly what I mean!

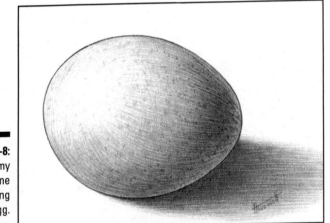

Figure 4-8:
From my fridge came this drawing of an egg.

When looking for drawing subjects, it pays to actively search for something that interests you. Root through the attic, take a trip to the garage, or shine a light into the deepest corners of your basement until you locate an object or scene that calls to you. Especially when you first start out with drawing, you need a vested interest in your subject matter. Otherwise, you may become bored or frustrated when the first few lines don't work out as you expected.

Surveying your neighborhood and beyond

From the moment you walk out the front door of your home, drawing subjects surround you. Maybe sidewalks and skyscrapers greet you as you exit your building. Depending on where you live, chickens and ducks may walk up to you as you step outside. Maybe lush tropical forests surround your home.

Take a moment, and appreciate your surroundings from the perspective of an artist. See beyond your habitual perceptions. Look at the little flower attempting to grow from a crack in the pavement. Observe the intricate shapes of the branches on your neighbor's apple tree. Notice the lines created when the roofs of buildings meet a dark, stormy sky. Capture some of these images in the pages of your sketchbook and then have a quick conversation with your neighbor to explain why you're staring at her house.

Figure 4-9 shows you what I see as I step from the back deck of my home. It's your typical view of some trees, but on closer inspection, there is a staid beauty in the parallel lines of the tree trunks.

Figure 4-9:
Taking advantage of the artistic possibilities in your neighborhood.

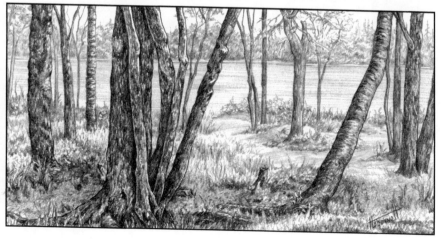

Discovering the World inside the Artist

No chapter on seeing as an artist could be complete without discussing your *inner eye* (sometimes called your *mind's eye* or your *third eye*). Lots of exciting drawing subjects are hiding right where you hang your hat.

Your inner eye can see something long after it's out of your line of vision. I call this *visualization.* Close your eyes and visualize a blue sky with white fluffy clouds. Now try to visualize the face of someone you know well. (I tell you more about visualization in Chapter 12.)

The really cool thing about your inner eye is that it can conjure up a subject exactly as it occurs in real life (the work of the left brain), or it can embellish on the truth and morph into something entirely fantastic. Where your inner eye is concerned, you can literally let your imagination run wild.

Comparing right- and left-brain perceptions

Your right and left brain allow you to look at the exact same thing and yet see two completely different images. Here are a couple of ideas to help you see the right-brain and left-brain possibilities in drawing subjects:

✔ The next time you go outside, examine the clouds in the sky. Your left brain allows you to see only clouds. But sometimes you can look at a cloud and see the shape of something else. Your right brain allows you to see other things in clouds, such as animals or faces.

✔ The logical left brain allows you to see a pattern as a pattern and a texture as a texture. Look at a pattern or texture and try to see images that your left brain doesn't recognize. The right side of your brain can often help you find and see different images, such as a face hiding in the texture or pattern of your carpet. Check out fabrics, flooring, rocks, wood grain, and anything else patterned or textured. With patience and practice, this skill is accessible to you. Try not to get freaked out if you see a tiger pouncing on you from your laundry pile.

Figure 4-10 demonstrates what happened when I drew a woodlike texture (left) and then looked at it from all four sides. I was soon seeing new things (on the right). Of course I take artistic license, especially when I add eyes and teeth.

Figure 4-10:
A texture
becomes
something
else when
the right
brain is
given a
hand.

Doodling with doodles

The artist within you is creative, curious, and eager to express the art within your mind. Your right brain fuels your imagination and creativity.

Few people recognize the virtues of simple doodling, especially for exercising your right brain. Coming up later in this chapter, you draw your own doodle. For now, just follow along with me and visually explore the evolution of my doodle.

In Figure 4-11, I incorporate three different types of lines into a doodle. (I illustrate the three different types of lines in Chapter 5.) I draw one continuous line (actually several lines joined together) all over a page.

Have a closer look at my doodle. Some parts are straight, and some parts curve in different directions. The line even cuts across itself in many places, creating lots of different shapes, and an abstract composition.

Try turning this book around in all four directions and look at my doodle from each different perspective. You might see a couple of familiar things in the doodle as you allow your right brain to explore.

Figure 4-12 shows some of the shapes, objects, and faces that I found in my doodle. How many of them can you find in my doodle drawing? Try turning the book around in different directions.

See Figure 4-13 to find out what happens to these silhouettes when I turn them into line drawings.

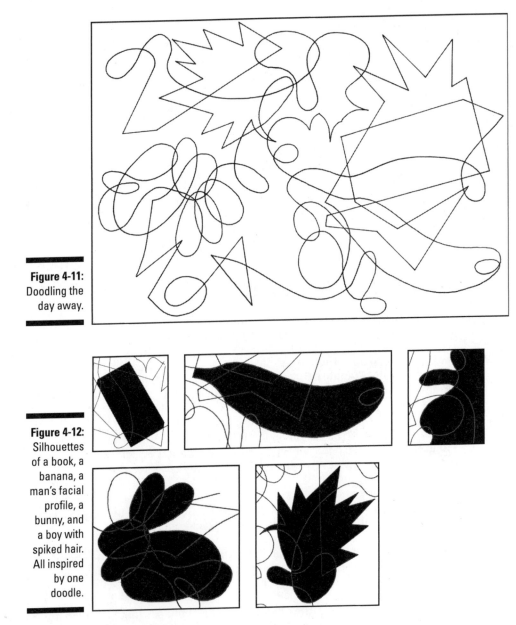

Figure 4-11:
Doodling the
day away.

Figure 4-12:
Silhouettes
of a book, a
banana, a
man's facial
profile, a
bunny, and
a boy with
spiked hair.
All inspired
by one
doodle.

Despite what your boss may say as he disparages the doodles on your minutes of the last company meeting, doodling activates your brain and keeps your creativity juiced up. Remind him about this during your next bonus review.

Figure 4-13:
Transforming
silhouettes
from a
doodle into
line
drawings

Project 4: A Doodle of Your Own

Each time you draw, your artistic visual skills improve. Have some fun with
doodles and give your right brain a workout. You have no illustrations to
guide you, only your right and left brain. Have fun! This project is divided
into three parts, each with its own set of instructions.

Putting down the lines

As you draw, remember to include straight, angle, and curved lines. Have
your doodle cross over other lines in lots of places, and change the direction
of your lines frequently. Follow these steps as a guideline:

1. **Pick a place on your page to begin.**

2. **Make a small dot.**

 This dot is the place you begin your doodle and also the place where
 you end.

3. **With a fine-tip marker or a pencil, begin to draw a doodle that covers
 your page.**

4. **To finish, just head your line back toward the dot you began with.**

 End by joining the two ends of the line together at this dot.

Seeing beyond the lines

Clear your mind by taking a two-minute break. Then sit comfortably in your chair with your doodle drawing in front of you. Your drawing paper has four sides, unless of course, your poodle ate part of your doodle. As you turn your paper around in each direction, each side becomes a bottom. Follow these steps to see the possibilities in your doodle:

1. **Number the bottom of each side 1 through 4. On a separate piece of paper write the numbers 1 through 4, leaving room between each to add a list.**

2. **Look at side number 1 first. Relax your mind and observe the doodle from this perspective.**

 Find something that reminds you of a face or an object. If you find something, write it down under number 1 on your list. Don't make any marks on your actual doodle.

3. **Turn your paper to the next side and see what you can find.**

 Continue on through numbers 3 and 4. Then start all over again until you have found a few items, objects, or faces.

 Don't be disappointed if you don't see anything at all for the first few minutes. Take another little break, and come back and have a fresh look. Try closing your eyes for a few seconds and then opening them again. You can even let your eyes go "out of focus" for a few seconds, and then bring them back into focus. It takes practice to encourage your right brain to cooperate with you.

4. **When you have found a few things you like, take a colored pencil and color in the shape of each.**

 Some objects may overlap others, so you should use a different color for each object.

Creating drawings from doodles

How many shapes and objects did you find in your doodle? Choose your favorites and add more lines and details to turn them into drawings (see Figure 4-13).

Don't worry about turning out masterpieces! Simply use your imagination and have fun with these drawings.

Chapter 5

Seeing and Drawing Lines

In This Chapter

▶ Appreciating lines from a new perspective

▶ Investigating lines in drawings and objects

▶ Seeing and drawing the simple beauty in lines

▶ Translating complex objects into contour drawings

*I*f you look very closely at most drawings, you discover that every section is composed of lines. The lowly line is the primary ingredient in all my drawings.

Lines can separate the individual elements of drawing subjects or come together to create shading. Different types of lines can inspire diverse emotions and illustrate creative concepts.

Three families of lines (straight, angle, and curved) can be found in line drawings. Each family includes an infinite range of different lines from thick, dark, and bold to thin, light, and subtle.

In this chapter, you discover how to identify each family of lines, in drawings and actual objects. You also find lots of visual exercises to stretch your mind.

Appreciating Diversity in Lines

With only three types of lines — straight, curved, and angle — you can draw everything you can see or imagine.

When the shared edges of two spaces meet, a *contour line* is created. (I explain contour lines in "Finding the line between the spaces" later in this chapter.) A *contour drawing* is created when you combine contour lines to define all the various components of a drawing subject.

Lines can also define small sections or details within your drawings. You can even combine different lines into a group (sometimes called a *set*) to make shading, which helps you add a realistic, three-dimensional feel to your drawings. (I tell you everything you need to get started with shading in Chapters 6 and 7.)

Lining up straight lines

Straight lines can be thick or thin, long or short, and they can be drawn in any direction. Various types of straight lines illustrate different concepts and emotions in drawings. The basic types of straight lines include the following:

- **Horizontal:** Lines that are parallel to the *horizon* (the imaginary line where the earth meets the sky) and are at right angles to vertical lines. Horizontal lines reflect stability, peace, and serenity.

- **Vertical:** Lines that are straight up and down and at a right angle to a level surface (such as the horizon). Vertical lines reflect strength, grandeur, and dignity.

- **Diagonal:** Lines that are not vertical or horizontal but rather, slant at various angles. Diagonal lines offer a sense of movement and power to drawings.

Figure 5-1 shows you some examples of horizontal, vertical, and diagonal lines. Try your eye at identifying these three types of lines.

Figure 5-1:
Examples of horizontal, vertical, and diagonal lines.

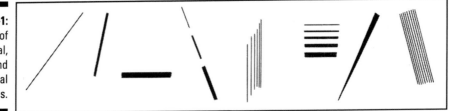

Have you ever heard someone complain that they can't draw a straight line with a ruler? Well, you can! It's perfectly okay to use a ruler to draw straight lines for some drawing subjects.

If your ruler doesn't have a beveled or raised edge, it may smudge your beautiful straight lines as you draw. To help prevent smudges, try taping three pennies to the underside of your ruler to raise its edge from your drawing surface.

You need to be able to sketch a relatively straight line freehand in the initial stages of many drawings. Sketching is a lot more fun when you don't have to depend on a ruler.

Drawing straight lines freehand isn't easy, but with practice, you can master this skill. Follow these three easy steps and draw some straight lines in your sketchbook:

1. **Draw a dot at the place where you want your straight line to begin and another where you want it to end.**

2. **Before you actually draw, imagine the straight line connecting these two dots.**

3. **Connect the dots.**

You can draw the straight line in between the dots in one continuous movement from your elbow (don't move your fingers or wrist) or in a series of stroking movements (I prefer the second method for short lines). Practice drawing straight lines in any way you find comfortable.

It's true that straight lines can only go in three directions on a flat piece of paper — vertical, horizontal, and diagonal — but there's a lot of power in those three directions! Before you get the idea that straight lines are boring, I want to show you how you can use these lines to create line drawings of simple, square objects.

Figure 5-2 shows how I used straight lines to render a tissue box (which is, of course, nothing to sneeze at):

- ✔ **The first stage:** The first illustration in the next set of three is a very rough freehand sketch. My goal is to simply establish what size I want the box to be and where I want to place it within my drawing space.

- ✔ **The second stage:** In the second drawing, I refine the drawing and add a little more detail (the tissue is drawn with curved lines, which I discuss in "Following the flow of curved lines" later in this section).

 I lighten my first lines by patting them with my kneaded eraser. Then I draw in a new set of straight lines freehand.

- ✔ **The final stage:** In the last drawing, I lighten the second set of sketch lines with my kneaded eraser until I can barely see them. Then I use a 2B pencil and a ruler to create a more precise drawing.

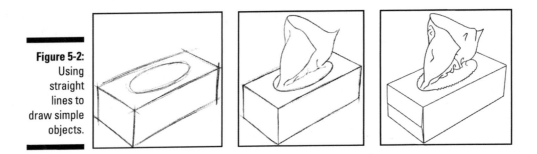

Figure 5-2:
Using
straight
lines to
draw simple
objects.

Cutting corners with angle lines

Angle lines (see Figure 5-3) occur when two straight lines meet (or join together). The angle can be any size. The size of the angle determines the shape of the object.

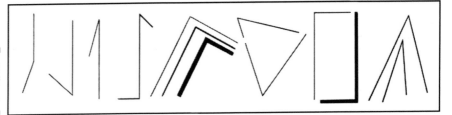

Figure 5-3:
Examples of
angle lines.

Angle lines are used to draw various shapes, such as squares, rectangles, and triangles. When you combine angle lines with geometric perspective, three-dimensional forms emerge. (In Chapter 9, I illustrate several angle lines used in geometric perspective.) Angle lines denote many characteristics including strength, solidity, and movement.

By combining angle lines in a drawing, you can make complete figures. Figure 5-4 helps you see how just a few angle lines combine to help drawing subjects take shape.

Following the flow of curved lines

Curved lines happen when a straight line curves (or bends). Curved lines can be thick or thin, and they can even change directions, which is called a *compound curve* (see Figure 5-5).

Common examples of curved lines include the letters *C, U,* and *S.* A curved line becomes a circular shape when the ends meet. (I discuss shapes in Chapter 3).

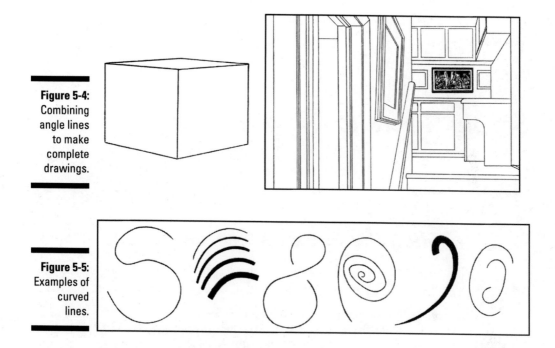

Figure 5-4:
Combining
angle lines
to make
complete
drawings.

Figure 5-5:
Examples of
curved
lines.

Curved lines typically reflect beauty, gentleness, and calmness. The s-curve denotes balance and grace. Figure 5-6 shows a couple of examples of how curved lines combine to create not only shapes but also recognizable contour drawing of objects.

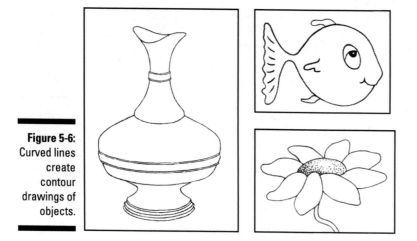

Figure 5-6:
Curved lines
create
contour
drawings of
objects.

Take a few moments and look around you. See how many different types of lines you can find in actual objects. Try combining different types of lines to draw an object or a doodle. Don't worry about how the drawing looks. Simply experiment with combining different types of lines.

Seeing Where to Draw the Line

Complex objects sometimes overwhelm artists. However, drawing complex subjects doesn't have to feel intimidating. Even complicated objects are easy to draw when you understand how to see them from simple perspectives.

Finding the line between the spaces

Before you can actually see where to draw a line, you need to know where to look for a line in an actual object.

Negative and *positive* spaces meet to form lines on the edges of objects. Positive space is the space occupied by the drawing subject, and negative space is the background behind your subject.

In Figure 5-7, you see a photograph of a swan and the completed drawing beside it; try to identify the positive and negative spaces in each.

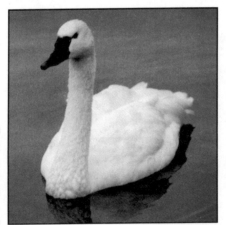 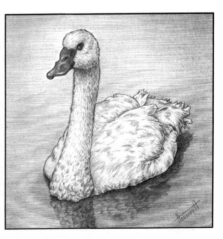

Figure 5-7:
Finding positive and negative spaces.

The first drawing in Figure 5-8 shows the positive space. (Notice that I consider the reflection in the water to be positive space.) The second drawing shows the negative space.

Think of the swan shape in the first drawing as a piece of a puzzle. Use your imagination to visually lift the swan out of the first drawing and place it inside the white space created by the negative space. The places where the two types of spaces meet are the birth of lines.

Figure 5-8:
The positive and negative spaces form lines that define the subject.

In addition to separating a subject from the background, lines can also separate various sections of the subject from one another.

Compare the lines in the photograph (Figure 5-9) with the lines in my drawing beside it. In addition to the lines outlining the positive space, I added other lines. Visually locate the lines in the photograph that separate the following:

- Her bill and eyes from her head
- Her neck from her body
- Her wings and tail feathers from her body
- Her body from the reflection in the water
- The edges of the reflection from the rest of the water

Figure 5-9:
Seeing the
lines that
define a
subject.

Simplifying what you see

Clear your mind as you look at an object's intricate details. With practice, you can simplify your mind's image of an object into the three families of lines.

Look around you and find a familiar object. Drawing the object becomes similar to putting a puzzle together. Once you can see the simple shapes and lines, then you only need to find the right place on your drawing surface to draw them.

In your mind, break this object down into simple lines (refer to the previous section "Finding the line between the spaces" to find out how to see lines in objects) and shapes:

- ✔ **Visually explore the object's edges.** Look for horizontal and vertical lines. Are they curved or straight? If they are curved, in what direction do they curve?

- ✔ **Observe the places where the lines meet to form angle lines.** Take note of the size of the spaces inside the angles.

- ✔ **Look for compound curves.** Do you see any curved lines that change directions to make compound curves, such as in the letter *S*?

- ✔ **Look for the outlines of shapes formed by different lines.** Do you see any circular, rectangular, or oval shapes?

Warming up to drawing

Exercising your drawing hand and relaxing your mind help you get into an artistic frame of mind. Try these simple exercises to prepare for your next drawing workout:

✔ **Writing your name:** First write (or print) your name as you usually do from left to right. Then write it in reverse from right to left.

✔ **Doodling:** Grab a sheet of paper and a pencil. Fill in the entire page with as many different types of lines and shapes as you can draw, just letting your pencil and mind go where it wants to go (see "Doodling with doodles" in Chapter 4 for a fun project with doodles).

Making simple drawings from complex subjects

Simplifying a subject visually helps you render simple contour drawings. By reducing an object to its basic component lines and shapes, you can render a simple drawing of any object, no matter how complex it may be.

Some lines need to be drawn more precisely than others to be believable. This means patiently observing your drawing subjects and taking your time in determining where and how your lines need to be drawn.

Examine the next two drawings in Figure 5-10 (yes, I live with a couple of dogs, Chewy and Shadow). The first drawing is an example of what I mean by having to be more precise. The dog dish was easy to draw but took more time. The oval shapes (called *ellipses*) of the top and bottom of the dog dish needed to be symmetrical in order to create the illusion that the dish is round. It doesn't matter if my lines are off a little for the rawhide bone because all rawhide bones differ slightly in shape anyway.

Figure 5-10:
Complex subjects reduced into a series of lines.

Making complex drawings of complex subjects

Line drawings don't have to be simple. They can include as much detail as you have the patience to draw.

Figure 5-11 was done as a study for a small section of painting called *Serendipity*. This little dragon existed only in my imagination until I decided to transform him into a drawing (and a painting). Now he's real enough to share with you, just one more perk of being able to draw!

Look at all the details in his wings and scales and the twigs that make up his nest. This wonderfully detailed contour drawing results from layering and building sets of simple lines and shapes.

Figure 5-11:
Laying
simple lines
and shapes
to create
a complex
image.

Focusing on proportions and shapes

In addition to seeing and drawing lines correctly, seeing and drawing the accurate proportions of the subjects, and the shapes created by the lines, helps you visually simplify your drawing subjects.

A couple of simple techniques may help you draw complex objects. When you first look at an object try to see the following:

✔ Distances between lines that appear to be the same length or height, in both the negative and positive spaces of your drawing subject.

✔ The outlines of the shapes (such as ovals, squares, or rectangles) created by the negative and positive spaces and their relative sizes as compared to other spaces.

Proportion refers to the relative size of an object (or objects) in your drawing as compared to another (or others). You can draw the shape of any object correctly when your proportions are correct.

Getting Comfortable with Lines

In this exercise, you draw without looking at what's happening on your paper. You only look at your drawing subject. And, yes, there's a method to the madness! Coordinating your vision with your drawing hand is an integral aspect of drawing accurately. This project shows you how to see the lines in objects.

Choose a time and place when you can work without interruptions. Plan to focus your complete attention only on the edges and lines of the object you draw, and then follow these steps:

1. **Tape a sheet of drawing paper (from your sketchbook if you wish) to your drawing surface so that the paper doesn't move as you draw.**

2. **Find a simple object to draw.**

 If you're right-handed, place the object on your far left, and if you're left-handed, put it on your far right.

3. **Face the object, but sit so that can't see your drawing paper.**

 Rest your drawing arm on the table in a comfortable position.

4. **Choose one edge on your object and focus on it until you can see its line. Then place the point of your pencil on your drawing surface and look back at the object.**

 For the rest of this exercise, resist the urge to look at what you are drawing. No cheating now!

5. **Allow your eyes to focus on one section of an edge of the object and very slowly visually follow the line created by this edge. At the same time, move your pencil very slowly in the same direction as your eyes.**

 Keep your eyes and pencil moving together at the same slow, steady pace. Don't take your pencil off the paper as you draw; you may get lost.

 Carefully notice each time the line on the edge of the object changes direction. Without peeking at your paper, allow your pencil to record every detail of the line (or lines) you are seeing.

6. **Continue looking and drawing until your eyes return to the place where you began your drawing.**

You may want to repeat this exercise (with the same object or different objects) several times until you experience true right-brain contour drawing. When you find yourself no longer naming the individual parts of your drawing subject, but rather focusing on the lines themselves, you know you are drawing on the right side of your brain.

The process by which you do these drawings is more important than what the final drawings look like. You may not be happy with your drawings using this method, but your new visual skills do improve your drawing overall.

You take your new observation skills to rendering a drawing where you are actually looking at your paper. You thus have more confidence in drawing the perspective you actually see rather that your preconceived notions of what you think you see.

Figure 5-12 shows three drawings I did using this technique. Don't expect your drawings to be as good as mine. My artistic vision has been developing for more years than I care to mention. You are just beginning.

Remember that the goal of this exercise is to improve your visual skills. By developing your visual skills your drawing skills naturally improve.

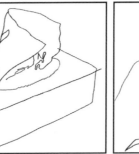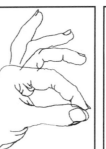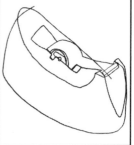

Figure 5-12:
Practicing
with lines.

Project 5: Fragile Melody

In the initial stages of this project, you draw upside down incorporating your visual skills into a line drawing.

You also identify the lines of your drawing subject by observing the negative space and visually measuring proportions.

Before you start to draw, here are a few tips to make your drawing experience easier and more enjoyable:

- ✓ **As you draw, don't think about what the subject is.** Instead, focus on the shapes and negative and positive spaces that define the actual lines.

- ✓ **Set up your drawing space in your sketchbook by drawing a large square any size you want.** Divide it into four equal squares by drawing two lines from top to bottom and side to side. Now you have four squares, which become a drawing grid.

- ✓ **Think of each square as a separate drawing.**

Your grid is drawn and your HB pencil is all warmed up. For the first three steps of this project, pretend the first square is the total drawing.

1. **Find the place where the line meets the top of the first square (it is almost in the center) and then make a dot here.**

 Focus only on the upper-left square of the first drawing in the next set of two.

2. **Make another dot where the line meets the left side of the square.**

 It is close to the bottom.

3. **Draw the line in the first square.**

 Start at the dot you made on the top of the first square and end with your second dot on the left side of the first square.

 Notice how the line curves in different directions. Think about negative and positive spaces. Observe the spaces and shapes on either side of the line.

4. **Use the same technique you just used for drawing the first square, to draw the lines in the other three squares (refer to the second drawing).**

 Did you guess that you were drawing upside down? You can turn your drawing right side up now. Refer to the photo of the little angel and complete the drawing as you want, or follow along with me as I add more details to my drawing.

5. **Look at the first drawing in the next set of two, and draw the lines for the hair and face.**

6. **Take your time and draw what you see in the other three squares.**

 Look closely at other details such as the folds in the fabric of the sleeves and line of the shoulder that separates the angel from her wing.

7. **Carefully erase the lines that divide the square into four sections.**

8. **Draw the eyes, nose and mouth of the little angel.**

9. **Draw her hands and fingers.**

 Look closely at the fingers on her hands. Observe their shapes and the way her fingers curve.

10. **Add her second wing.**

 Change any little details you aren't happy with. You can refer to my drawing or make up your own details.

Chapter 6

Exploring the Third Dimension

· ·

In This Chapter

▶ Training your eyes to see light and shadows as values

▶ Translating your vision into shading

▶ Taking basic shapes to three-dimensional drawings

· ·

Drawing realistically involves creating the illusion of a three-dimensional space on a two-dimensional drawing surface. In this chapter you explore the various drawing elements of light and shadows, which transform shapes into three-dimensional forms.

Everything you see has at least one light source. Otherwise it would be in complete darkness and you wouldn't see it at all. In this chapter, you discover how artists see light and shadow. You examine light and dark values to find the origin of light sources.

Seeing Light and Shadows

Light and shadows visually define objects. Before you can draw the light and shadows you see, you need to train your eyes to see like an artist.

Values are the different shades of gray between white and black. Artists use values to translate the light and shadows they see into *shading,* thus creating the illusion of a third dimension.

Hatching and *crosshatching* are simple and fun techniques for drawing shading (see Chapter 7 for more information on these techniques).

A full range of values is the basic ingredient for shading. When you can draw lots of different values, you can begin to add shading, and therefore depth, to your drawings.

With shading, the magical illusion of three-dimensional reality appears on your drawing paper. Figure 6-1 demonstrates how I took a simple line drawing of a circle and added shading to transform it into the planet earth.

 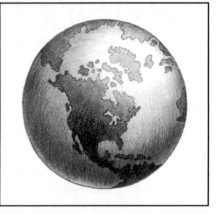

Figure 6-1: Turning a simple line drawing into planet earth.

You know the objects around you are three-dimensional because you can walk up to them, see them from all sides, and touch them. Take a moment to look around you at familiar objects. Try to discover why you see their actual three-dimensional forms. Look for the different values created by the light and shadows.

Taking a closer look

Before you can draw the appropriate values that illustrate light and shadows correctly, you need to be able to visually identify the following:

- ✔ **Light source:** The direction from which a dominant light originates. The placement of this light source affects every aspect of a drawing.
- ✔ **Shadows:** The areas on an object that receive little or no light.
- ✔ **Cast shadow:** The dark area on an adjacent surface where the light is blocked by the solid object.

The light source tells you where to draw all the light values and shadows (I show you how to draw values in Chapter 7).

Figure 6-2 gives you some practice in locating the light source, shadows, and cast shadows around an object, which in this case is a sculpture made by my friend Jesse. As you look at two drawings of the sculpture, ask yourself the following questions:

- ✔ **Where are the light values?** Look for the lightest areas on the object. The very brightest of the lightest values are called *highlights*.

- ✔ **Where are the dark values?** Dark values often reveal the sections of the object that are in shadow. By locating shadows, you can usually identify the light source.

- ✔ **Where is the cast shadow?** The section of the cast shadow closest to the object is usually the darkest value in a drawing. By locating an object's cast shadow, you can easily discover the direction from which the light source originates.

Figure 6-2:
Looking for light and dark values and cast shadows.

The two drawings in Figure 6-2 have different light sources. Compare them and find the dominant light source in each.

If you guessed that the light is coming from the right in the first drawing, you would be correct. In the second drawing, the light originates from the left.

Seeing how a light source affects an actual object is more challenging than examining a drawing. Place an object on a table in a dimly lit room. Shine a powerful flashlight or a lamp (a light source) on the object. Observe it from different perspectives.

Each time you reposition the light source, identify the following:

- ✔ The shadows on the object (dark values)
- ✔ The brightest areas (the highlights)
- ✔ The light values (areas closer to the light source or not in shadow)
- ✔ The cast shadow (the darkest values)

Exploring contrast in a drawing

Contrast can be used to make your drawings more three-dimensional by accentuating the light and shadows. By using extremes in values (more light and dark values than middle values) you create a *high-contrast* drawing. For a really powerful, strong, and dynamic drawing, you can draw very dark shading right next to the light areas.

When a drawing has mostly light and middle values it is called *low contrast.* Some drawing subjects need to be soft and gentle. You can create a very soft drawing and still use a full range of values. Think about a white kitten, for example. Most of the shading is very light, but the drawing becomes more powerful if you use a little dark shading in a few selective areas such as the pupils of the eyes and the shadows.

Your drawings can appear flat rather than three-dimensional when you use too little contrast in values. Unless you are trying to achieve a specific mood or want the subject to look flat, always use a full range of values. (I show you how to draw full value scales in Chapter 7.)

Figure 6-3 helps you see contrast while exercising your vision. Take a few moments to explore the light and shadows in this drawing more closely. The face of the girl is drawn in profile. The boy's face is a frontal view. Notice how I place the girl's profile in the shadow of the boy's face.

The bright light on the front of her face presents a strong contrast to the dark shadow on the side of his face. This makes for a powerful visual separation even though the two faces seem close together.

Figure 6-3:
High
contrast
makes a
drawing
appear
more three-
dimensional.

Translating vision into values

Almost everything has more than one value. Depending on the light source, most things have some areas that are very light and others that are quite dark.

If you look closely at a mound of dark earth, you notice that it has several different values. If a fresh layer of snow covered this mound of earth, there would still be lots of values. When you can see a range of different values you can draw your subject in the third dimension.

Squinting to see values and simple shapes

Seeing values is key to drawing in the third dimension. Many artists can visually simplify complex drawing subjects by simply squinting their eyes. Squinting helps you screen out details and see simple values and shapes. When you can see the shapes created by different values, you can draw your subject more accurately.

Look at Figure 6-4 and squint your eyes until the image seems to go out of focus. Compare the darkest values to the lightest, and try to see the abstract shapes created by the different values.

The second drawing shows what I see when I squint. I've drawn it with only black, white, and two values. Take note of the shapes created by the values.

Figure 6-4:
Squinting to
see values
and shapes.

Turning colors into values with squinting

Many drawing media, such as graphite, are designed for black and white drawings. Yet, almost everything in the world is in color. You need to adjust your visual perceptions to see these colors as shades of gray when drawing.

Wouldn't it be nice if you could simply press a button in the middle of your forehead and magically transform the world from full color to gray values? This ability would certainly make drawing a lot easier. Thankfully, simply squinting your eyes can help you develop this skill.

Try these suggestions to help you train your mind to translate colors into values:

- ✔ Look around you at different objects. Focus on only the light and dark areas and not the actual colors. Concentrate on the light and shadows. Then squint your eyes until you see the values of that object.

 Take a mental note of where the lights and darks are. Think about how you could draw these darks and lights. Don't get discouraged if you can't do it right away. With practice, you get better.

- ✔ Find a colored photograph with lots of contrast. Squint your eyes to block out the colors and details. In your sketchbook, draw only the simple shapes and values you see. Add shading with only black, white, a light value, and a middle value (as I do in Figure 6-4).

If your subject has, for example, light-pink and dark-red stripes, seeing two different values in the two colors is easy. You simply draw the dark red as a dark value and the pink as a light value. But, some objects have colors that seem to be the same in value. When this is the case, you simply have to rely

on your own discretion to decide which colors should be drawn lighter or darker than others. If your subject has stripes of dark green and dark red, you need to pick one to be a lighter value. Otherwise, you end up drawing a solid tone instead of stripes.

Taking Shapes into the Third Dimension

Objects are made up of lots of different shapes, including circles, squares, and triangles. With shading, these shapes transform into three-dimensional objects such as spheres, cubes, cones, and cylinders.

From circle to sphere

When you think of the word *sphere,* you may sometimes think of a planet, orb, or ball. Simply stated, a sphere is a three-dimensional circle.

Hitting the highlights

The highlight in Figure 6-5 is the white circular shape that is represented by the white of this paper. From the perimeter of the highlight, the shading begins with very light values. The shading then graduates from light to dark. Less light reaches the other surfaces of the sphere that are closer to or in the shadowed areas.

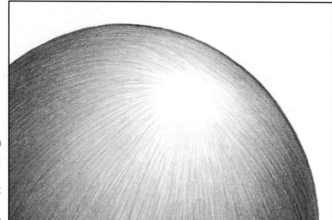

Figure 6-5:
Identifying the highlight on a sphere.

"Drawing" a highlight is quite simple because you don't really have to draw it at all! You only need to know where to place it in your drawing. By carefully observing the object you are drawing, you know where the highlight belongs.

Drawing believable shadows

When you can draw shadows well, your drawings appear much more realistic. Shadows are not quite as easy to draw as light. They require a lot of shading. Have a close peek at Figure 6-6. Note the dark shadow on the lower section of the sphere and the cast shadow on the surface on which it's sitting.

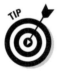

The shading in a cast shadow (on the surface on which an object is sitting) is darker closer to the object and becomes gradually lighter as it moves outward.

Figure 6-6: Identifying the shadow areas and cast shadow on a sphere.

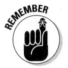

Shadows can give the illusion of weight to any object by making it appear that the object is sitting on a surface. You can also create the illusion that an object is floating above a surface by changing the placement of the shadow.

Figure 6-7 shows the changes in the shadows, as a sphere appears to float upwards. You can create this illusion with objects of any shape, not just spheres. However, the shadows may not be oval. They assume the shape of the objects.

Making use of reflected light

Reflected light is a faint light reflected or bounced back on an object from the surfaces close to and around it. When you understand reflected light and know how to draw it well, your subjects appear more three-dimensional.

Practicing circles and ovals freehand

No one can teach you how to draw a circle or an oval. The best teacher is practice. In other words, you must teach yourself. Drawing a realistic circle or oval freehand becomes quite simple when you've devoted lots of time to practicing this skill.

Try rotating your paper and looking at your drawing from different perspectives. This little trick often allows you insight into the problem areas. Looking at the reflection of your circle or oval in a mirror also helps you to see areas in need of fixing.

Figure 6-7: Altering the shadow to create the illusion that the sphere is floating.

Take a moment to find a sphere (a ball or another round object) and place it on a lightly colored surface. Shine a light on the sphere from above and closely examine its edges close to the surface on which it has been placed.

The reflected light should be visible along the side of the sphere that is closest to the surface on which it is sitting. It is lighter in value than the shadow on the sphere but not as light as the sections closer to the light source. If an object is sitting on a colored surface, you can often see that same color in the reflected light.

Examine the bottom section in Figure 6-8 to see how I draw reflected light. I use light values that graduate darker until they meet the dark shading of the shadow.

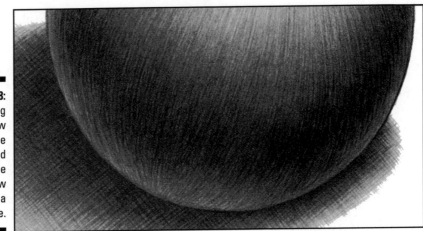

Figure 6-8:
Discovering
a tiny glow
from the
reflected
light on the
shadow
side of a
sphere.

From square to cube

A square is a two-dimensional shape with four equal sides and four right-angles. A *cube* is a three-dimensional square with six square surfaces of the same size.

In Figure 6-9 I first drew a square. I transformed it into a cube by giving it a more realistic perspective. (I explore *perspective* in depth in Chapter 9. I also show you how to draw a cube.)

In the third part of Figure 6-9, I've added shading to make it appear even more three-dimensional. Look for the highlights, shadows, and reflected light and see how they play out on a cube.

Figure 6-9:
Adding
perspective
and shading
to a square
to turn it
into a cube.

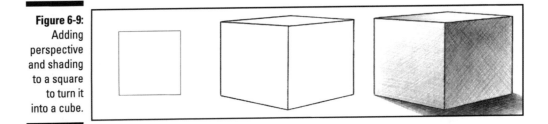

Combining shapes with other skills

This chapter wouldn't be complete without briefly mentioning a couple of other skills, besides shading, that artists use for drawing in the third dimension.

🖊 **Composition:** The organization and arrangement of objects within the borders of a drawing space. I discuss composition in Chapter 10.

🖊 **Perspective:** The rendering of a three-dimensional space on your flat drawing surface. Perspective is the very foundation on which a composition succeeds or fails. You find lots of valuable information on perspective in Chapter 9.

Rectangles and triangles

Figure 6-10 shows how shading and geometric perspective transform rectangles and triangles into three-dimensional cones and cylinders. (In Chapter 9, I show you how to draw cubes and cylinders.) For now, just take note of how highlights and shadows add a third dimension to these shapes.

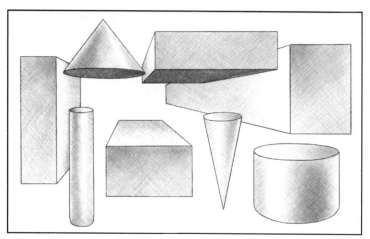

Figure 6-10:
Shading and highlights turn 2-D shapes into 3-D objects.

Project 6: Drawing a Sphere

Drawing a realistic sphere isn't magical. You are invited to draw along with me through four simple steps to transform a circle into a sphere.

Use a compass if you feel uncomfortable drawing circles freehand. Keep your drawing very light for now. Some lines will need to be erased later.

1. **Draw a circle slightly to the right of your drawing space.**

2. **Draw an oval shape (an ellipse) to represent its cast shadow.**

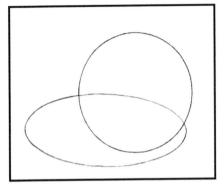 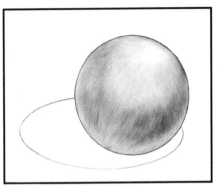

Take note that my oval shape looks like a partially flattened circle, and extends past the circle towards the left of the drawing space. It's entirely in the bottom half of my drawing space and is vertically shorter and horizontally longer than the circle.

Don't worry if your oval is shaped a little differently than mine. Even a slight repositioning of a light source can change the shape of a cast shadow.

3. **Erase the part of the ellipse that is inside the perimeter of the circle.**

4. **With your 2H or HB pencil, draw the light values on the sphere.**

The light source in this drawing is from above, slightly to the right, and a little in front of the sphere. Don't forget to identify the location of the highlight and leave this space white. Also leave a lighter section along the bottom edge of the sphere to represent the reflected light.

Add the shading with the method you are most comfortable with. My hatched shading (I discuss hatching in Chapter 7) follows the contour of the shape, but you may use any way of shading that you prefer.

5. **Add the middle values with your 2B pencil and use your 6B pencil to draw the dark shadows on the sphere.**

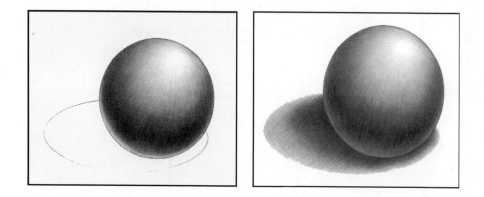

Use the same shading technique you chose to shade the light values.

6. **Pat the line of the ellipse (the oval that outlines the shadow) with a kneaded eraser until it is barely noticeable.**

7. **Use your 2B and 6B pencils to draw the shading of the cast shadow.**

The shading is darker closer to the sphere and becomes lighter in value toward the outer edges.

Chapter 7

Adding Life with Shading

In This Chapter

▶ Exploring shades of gray with hatching

▶ Making values with crosshatching

▶ Applying shading techniques to your own drawings

A full range of values is the core of realistic shading. When you add shading to your drawings, you create the magical illusion of three-dimensional reality.

In this chapter, I show you the two classical shading techniques that I use in almost all of my recreational and forensic drawings. Once you understand the basic concepts of hatching and crosshatching, you discover that you can use these techniques as a very fast and simple way to achieve smooth and realistic shading in your drawings.

Hatching Shades of Gray

Hatching is a series of lines (called a *set*) drawn closely together to give the illusion of values. This very simple method of shading can produce a complete range of different values in your drawings.

Three factors affect the darkness or lightness of the value you create with hatching:

✔ **How close the lines are to each other.** In general, the closer the lines are to one another, the darker the value.

✔ **How you hold your drawing media.** The harder you press and the tighter your grip on your pencil, the darker the value. Achieving a lighter value requires that you press lightly and loosen your grip a little.

✔ **What kind of drawing media you use.** For example, some pencils just lend themselves to making light marks — the 2H is great for light marks. The 2B is a natural for medium values, and the 6B makes wonderful dark values easily. Check out the Cheat Sheet at the very beginning of this book to see the values created by different pencils.

These three factors also influence the values you can make with crosshatching, which I discuss later in this chapter.

Drawing hatching lines

As you soon find out, hatching is very simple — as easy as drawing a line (or lines)! Grab your sketchbook and a pencil. In this exercise, you draw three sets of hatching lines, all with different values:

1. **Draw three squares, 2 x 2 inches, on a page in your sketchbook.**

2. **Draw a set of parallel lines in your first square with your 2H pencil.**

 The old expression "few and far between" works well here. The lines are far apart and few in number. Press very lightly with your pencil. Doing so creates a light value, as in the first square in Figure 7-1.

3. **In your second square, draw a second set of parallel lines, closer together than in your first drawing.**

 Observe that my second set has more lines than my first set. You can use your 2B pencil to draw this set of lines. This value is darker and heavier, as seen in the second square in Figure 7-1.

4. **Draw a third set of hatching lines very closely together, using your 6B pencil, in your third square.**

 Note that more lines make up the third hatching set and they're much closer together than the second set. Use a nice, sharp 6B pencil to get crisp, dark lines. This gives you a very dark value, such as in the third square in Figure 7-1.

Figure 7-1:
Hatching
three
shades
of gray.

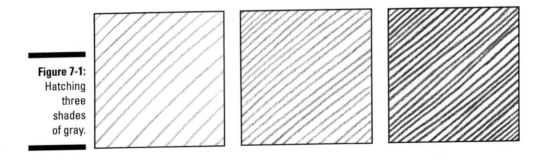

You should try many different ways of moving your pencil or changing the angle of your lines until you find the motions that are the most natural for you. I usually draw the first line in the upper left-hand corner and continue making lines until I get to the lower right. Experiment until you find the direction that makes sense to you.

Your hatching marks don't always have to be plain-vanilla straight lines, either. Different styles of hatching marks lend a variety of moods to your drawings. In Figure 7-2, I show you a small sampling of six hatching styles. You see several different types of lines, such as curved and straight. Some styles have long or short lines or even combinations of different types and lengths (I discuss lines throughout Chapter 5). Some sets have noticeable spaces between the lines, and others have lines drawn very closely together.

Note the textures created by some of the styles (I tell you about textures in Chapter 8). Try to imagine how you could apply each of these sets of hatching lines to something in a drawing.

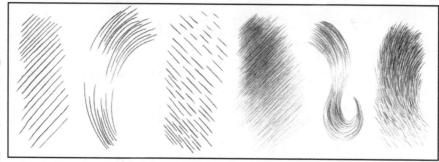

Figure 7-2:
Making a variety of hatching marks.

Take a few minutes and try drawing some different types of hatching lines in your sketchbook. For inspiration, look at some of my drawings throughout this book and spot some different ways I use hatching. Have a closer peek at hair in portraits and fur on animals!

Building value scales with hatching

By varying both the density of the lines and the pressure used in holding your pencils, you can achieve many different values with hatching. Together, these different shades of gray, from light to dark or from dark to light, create a *value scale*. When you can create a full scale of values, you can conquer shading.

Drawing sets of lines and value scales with hatching requires lots of practice before you can do it well. Don't give up immediately if you don't get it exactly right the first time.

In Figure 7-3, you see a full range of values I created using hatching. With your 2H pencil, begin with the lightest and try to draw all seven different values. You may prefer to use your 2B or 6B for the darker values. Keep practicing this value scale in your sketchbook until you can draw all seven different values. Then try this same exercise in reverse from dark to light.

Figure 7-3:
Hatching
seven
shades
of gray.

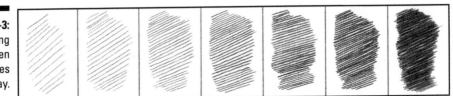

Smoothing out your shading

A *graduation* (or *graduated values,* as they are sometimes called) is a continuous progression of values. Imagine all the values in Figure 7-3 melded into one continuous stream, where the values gradually change from one to the next, without a seam or break — that's a graduation. The transition of values in a graduation can be from dark to light or from light to dark.

When it comes to graduations, your goal is to keep the transition between the values as smooth as possible. Throughout this book, you discover more than a hundred illustrations showing how smoothly drawn graduations make shading look realistic.

The pencils you use can play a big part in the smooth progression of your graduation. (See Chapter 2 to find out everything you need to know about drawing pencils.) Experiment with your 2H, 2B, and 6B pencils by drawing sets of lines in your sketchbook. Take note of their differences. In general, the 2H works well for light values, the 2B is great for middle values, and the 6B is very good for darker values.

Time to try a basic hatching graduation of your very own. You need your 2H, 2B, and 6B pencils. With lots of practice, you can develop this skill very quickly. Just remember to use your most comfortable hand movement for hatching, and then follow these easy steps:

1. **Draw a long rectangle any size you want (mine is 1½ x 6 inches) in your sketchbook.**

2. **On the left side of your rectangle, press very lightly with your 2H pencil to draw the lightest lines in your graduation. (If you're left-handed, you may find it easier to work from right to left.)**

3. **Continue to make your shading darker as you move toward the right.**

 As you get closer to the middle, make your hatching lines closer together and press a little harder with your pencil, as you see in Figure 7-4.

Figure 7-4:
The beginning of a hatching graduation.

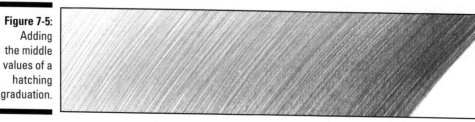

4. **With your 2B pencil, add the medium values.**

 Eyeball a good place to begin your medium values, about halfway across your drawing space (see Figure 7-5). Continue making your shading darker and darker until you get almost to the end of your drawing space.

5. **With your 6B pencil draw the darkest values.**

 Make sure your pencil is sharpened. Approximately two-thirds across your space begin making your lines close together. Continue pressing a little harder with your pencil until the end of your graduation is very dark (see Figure 7-6).

Figure 7-5:
Adding the middle values of a hatching graduation.

If you notice that the transition between your values isn't as smooth as you like, you can improve it. Try adding a few more short hatching lines in between some of your lines.

Figure 7-6:
Adding the darkest values of a hatching graduation.

Resist the temptation to use your finger to "smudge" your values together. With patience, and lots of practice, you can draw this type of graduation!

Shading with Crosshatching

Crosshatching is a technique for rendering shading in which one set of lines crosses over (overlaps) another set. You can render an infinite range of values using crosshatching.

Your sets of overlapping lines can cross at any angle. I generally draw mine at right angles (perpendicular to one another). From time to time, I prefer to use other angles, especially if I'm doing human anatomy studies, where the lines need to follow the contours of the muscles and the outlines of the body. I show you a drawing of a hand, utilizing this method of crosshatching, on the front cover of this book. Many classically trained artists prefer their crosshatching lines to cross over at more of a 45-degree angle. Try experimenting with drawing crosshatching until you discover which angles you prefer.

Creating values with crosshatching

You draw three sets of crosshatching lines, with different values, in this exercise. As with hatching (see the previous section), three factors affect the value you make with your crosshatching — the density of the lines, how you hold your media, and what media you use:

1. **Draw three squares, 2 x 2 inches, on a page of your sketchbook.**

2. **In your first square, use your 2H or HB pencil to draw a set of hatching lines (see Figure 7-7) that are far apart from each other. In the same square, draw a second set of hatching lines that cross over the first set.**

 Your two sets of hatching lines just became a crosshatching set. Remember to draw your lines lightly.

Crosshatching from the masters

Crosshatching is considered by many to be the ultimate in shading techniques. The measure of many artists' technical skills is determined by their ability to render shading with crosshatching. Many famous classically trained artists, such as Edgar Degas, Michelangelo, Leonardo da Vinci, and Albrecht Durer, used crosshatching.

My favorite artist, Leonardo da Vinci, did the most incredible crosshatching drawings I have ever seen, everything from brilliant scientific inventions to incredibly precise drawings of the human body and its anatomy. His shading skills were beyond phenomenal. His drawing

Vitruvian Man, a study of proportions, may look familiar to you. Also, check out his studies of human anatomy, architecture, and machines.

Don't miss the detailed figurative drawings of another favorite artist, Michelangelo.

I've learned a lot from studying drawings, or photos of drawings. Take some time to research drawings, and learn crosshatching from the masters. Visit art galleries, search the Internet, or look for art books on drawing in your public library. Don't limit yourself to a specific period in history. You also find inspiration in viewing the diverse drawings of contemporary artists.

3. **In the second square, draw your lines closer together and press a little harder on your pencil (use your HB or 2B) to make a second crosshatching set (see Figure 7-7).**

 Note that there are more lines than in the first set and each line is darker. Don't forget to draw the lines closer together than you did for the first crosshatching set.

4. **In the third square, draw two overlapping hatching sets with the lines very close together (see Figure 7-7).**

 You can use your 4B or 6B pencil to create this dark value.

Figure 7-7:
Creating three different values using crosshatching.

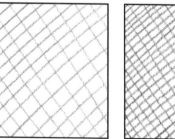

For crosshatching, I personally prefer to turn my drawing paper around in various directions as I draw, so that I am always using my natural hand motion. You may also want to try holding your arm in different positions as you draw. There is no right or wrong way to draw. Whatever you find to be the most comfortable is right for you.

Scaling from light to dark

Crosshatching is an exceptionally good way to create value scales (see "Building value scales with hatching," earlier in this chapter, for more information about value scales).

I encourage you to use your 2H, 2B, and 6B pencils to help you draw the range of values. By allowing your pencils to do some of the work, you won't need to press as hard with your pencil to achieve the dark values, and you have more control doing the light values.

Use crosshatching to draw a full range of ten different values in your sketchbook, as shown in Figure 7-8. To make this a little, easier I have divided a value scale of ten in half, the first set of five is light values and the second set of five is dark values.

Concentrate on the light values first (see the first set of five values in Figure 7-8). With crosshatching and your 2H pencil, draw the first three values beginning with the lightest. Then use your 2B for the next two values.

For the value scale of dark values (the second set of five values in Figure 7-10), use your 2B for the first two dark values and your 6B for the three darkest values.

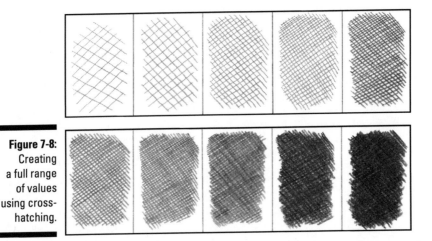

Figure 7-8:
Creating
a full range
of values
using cross-
hatching.

Crosshatching can be used for many diverse drawing styles, from incredibly precise and realistic drawings to loose and impressionistic renderings. If you think crosshatching lines are boring, have a look at the ten examples of various techniques in Figure 7-9. Note that some of them have sets of straight or curved lines. Both short lines and curved lines make up some sets. Some sets have lines that are far apart, and others have lines that are drawn very closely together. Check out the creative textures in some sets. Try to imagine how you would use each in a drawing (some may even remind you of objects).

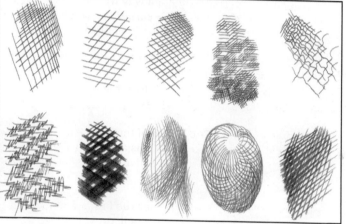

Figure 7-9:
Different styles of lines affect the mood you create with cross-hatching.

Graduating values with crosshatching

Graduations, or the seamless progression of one value to another, are key to shading well. Achieving a smooth transition between values makes shading in a drawing look more realistic.

Use your most comfortable hand movement, and don't forget that you can turn your sketchbook around as you draw. I usually turn my paper upside down to draw the second set of lines in crosshatching sets. Use a piece of paper under your drawing hand to prevent smudging your hard work.

The next exercise helps you get some practice with this important technique. Exercises may not be a whole lot of fun, but if you practice, you will see a big improvement in the next drawing you do:

1. **Draw a long rectangle in your sketchbook.**

2. **Crosshatch light values on the left side of your paper.**

 If you're left-handed, you may find it easier to work from right to left. Press lightly with your 2H pencil to draw the lightest sections. Continue to make your shading darker as you move toward the right (see Figure 7-10).

Figure 7-10:
The beginning of a graduation using cross-hatching.

As you get closer to the middle, make your hatching lines closer together, and press a little harder with your pencil. You discover that the values get darker very quickly when you add the second set of lines.

3. **With your 2B pencil, continue making your shading darker and darker until you get almost to the end of your drawing space (see Figure 7-11).**

Figure 7-11:
The middle of a graduation using cross-hatching.

4. **With your 6B pencil draw the darkest values.**

Start using this pencil approximately two-thirds of the way across your space. Continue making your lines closer together and pressing harder with your pencil until the end of your graduation is as dark as you can make it (see Figure 7-12).

Figure 7-12:
The ending of a graduation using cross-hatching.

Applying Shading to Your Drawings

After you draw the basic outlines of your subject (as I tell you how to do in Chapter 5), you can get down to the business of applying the shading necessary to make your drawing three-dimensional.

Hatching, crosshatching, or a combination of both techniques can render shading. (See the sections earlier in this chapter for the basics on these techniques.) Hatching works beautifully for drawing hair, fur, and lots of other textures such as wood. (I discuss textures in Chapter 8.) Crosshatching is perfect for portraits, figure drawings, and numerous textures, including most fabrics. Together, they can render infinite combinations of subjects and textures in a drawing.

Consider the following qualities of hatching and crosshatching when trying to decide which to use:

✔ Hatching is somewhat easier for a beginner because you deal with only one set of lines.

✔ Crosshatching generally give a smoother transition of values in graduations. It lends itself beautifully to smooth or shiny textures, such as human skin, glass, or droplets of water. Most fabrics also tend to look more realistic when drawn with crosshatching.

✔ Hatching is the perfect choice for rendering realistic linear textures, such as wood, hair, or fur.

✔ Crosshatching gives you more control over where you need light and dark values. Because you have two sets of lines, it's simple to adjust your shading in any direction by simply adding extensions to one of the two sets of lines.

Mapping your values

The most important phase of drawing realistically is seeing! You need to carefully observe how the light source identifies the light and shadow areas of your drawing subject. (I explain how light creates the illusion of the third dimension throughout Chapter 6.)

Identify where the highlights, light and medium values, and shadow areas of you subject are located before you add shading. After you identify these values, you can very lightly sketch out their shapes right on your line drawing. This gives you an outline to follow as you add your hatching or crosshatching.

Look closely at your subject and follow these steps to map out the values in your line drawing:

1. **Locate your highlights and light values first.**

 The lightest areas of a subject are often the easiest to locate. When you find the highlights in your subject, use your lightest pencil to very faintly draw their shapes on your drawing. You can even label them with a very faint *H,* so that you don't confuse them with other value areas later on. You can use an *L* to label your light values.

2. **Locate the darkest shadow areas.**

 Again, the darkest areas are usually pretty easy to identify. Remember that the darkest values in your drawing subjects may be in the cast shadows (see Chapter 6) and not on the actual objects. Define the shapes of these areas using your lightest pencil, and then label them with a letter *D* to distinguish them from your other values.

3. **Locate your medium values.**

 The medium values should spring out at you from between the lightest and darkest values you have already defined. Outline shapes of these values and mark them with an *M.*

4. **Make note of transitions between these values.**

 Sometimes the transitions between values in a scene are dramatic and abrupt, especially when a strong light, such as the sun, lights a scene or object. Other transitions may be more gradual. (I discuss high- and low-contrast drawings in Chapter 6.)

Following your shading map

Most artists prefer to work from light to dark. By drawing your light values first, you can then layer your medium shading on top of your light shading. This layering creates a nice, smooth transition between different values. The darkest values are then built in layers on top of the medium values.

Don't press too hard with your pencils. Not only do these areas become impossible to touch up, but they also leave dents in your paper. When you try to draw over dents in the paper with a soft pencil, such as a 2B or 6B, they show up as light lines, spoiling the overall appearance of your drawing. If you feel yourself pressing too hard, go to a darker pencil.

Your various pencils from light to dark can do a lot of the work in drawing values. You only need to decide where to place all your values by developing your drawing map. Refer to the Cheat Sheet at the beginning of this book for a guide to using different pencils.

After identifying the various values in your subject, you have a working plan that you can follow as you hatch and crosshatch. Just follow these steps:

1. **Draw the really light shading around your highlight areas first.**

 The actual highlights should remain the white of your drawing paper.

 Look for other areas that are light in value, such as those areas closest to the light source.

 Draw your hatching or crosshatching lines lightly and far apart at first. Then gradually add more lines (closer together and darker) until you achieve the intended value.

2. **Fill in the medium values.**

 Follow the contour of their shapes in your map. Keep the transitions between values in mind as you hatch and crosshatch. As you approach the dividing line between values, you may need to darken or lighten your lines so that they flow (graduate) into the next value area smoothly.

3. **Hatch or crosshatch the dark values and the darkest shadow areas.**

 Again, follow the shape of these areas in your map. Taper off the darkness of your hatching and crosshatching lines as you approach any light areas, and darken your lines as you move toward the darkest shadow areas.

Project 7: Drawing a Mug

This mug is as easy to draw as ABC. Well actually UCX, but I explain this in a moment! If you can find a mug in your kitchen cupboard, place it in front of you as you draw. Having the actual object to look at is a fantastic help in fine-tuning your observation skills. Peek ahead to the final drawing of this project and position your mug the same way.

You need your sketchbook, pencils, and erasers. Set aside at least an hour to do this project. Use your sketchbook horizontally.

Don't press hard with an HB pencil and dent your paper when you want a dark line. Instead, press lightly with your 4B or 6B. You end up with a dark line that can still be partially erased. By drawing lightly, mistakes are easy to fix. Erasing some sections of your drawing is inevitable. In addition to erasing mistakes, your eraser is often used to lighten specific areas such as highlights. If your lines are too dark, the eraser damages your paper.

1. **Draw an oval (called an *ellipse*) in the upper-left section of your sketchbook page.**

 See the first drawing in the next set of two. Look closely at the rim of the mug (the long, thin ellipse). Position it in the upper left-hand corner of your drawing space to leave room on your paper for the rest of the mug and its handle.

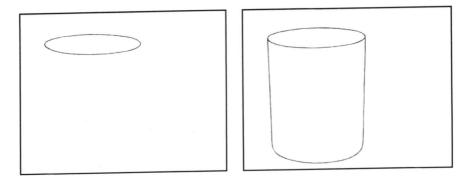

2. **Draw the sides of a U-shape by drawing a straight line down from each end of the oval.**

 You may use a ruler if you want.

3. **Add a curved line along the bottom to complete the U.**

 Now you have a mug without a handle. Notice that the sides are symmetrical and combined with the bottom of the mug form the shape of the letter *U*.

4. **Draw the two ends of the handle slightly inside the right edge of the mug.**

 See the first drawing in the next set of two. Look closely at the two ends of the handle where they join the mug. These two sections are a little wider than the rest of the handle.

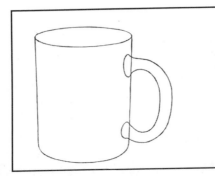 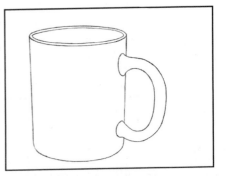

5. **Draw two backwards C-shapes, which complete the handle of the mug.**

6. **Draw a smaller oval inside the other one, on the rim of the mug.**

7. **Erase the two short straight lines that are inside the handle (the edge of the mug "behind" the ends of the handle).**

 Your line drawing of a mug is now complete. You are ready to begin your shading with hatching lines. You later add overlapping lines to transform your hatching lines into crosshatching sets.

8. **Use hatching lines to begin your shading.**

 See the first drawing in the next set of two. The light source in this draw-ing is from the left, as indicated by the arrow (you don't need to draw the arrow). The shading is darker on the right side of the mug, which is farther away from the light source. Don't forget the dark shading on the right edge of the handle and inside the rim on the left.

9. **Add overlapping lines across your hatching lines to make crosshatch-ing graduations.**

 See the second drawing in the next set of two. Shade all the lighter values first, and then draw the crosshatching lines gradually darker towards the dark values.

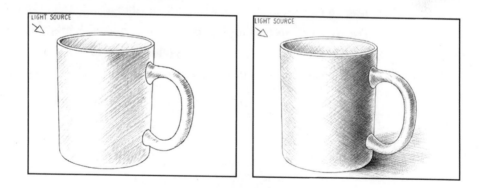

 You have drawn the U (the sides and bottom) and the C's (the handle). Shading lines that overlap your hatching lines are X's (called crosshatch-ing). See, this mug is as easy to draw as UCX!

10. **Draw the shadow with crosshatching graduations.**

 Observe the cast shadow on the surface on which the mug is sitting. It visually anchors the mug to the surface so that it doesn't look like it's floating. Those shadow areas closest to the mug are very dark. Graduate your shading lighter as the shadow gets farther away from the mug.

TIP

Using erasers as drawing tools

You're familiar with drawing dark values on a light surface. Do you know you can also draw light values on a dark surface with an eraser? First you need to completely shade in an area. Then gently blend it with tissue or paper towel.

A vinyl eraser works well for drawing really light areas and fine details. If the edge of your vinyl eraser gets too dull to draw properly, just cut off a new piece (about an inch long) or simply cut a small slice off the end with a very sharp blade or knife.

A kneaded eraser is great for lightening large areas. You can either pat or gently rub the surface of your paper. To draw fine detail, simply mould its tip to a point. To clean your kneaded eraser, simply stretch and reshape (called *kneading*) it several times until it comes clean.

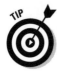

TIP

Adding highlights makes the mug look shiny. In this particular drawing, "adding" highlights entails taking away some shading and lines. The white of the paper becomes the highlights. You need your vinyl eraser to "draw" highlights.

11. **Erase a section of the line along the outside oval to make Highlight A.**

12. **Erase a small section of the inside oval to make Highlight B.**

13. **Erase an oval section on the top of the handle to make Highlight C.**

14. **Erase a long, thin section along the handle to make Highlight D.**

Chapter 8

Identifying and Rendering Textures

Textures provide viewers with vital information about your drawing subject, such as whether its surface is smooth, shiny, rough, or jagged. Drawing textures realistically helps create the illusion that an animal is furry, a human face is smooth, or an eye is glistening. You can even get creative and have fun with textures by drawing a snake fluffy and fuzzy, or a porcupine shiny and smooth!

I illustrate and discuss several textures throughout this chapter to show you a small sampling of the endless possibilities for creating textures in your drawings.

A Rough Tale: Textures versus Patterns

The words *texture* and *pattern* are often interchanged when describing the surface of an object, but in drawing, there is a difference. I use these two words frequently throughout this chapter, so pay close attention to the following definitions:

✔ **Texture:** The surface detail of an object, as defined in a drawing with various shading techniques. Your senses of touch and sight can help you identify the surface texture of your subject before you begin to draw.

✔ **Pattern:** The different values (or colors) of your drawing subject, represented in a drawing by lines or shading. Your sight alone identifies patterns.

A smooth, glazed porcelain cup can have a pattern of stripes of different colors, but its texture is still shiny. A wool sweater can also be striped, but its texture is bumpy.

Of course, a drawing subject can have both pattern and texture. When you're dealing with patterned textures, consider both the pattern and the texture in order to decide how to do the shading. Figure 8-1 illustrates two different examples of striped textures to help show you the difference between pattern and texture and how both pattern and texture can play out in a drawing.

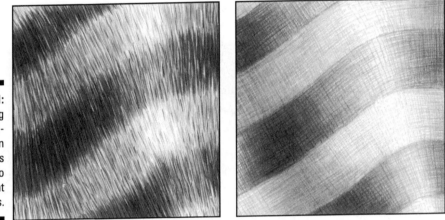

Figure 8-1: Examining an identical pattern of stripes on two different textures.

The pattern of fur on some animals, such as zebras, is striped. However, the *texture* is furry. You need to draw the dark stripes with dark values and the light stripes with light values. The first illustration in Figure 8-1 shows how shading with hatching lines creates the illusion of a furry texture. (To find out more about hatching, see Chapter 7.)

Some fabrics, such as silk, may have a pattern of stripes but a smooth texture. You need to use two different value graduations to define the striped pattern but smooth shading to define its texture. In the second drawing in Figure 8-1, observe how nicely the crosshatching helps define the finely woven texture of the fabric. (I tell you all about crosshatching in Chapter 7.)

Identifying Textures

Mother Nature brings artists many challenges with the diverse textures of her creations, from the smooth placid surface of a serene pond to the jagged edges of rocks. The texture of fur can identify a light source and define the form of an

animal. Textures define hair and fur as curly, straight, or frizzy. The shiny sur-
face of animals' eyes provides a strong contrast to their fur. A human face can
be drawn rugged like an old piece of leather or smooth like porcelain.

Objects created by humans bring even more exciting challenges into drawing
textures. Think about the smooth texture of glass or the uneven textures of
various fabrics, such as a knit sweater.

The world is chock-full of different textures for you to draw. However, the
majority of these textures fall into one of the following types:

- ✔ **Smooth:** You find little or no surface features. When you run your hand
 over a smooth surface, you feel no unevenness or roughness. Smooth
 textures can have surfaces that are dull and matte (such as a smooth
 stone), wet and glistening (like the smooth petals of a rose after rain), or
 shiny and soft (as in a smooth silk shirt).

- ✔ **Rough:** Surface features are visible, and when you touch them, their tex-
 tures feel uneven, irregular, or jagged. Think about the rough textures of
 the bark on a tree, a piece of coarse sandpaper, or the surface of a
 cheese grater.

- ✔ **Matte:** Dull and lusterless (not shiny) objects often have additional char-
 acteristics, such as smooth or rough. Many fabrics, smooth rocks and
 stones, and unfinished wood, have a matte texture.

- ✔ **Shiny:** Highlights reflecting off the surface help define objects as shiny,
 glossy, or highly polished. Think about the surface of polished stone or
 brass, porcelain, or a shiny new penny.

- ✔ **Glistening:** Very pronounced highlights identify sparkling (sometimes
 wet) surfaces. Think about the shimmer of the sun's light on calm water,
 the surface of a human eye when the person is close to tears, or a
 freshly shined, new car glistening in the sunlight.

- ✔ **Furry, fuzzy, fluffy, and hairy:** Human hair and animal fur can be soft or
 coarse, long or short, thick or thin, or curly or straight. The surface of a
 peach and the hair on a newborn infant's head both feel soft and fuzzy.
 The outside shell of coconut or beard stubble on a man's face feels
 coarse and fuzzy. A sweatshirt, carpeting, and a blanket can be fuzzy or
 fluffy.

- ✔ **Jagged:** The surface of jagged objects tends to have sharp points pro-
 truding outward. Think about a jagged rock face.

Don't feel overwhelmed by identifying and drawing textures. Consider each
one to be a challenging opportunity to solve a fun problem. Expect to experi-
ment with several different techniques before you get your texture to look
the way you want. With time and patience, you discover your very own shad-
ing techniques for rendering many realistic textures.

Some of the best techniques for shading textures are discovered by accident. Think of it this way: If your shading of fur looks more like carpet, you now know how to draw the texture of carpet!

Shiny textures

In Figure 8-2, note the similarities in the shading of two very different shiny objects. The highlights and dark shadow areas are often right beside one another, and there's a very short distance between the graduations of values from light to dark. Shiny (or glossy) surfaces, such as polished stone or glass, generally have distinctive highlights. A full range of values, including white and black, helps to create the illusion that an object is shiny.

Figure 8-2:
Shiny textures of a stone sculpture and a crystal figurine.

Matte textures

Even though a lobster claw is hard and human skin is soft (Figure 8-3), the shading techniques for rendering both matte-textured subjects are very similar. The distance from light to dark is gradual. Notice that the lobster claw has a spotted pattern while the skin is clear. Matte surfaces, such as smooth fabrics or human skin, don't always have distinctive highlights. Shading tends to be a smooth, solid graduation of values.

Glistening textures

Compare the textures of the two sections of spheres (yes, an eyeball is a sphere) in Figure 8-4. The surface of the first sphere seems smooth and dry,

while the cat's eye is obviously wet and glistening. Notice that the transition between values is more gradual in the first sphere, but the values are compacted into a shorter space in the eye. Notice the pronounced highlights, which help create the illusion that the surface of the eye is wet.

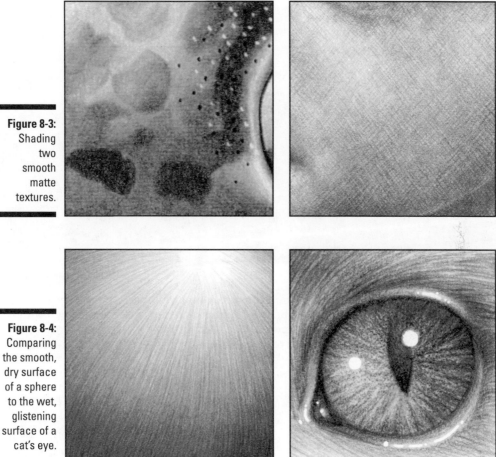

Figure 8-3:
Shading two smooth matte textures.

Figure 8-4:
Comparing the smooth, dry surface of a sphere to the wet, glistening surface of a cat's eye.

Fuzzy and fluffy textures

You can walk into any department store and see the infinite range of fabrics people use for dressing their homes and themselves. Fabrics are lots of fun to draw because of their diverse textures and patterns.

Have a look at the first illustration in Figure 8-5. If you look closely, you can see the soft, fuzzy texture of the fibers that make up each individual strand of yarn. Curved hatching lines create the illusion that each strand is circular. The second illustration shows how the texture of yarn changes to a fuzzy, bumpy texture when it's knit into a sweater. Observe its striped pattern of light and dark values. While you don't need to know how to knit to render this texture, you do need a sharp pencil and lots of patience.

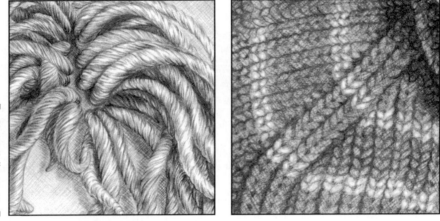

Figure 8-5: Examining the textures of strands of yarn and a sweater.

In Figure 8-6, explore the contrasting textures of the garments in the two drawings. The soft, matte texture of the t-shirt and kerchief is shaded with very few visible lines and mostly light and medium values. In the second drawing, the shiny leather texture is rendered with extremes in values and pronounced highlights.

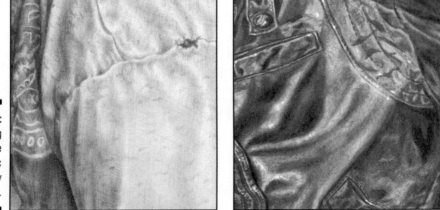

Figure 8-6: Comparing soft, matte fabric with shiny leather.

Furry and hairy textures

The diverse furry textures of different animals are drawn in much the same way as hair. (I discuss drawing hair throughout Chapters 17, 18, 19, and 20, and I demonstrate drawing fur in Chapter 16.) If fur is long, long hatching lines work beautifully, and if it's short, short lines look more realistic.

In Figure 8-7 compare the fur of a long-haired dog (a Soft Coated Wheaton Terrier) to the fur of a shorthaired cat (a Domestic Shorthair).

Figure 8-7: Comparing the hatching lines used for shading the fur of a long-haired dog to those used for shading a short-haired cat.

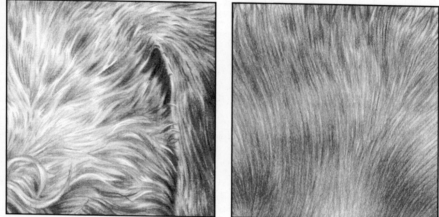

The texture of hair in a portrait outlines the face, defines the shape of the skull, and creates a strong contrast to the texture of the skin and eyes. In addition to hatching the texture of hair, you can also illustrate whether it is light (shaded with mostly light values) or dark (mostly dark values). Compare the two drawings of straight hair in Figure 8-8 to see how light and dark hair are rendered. (I tell you about a fun technique called squirkles later in this chapter, which works well for drawing the texture of curly hair.)

Rough and jagged textures

From the rough bark on the trunks of trees to diverse rugged ground surfaces and jagged rocks, rendering textures is integral to creating realistic and believable landscape drawings.

In the first drawing in Figure 8-9, note how hatching lines of different widths, lengths, and values, give texture to the trunk of the tree. In the second drawing,

a combination of hatching and squirkles creates diverse textures in the grass and ground foliage.

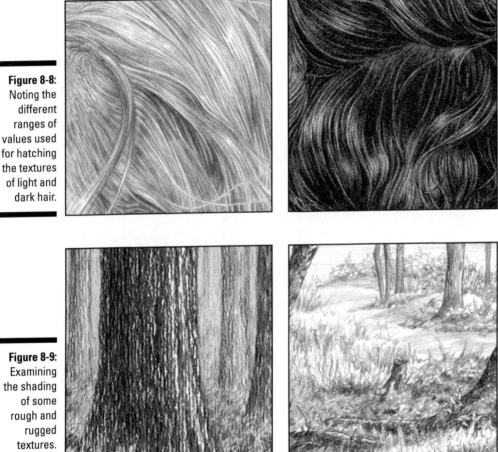

Figure 8-8:
Noting the different ranges of values used for hatching the textures of light and dark hair.

Figure 8-9:
Examining the shading of some rough and rugged textures.

Translating Textures into Drawings

When you begin to translate textures into drawings, implement the K.I.S.S. principle: **Keep Its Shading Simple!** Try to capture the essence of the texture with simple shading techniques without getting too caught up in intricate details. Squinting slightly at the object often helps block some of the details and lets you focus on the overall texture.

Planning your textured drawing

Your vision, sense of touch, and general knowledge of your subject help you identify the properties of a texture. However, if your subject is an alligator, you may prefer to use only your vision and knowledge.

Once you have identified the texture of your subject, observe your subject carefully. You can then use your own judgment to decide which shading techniques work best. For example, shading lines, drawn closely together, help create the illusion that an object is smooth. The following tips should help you prepare to add texture to your drawing:

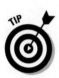

✔ Look for lines, such as in hair, fur, or the weave of some fabrics. For example, in Figure 8-1, hatching works for the fur texture and cross-hatching is best for the fabric texture.

✔ Examine the highlights and shadows for clues about how drawing the object's values can help define its texture. For example, see Figure 8-2 and note the highlights and shadows of shiny stone and crystal.

✔ Look for the shapes and forms created by the light and dark values. (I explain how to identify the forms and shapes of light and shadows throughout Chapter 6.) The rough texture of the trunk of a tree (see Figure 8-9) is an example of drawing forms to define texture.

You can experiment with several different shading techniques to successfully render a specific texture. To get you started, the following shading techniques generally work well for the various textures listed:

✔ **Hatching:** Straight hair or fur, knits and linear fabrics such as corduroy, surfaces of calm bodies of water, jagged rocks and mountains, bark on trees, and wood.

✔ **Crosshatching:** Smooth matte surfaces, woven and shiny fabrics, shiny and glistening surfaces, flower petals, polished stone and smooth rocks, human skin, and shiny metal.

✔ **Squirkles:** Fuzzy fabrics such as fleece, curly hair or fur, masses of leaves on trees, ground foliage, bushes, and beard stubble on a man's face.

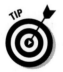

Keep in mind that these are merely suggestions. Choosing techniques for specific textures is a matter of personal preference.

Getting it down on paper

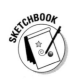

To get a "feel" for shading textures, first try drawing from an actual object rather than a photograph or another drawing.

Find a simple object, such as a ball or box, with an interesting texture. Examine it closely and try to visually translate what you see into an appropriate shading technique. (Refer to "Planning your textured drawing" earlier in this chapter for guidance.) When you decide how you want to render its texture, begin your drawing:

1. **Draw the basic shape of the object.**

2. **Map out the outlines of the highlights, and the light and dark values.**

 (I tell you how to map your values in Chapter 7.)

3. **Shade the light areas of the object with light values, using the shading technique you feel best illustrates its texture.**

 Refer to "Identifying Textures" in the preceding section for guidance. Because of perspective, the texture appears smaller on the more distant surfaces of the object. (I tell you about perspective in Chapter 9.)

4. **Draw darker textural shading in the shadow areas.**

 Take note of how light and shadow define the form of your object.

Combining form with pattern and texture

Drawing an object's form is more important than drawing patterns or textures. (Refer to Chapter 6 to find out more about light, shadows, and form.) Shading an object with both texture and pattern, in addition to form, can be very overwhelming for a beginner. If the object has a complex pattern and texture, you can choose to draw only its pattern or texture rather than trying to draw both.

You may even consider doing a couple of rough sketches of the object before you begin the final drawing. The first rough sketch could be of just the pattern; then draw it again rendering only its texture. By planning your shading strategy in this way, you experiment with different techniques and work out any problems in advance.

Drawing a patterned texture from an actual object provides insight into the actual form of the object rather than simply its surface. (In Project 8, I offer step-by-step instructions on drawing the patterned, surface texture of spotted fur from drawings.) Find an object with a simple pattern, and place it in front of you. Use any pencils you want and follow these guidelines:

1. **Draw the shape of the object.**

2. **Map out the outlines of the pattern.**

3. **Shade the form of the object and its pattern, with the shading technique you feel best defines its texture.**

 As you add shading, pay close attention to the different values that define the pattern. Observe how some areas are darker than others. Take note of how the pattern becomes smaller on more distant surfaces and is shaped around the form of the object.

Trust your own judgment if you're confused about how to draw a specific texture. For example, think about a beautiful, shiny, multicolored snake. You can draw its form by rendering either its texture or pattern. If you choose to draw both the texture and pattern, don't try to include too much textural information. After your drawing skills improve, you can choose a more complex approach, such as shading the patterns (or colors) and rendering the shiny texture of the scales, in addition to drawing the snake's three-dimensional form!

Project 8: Two Fun Textures

This project has two sections. The first challenges you to discover and draw a useful and versatile texture using squirkles. In the second section, I take you step by step through drawing the patterned texture of spotted fur.

Sketching with squirkles

When you morph (or combine) squiggles and circles, you get squirkles, a word I invented to describe this texture. The shading technique is simple, just a bunch of squiggly, curved lines (often called doodles) crossing over in many different directions. The more lines you draw, the darker the value becomes. Try your hand at drawing light, medium, and dark values of squirkles.

A graduation of this texture can illustrate form, light, and shadows in a drawing (refer to Chapter 7 to refresh your memory on drawing graduations with hatching and crosshatching).

1. **Draw light squirkles across your entire drawing space.**

2. **About one-third of the way from the left, draw more squirkles throughout and on top of the first set all the way to the far right.**

3. **Now choose a place about two-thirds from the left and draw even more squirkles until the end of the graduation is really dark.**

Drawing furry spots

Lots of animals have spots, but if you're partial to Dalmatians or cows, you'll love these!

1. **Use your HB pencil to very lightly map out some spots.**

 Make the spots all different shapes and sizes. (Don't worry about drawing your spots exactly like mine.) Try making a couple of partial spots that seem to disappear off the edges of your paper.

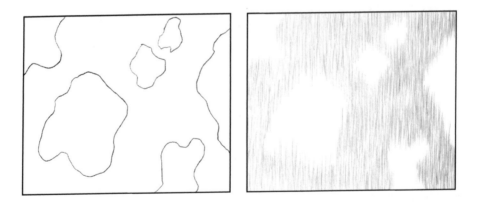

2. **Use your kneaded eraser to lighten your mapping lines until you can barely see them.**

3. **With your 2H pencil, draw a bunch of hatching lines of different lengths in all the areas without spots.**

 This drawing is from my mind, but even so, I like to define a light source. Pretend the light is coming from the left. Make your lines light on the left and then graduate darker towards the right.

4. **Use darker pencils (such as 2B, 4B, or 6B) to draw a bunch of hatching lines of different lengths in all the spots.**

 Remember to graduate your dark shading darker toward the right.

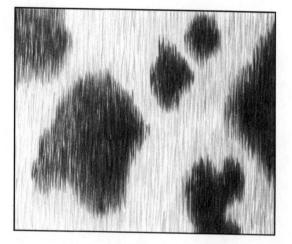

Chapter 9

Investigating Fresh Perspectives

Artists create the illusion of three-dimensional spaces on flat pieces of paper. A landscape or cityscape drawing can look so realistic that you feel like you can almost walk right into it. Some still-life drawings appear believable enough that you want to reach out and touch the objects.

With proper use of perspective, your representational drawings become visually correct and more realistic. In this chapter, I reveal how you can use the secrets of perspective to help create the illusion of three-dimensional spaces in your drawings. I explain some basic guidelines for rendering different types of perspective and show you how to apply them to your drawings.

Understanding Geometric Perspective

Geometric perspective (sometimes called *linear* perspective) makes subjects in a drawing look like they recede into distant space, appearing smaller the farther they are away from you.

Geometric perspective can also create the illusion that you are either above or below the subject of a drawing. Using geometric perspective makes your drawings appear three-dimensional (rather than flat), and more realistic.

To get started with geometric perspective, you first need to acquaint yourself with the following:

✔ **Horizon line:** An imaginary horizontal line, sometimes referred to as *eye level*, which divides your line of vision when you look straight ahead.

Objects below this line are below your eye level, and objects above this line are above your eye level. Artists draw horizon lines to accurately establish perspective in their drawings.

✔ **Perspective lines:** Straight lines, drawn at an angle from the edges of objects, back into perceived distant space, until they finally converge at a point on the horizon line. These lines establish guidelines for drawing objects in proper perspective.

✔ **Angular lines:** Straight lines that are neither parallel nor perpendicular to the horizon line.

✔ **Vanishing point:** The point on the horizon line where the angular perspective lines of an object visually continue past its edges and eventually converge.

Objects become smaller and smaller the closer they are to the vanishing point and, at this point, seem to completely disappear (or vanish). Some objects can even have more than one vanishing point. (I tell you about one- and two-point perspective later in this chapter.)

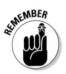

Lines of objects that are parallel or perpendicular (at a right angle) to the horizon line don't appear to go back in space (such as the top, bottom, and side edges of a building from a frontal view) and therefore don't meet the vanishing point.

Looking to the horizon line

Always draw your horizon line parallel to the top and bottom of a square or rectangular drawing space. You determine the viewer's eye level by choosing the position of the horizon line. You control whether you want viewers to feel like they're above, below, or at eye level with the objects in your drawing.

A bird's-eye view looking downward

In the first drawing in Figure 9-1, the horizon line is close to the top of the drawing space, higher than the cubes. Imagine that you are standing on the top of a high cliff, or floating in a hot air balloon. The perspective lines of objects below you angle upwards towards the horizon line and converge at the vanishing point.

If you want viewers of your drawings to feel like they are looking downward, draw the subjects below the horizon line.

Moving the horizon line

Exercise caution when attempting to drastically change the perspective of an object in a drawing. As the artist, you control the eye level of your viewer. By drawing the horizon line above or below your eye level, you change the perspective of the objects in your drawing.

I show you examples of the same object seen from different perspectives in Figure 9-1. Take note that as you view different perspectives, you see various sides of the object. Before you try to change the perspective significantly, make sure you're familiar with the object from all sides.

Perspective is a complex aspect of drawing. Don't expect to be able to master all components right away. Be patient with yourself. Careful observation of objects around you expands your understanding of perspective. Your skills at rendering perspective improve with practice.

Figure 9-1: Observing cubes from two different perspectives, below and above the horizon line.

Looking upward

The horizon line is below the cubes in the second drawing in Figure 9-1. You sense that you are below the cubes — maybe looking up into the sky or standing in a valley looking upward. The perspective lines of the objects all lead downward to the same vanishing point. The cubes almost look like helium-filled balloons, and the perspective lines seem to hold them anchored at the vanishing point.

To create the illusion that the viewer is looking upward, draw your subjects above the horizon line.

Eyeing the horizon line from a level perspective

You are at eye level as you look into Figure 9-2. The horizon line is the first horizontal line, almost halfway down from the top of the drawing space.

Look at the angular lines (neither horizontal nor vertical) that define the edges of the objects, and visually follow them to the vanishing point on the horizon line. You should notice the following:

- ✔ Angular lines of objects at your eye level (touching the horizon line) converge both downward and upward.

- ✔ The lines of objects above your eye level (above the horizon line) converge downward.

- ✔ Angular lines of objects below your eye level (below the horizon line) converge upward.

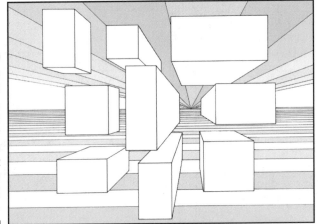

Figure 9-2:
An eye-level perspective, in which all angular lines converge at the same vanishing point.

Finding vanishing points

When an object's perspective lines recede into a properly placed vanishing point, your drawings appear more three-dimensional and visually correct. Finding and properly placing a vanishing point allows you to draw your subjects more realistically and in proper perspective.

TECHNICAL STUFF

Adjusting your perceptions on perspective

Drawing in proper perspective means unlearning some of what your brain currently knows about what it sees and readjusting its perceptions to a different set of rules.

You know a cube has six sides. But, you actually see no more than three sides at any one time (unless it is made of clear glass). Most objects are not transparent, and drawing them correctly requires that you record them as you actually see them, not as your mind knows or perceives them to be.

Finding the vanishing point in a photograph or sketch

Many artists work from photos, without realizing that a camera lens can sometimes visually distort a scene. This may not be a problem when drawing landscapes. However, if you have human-made objects in your scene, such as buildings, stairs, or other objects with horizontal lines, you need to find the vanishing point and use geometric perspective to make them look visually correct.

In the following steps, I explain how you can find a vanishing point in a photograph or sketch. These basic principles also apply to rendering a final drawing from one of your rough sketches. (I tell you about sketching in Chapter 11.)

Find an image that includes a level, man-made object with horizontal lines, such as a railing, deck, or wharf, or the roof, horizontal siding, or steps of a building. Then follow these steps:

1. **Find an object in the image that you know is level and has more than one horizontal line.**

 In Figure 9-3, the horizontal lines on the edge of the railing and the wooden planks in the deck are level.

2. **Tape a piece of tracing paper over the entire image.**

3. **With a pencil and a ruler, outline the upper and lower horizontal edges of this object, as well as any other lines that you know to be parallel, such as railings, decks, or the upper and lower edges of doors and windows.**

Look at the outlines of the upper and lower edges of the railing and some of the spaces between the boards in the second drawing in Figure 9-3.

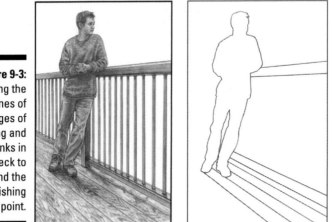

4. **Tape your traced drawing to a larger sheet of drawing paper, leaving room to extend the horizontal lines of the object.**

 Refer to the lines on your tracing and take note of the direction in which they point. You can visually identify which lines are going to eventually converge.

 Tape only the outer edges so that the tape doesn't tear the center area of your drawing paper when you remove it.

5. **Use your ruler and a pencil to extend all of the horizontal lines until they meet.**

 Keep your lines light, so you can erase them later. Note the point where most lines converge. This is your vanishing point, which is located on the horizon line.

 When an object has only one vanishing point, its perspective is referred to as *one-point perspective.*

6. **Draw a straight line (the horizon line) through the vanishing point, horizontal to the top and bottom of your drawing paper.**

 Figure 9-4 shows the location of the vanishing point and the horizon line (Line AB).

7. **Remove your tracing, redraw the lines of the object using the vanishing point as a guide, and complete your drawing.**

Sometimes you can see more than one side of an object, such as a building. If the angle (or corner end) of the building is closer to you than one of its sides, you need to use this same method to locate the second vanishing point (this is called *two-point perspective*). Horizontal lines on other visible sides of this object also converge at vanishing points somewhere on the same horizon line. (I explain two-point perspective in "Drawing One- and Two-Point Perspectives" later in this chapter.)

Figure 9-4:
Extending
the
horizontal
lines until
they
converge
at the
vanishing
point.

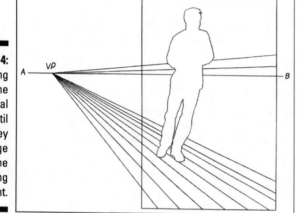

Finding a horizon line and vanishing point in real life

To identify the horizon line in an actual scene, mark it with your eye level. Remember — your eye level and the horizon line are one and the same. Look straight ahead, and the horizon line is in front of you.

Some clues for finding a vanishing point in a real setting include the following:

- A building or object with horizontal lines provides a perfect clue. Follow the same procedure as in "Finding the vanishing point in a photograph or sketch" earlier in this section. However, instead of drawing the lines, you simply eyeball them to find the approximate position of your vanishing point. Then you mark it in your drawing.

- Two parallel lines of the edges of straight roads, railway tracks, and fences can lead you to the vanishing point. Have a look at Figure 9-7 to see other examples.

Identifying Your Perspective on Depth

With an understanding of perspective, you discover how to draw objects the size you actually see them, instead of the size you know them to be.

In Figure 9-5, assume that in reality all of the happy faces are exactly the same size. Yet, some are drawn large, while others appear very tiny. To create the illusion of depth in this drawing, I have used three different components of perspective:

- ✔ **Size differences:** Objects appear to become smaller the farther they are away from you. The closer an object is to you, the larger it looks.

- ✔ **Overlapping:** Some objects that are in front of others overlap objects behind them, providing an obvious clue that one is in front of the other. Note how many of the happy faces overlap one another.

- ✔ **Arrangement:** The horizon line is above the happy faces in Figure 9-5. When you draw the horizon line above objects, those that are closer to you are usually near the bottom of your visual space.

 The larger, and therefore closer, happy faces, are near the bottom of the drawing space. (See Figure 9-7 for another example of closer objects being near the bottom of a drawing space.)

Figure 9-5: Creating depth using perspective.

Watching someone disappear

Figure 9-6 illustrates how people appear to become smaller, and finally seem to disappear, as they move closer to the vanishing point.

Imagine that the striped lines are a bridge that extends all the way back to the vanishing point. People (and objects) on this bridge appear smaller and smaller until they become too tiny to see.

Look at the outline of the man at the front of the line in relation to the vanishing point. Use your imagination to visually draw two lines, one from the top of his head to the vanishing point and the other from the bottom of his shoes to the vanishing point. The space between these two lines becomes progressively smaller closer to the vanishing point.

The horizontal lines of his body (such as the locations of his elbows and knees) also follow the rules of geometric perspective and converge at a vanishing point on the same horizon line.

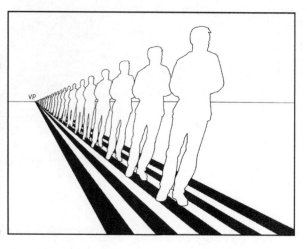

Figure 9-6:
Subjects become smaller until they seem to disappear at the vanishing point.

Watching a neighborhood become smaller

In Figure 9-7, I have combined nature with man-made objects to show some clues for finding the elements of perspective in an imaginary scene:

- ✔ All objects appear to disappear from view at the same point (VP).

- ✔ The trees, houses, and boats seem smaller the farther away they are.

- ✔ The widths of the sidewalk, road, fence, and beach appear narrower the farther they are away.

- ✔ Big trees overlap some houses, creating the illusion that they are closer to you than the house behind them.

- ✔ The tops of little trees overlap driveways, and thereby define their place in space as being in front of the driveways.

✔ The larger objects and wider spaces are close to the bottom of the drawing space and appear to be closer to the viewer.

✔ The position of the horizon line (where the earth seems to meet the sky) is close to the top of this drawing creating the illusion that you are looking down on this scene from above.

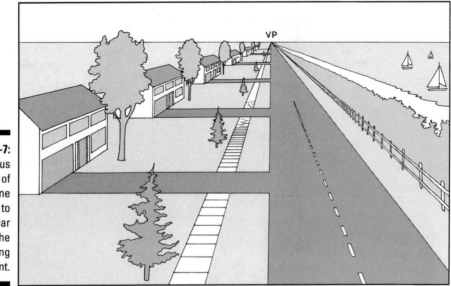

Figure 9-7:
Various elements of a scene seem to disappear into the vanishing point.

Expanding on Elements of Perspective

Creating the realistic illusion of spatial depth in your drawings requires an understanding of more than geometric perspective. Two more terms to become familiar with include:

✔ **Aerial perspective** (sometimes called *atmospheric perspective*): The farther an object recedes into the distance, the lighter in value it seems to become, and its edges and forms appear more blurred.

✔ **Foreshortening:** As the angle of viewing becomes more extreme, visual distortion becomes more pronounced.

Fading away with aerial perspective

On a clear day, your ability to see faraway objects is affected by a variety of components of the atmosphere, such as tiny particles of dust, pollen, or droplets of moisture. Your ability to see becomes even more obscured on a day when the air is filled with haze, fog, smoke, rain, or snow.

In Figure 9-8, meet the Globs and their cousins, the Blobs. They demonstrate how you would see them in a light fog.

Notice that Billy Blob (the shy one in the front center, experiencing a little stage fright) is the closest to you, and his details are crisp and clear. As the Blobs move farther back into distant space, the less detail you can see.

Figure 9-8:
The Glob and Blob cousins demonstrate atmospheric perspective by being in sharp focus close to you and becoming almost invisible in the distance.

In Figure 9-9, I combine atmospheric and geometric perspectives to show you a more realistic view. Take note of the following:

- ✔ The trees in the front have more contrasting values than the ones in the distance. Their shadows are darker, and their highlights are brighter.
- ✔ Closer trees appear more detailed than distant ones.
- ✔ The trees closer to you are larger than the ones in the distance.
- ✔ The bases of the trees become progressively higher in the drawing, as they recede into the distance.

Shortening subjects with foreshortening

Foreshortening creates the illusion that an object is shorter when viewed from an extreme angle. The foreshortened qualities of objects become more noticeable when you see long objects from an end.

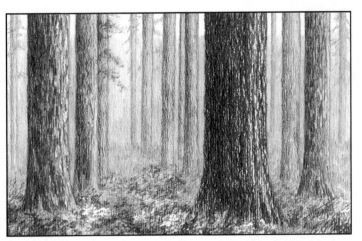

Figure 9-9: Atmospheric perspective creates the illusion that subjects are lighter in value and less detailed the farther they recede into the distance.

By drawing objects with proper geometric perspective, rather than trusting your visual perceptions, you can successfully render your drawing subjects with foreshortening.

Assume that each of the boards in Figure 9-10 is the exact same length. The ones closer to the left seem to be longer than the ones on the right. Note that the one directly under the vanishing point is the shortest of all, because its end seems to point straight out toward you.

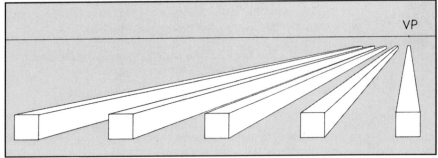

Figure 9-10: Foreshortening creates the illusion that objects closer to the right are shorter.

VP

Foreshortening becomes a little more complex in more intricate subjects, such as a human figure. In Figure 9-11, my friend Rob creates an unusual, fun pose, which demonstrates an excellent perspective on foreshortening.

Rob is well-proportioned and of average height, but foreshortening creates extreme visual distortions to his body. Without drawing the distortions as I see them, I could not accurately and believably render this pose.

✔ Observe, how short his lower legs, upper-right arm, torso, and right hand appear to be.
✔ His left arm and face are the only two parts of his body that appear to be their actual lengths.
✔ The sizes of various parts of his body are also distorted. Look at how tiny his right foot is when compared to his right hand.

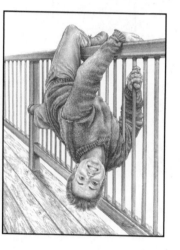

Figure 9-11: Foreshortening creates the illusion of extreme depth by visually distorting the sizes of various components.

Project 9: Drawing One- and Two-Point Perspectives

One-point perspective occurs when the frontal face of an object (such as a cube) is closest to you, and its edges recede in space and converge at a single vanishing point (see Figures 9-3 and 9-7).

Two-point perspective occurs when a corner edge, created when two faces of an object (such as a cube) meet, is closer to you than either face. The edges of two sides lead back to two vanishing points on the same horizon line.

Drawing one-point perspective

In this exercise, you accurately render a rectangular form with one-point perspective. Follow along with these simple step-by-step instructions:

1. **Draw a horizon line parallel to the top and bottom of your drawing space.**

2. **Place a small dot on the horizon line to represent the vanishing point (marked "VP" in my drawing).**

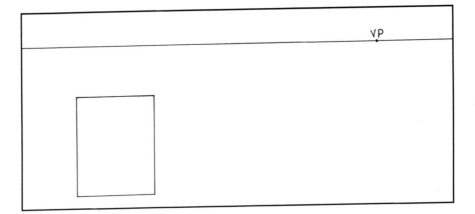

3. **Draw a square or rectangle slightly below the horizon line.**

 The top and bottom lines of this shape need to be parallel to the horizon line, and the two sides should be perpendicular (at a right angle, or a 90-degree angle) to the top and bottom lines (and the horizon line).

4. **With a ruler, draw lines from three corners of the rectangle to the vanishing point.**

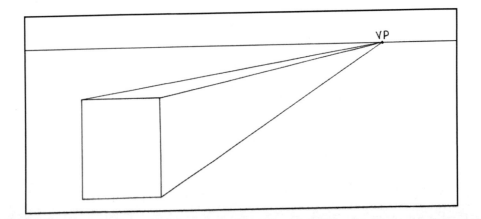

5. **Complete your 3-D form by adding a line connecting each of the two diagonal lines.**

 The top line is parallel to the top of the rectangle, and the one on the side is parallel to its side.

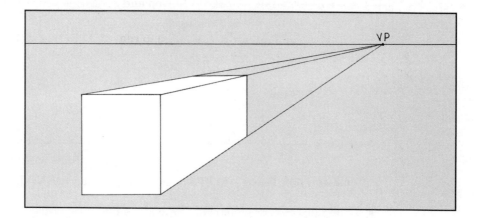

Pondering two-point perspective

When the corner of a building (or any straight-sided form) is closer to you than one of its sides, none of its sides are parallel to the horizon line. You can use two-point perspective to illustrate it correctly.

Try your hand at drawing a rectangle using two-point perspective:

1. **Draw a horizon line and mark two vanishing points (see the next drawing).**

2. **Draw a line (AB) vertical to the horizon line, to represent the corner edge of your form.**

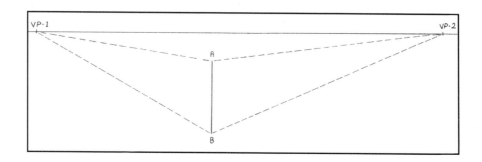

3. Connect the top and bottom of line AB to each of the vanishing points.

4. Draw lines CD and EF parallel to line AB.

The point where each line ends is on the diagonal perspective lines.

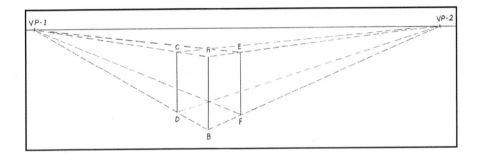

5. Connect points C and D to VP-2, and connect E and F to VP-1.

Now all the sides of your rectangular form are in their proper places.

6. Refine the lines that identify the form, and erase the perspective lines you don't need (see the next drawings).

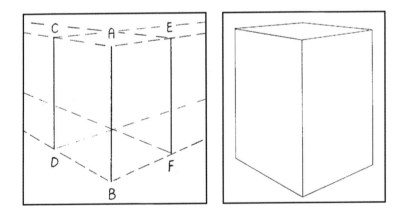

Part III
Time to Start Drawing

The 5th Wave · By Rich Tennant

"They say they're just out here for a walk. Neither one of them's got a drawing license, but one of them's carrying a 12-gauge lead pencil, the other's got a semi-automatic Rapidograph. Then I notice all these erase shavings around the ground and a string of mallard sketches in their backpack..."

In this part . . .

In keeping with food metaphors, you can call this the main course. Whet your appetite as you imagine this part of the book as a huge artistic buffet. Prepare to fill your plate with everything you love most.

You begin by deciding where on your plate (or drawing paper) you want to put all of your favorite delicacies! In other words, you explore various methods of planning your drawings. This is the really exciting part of drawing, with all its hopes, dreams, and chances to put your creativity into a visual format.

On to picking what to put on your drawing paper! Your menu includes items that stay still (like food and other still life objects) and entities that move, grow, and bloom. Some other choices include critters that fly, quack, purr, bark, or hide under your bed. Size really doesn't matter. You can add some huge drawing subjects to your culinary options, such as mountains, oceans, and buildings. The sky's the limit, and you can even choose it as a drawing subject!

Other potential drawing subjects await discovery amongst your memories, including wonderful vacations, outings with friends and family, and possibly even a few dust bunnies and collections of cobwebs.

But, save a little room for a serving of inspirational food from your own creative palette! You can wander through the regal rooms of your imagination, and choose exotic cuisine from the infinite choices of this delectable smorgasbord.

Chapter 10

Planning Your Drawings

Wise travelers have a map and travel itinerary before they embark on a journey. Likewise, artists need to plan their drawings before they begin. In this chapter, I tell you about various components of composition and valuable drawing tools that can help you plan your drawings.

Focusing on the Elements of Composition

Composition refers to the organization, arrangement, and combination of objects within the borders of a drawing space. You want to bring the eyes of the viewer toward your center of interest within an aesthetically pleasing composition.

Strong composition can intuitively engage your viewers. Many "rules" define a good composition, but these rules are only guidelines. Your personal preferences and natural instincts are also important.

When planning the overall appearance of a drawing, you need to be familiar with the following:

- ✔ **Focal point:** A primary center of interest (or focus) in a drawing.
- ✔ **Overlapping:** The visual separation of a drawing into foreground, middle ground, and distant space by overlapping (or layering) objects.
- ✔ **Negative space:** The space within your drawing not occupied by a focal point, important subject, or area of interest.
- ✔ **Lines:** Navigation tools used to guide the viewer through the different elements of a drawing.
- ✔ **Balance:** A stable arrangement of subjects within a composition.

- ✔ **Contrast:** Extremes of light and dark values that create shapes and patterns in your composition.

- ✔ **Proportion:** The amount of space allocated to the various components of a drawing.

Emphasizing the focal point

A drawing becomes much more interesting when it has *a focal point* — a specific area where you want your viewer to focus the majority of their attention when looking at your drawing.

Your drawings illustrate your choice of subjects from your own unique perspective. Think about what you want your drawing to say and choose a focal point that helps you express that message.

In a portrait, the focal point may be the eyes, and in a landscape it may be one specific tree or flower. You may choose to have more than one area of focus in your drawing; in this case, you have a *primary focal point* and *secondary focal point(s)*.

After you choose your main point (or points) of interest, you can use many artistic devices and techniques to highlight the point. In Figure 10-1, the Headde Family illustrates the following tips for emphasizing your focal point:

- ✔ **Always place your focal point off-center in your composition.** Stay away from the bull's eye. A focal point placed in the very center of your drawing space is a big NO unless you have a specific expressive or artistic reason to do so. Any object that you place dead center commands the viewer's full attention. All the other important elements of your drawing may be ignored, and the drawing loses its impact. In Figure 10-1, the main member of the Headde family appears right of center. Your eye may go to this figure intuitively at first, but you still register the other members of the family off to the left.

- ✔ **Make good use of secondary focal points.** Drawing less-interesting objects close to the primary focal point helps direct the viewer's eye toward your center of interest. In Figure 10-1, the small cluster of family members off to the left draws your eye, but then the eyes on these figures direct you straight back to the main figure on the right.

- ✔ **Use objects within your drawing space to point to your focal point.** The lines of the two steps on the platform in Figure 10-1 lead the view's eye to the focal point.

- ✔ **Define the focal point with more detail and a stronger contrast in values than other aspects of your drawing.** The shading of the hair, eyes, and nose is more detailed in my focal point. Also, I use a very dark value to shade the pupils of his eyes and for the shadows under him.

Overlapping for unity and depth

Overlapping objects, or placing some objects over (or in front of) others, unifies a drawing, enhances depth of field, and creates an aesthetically pleasing composition.

Observe your subject carefully before you begin your drawing and plan for places where you can utilize overlapping. To overlap subjects in a drawing, you simply draw closer objects in front of those farther away. For example, if two trees appear side-by-side in a scene, consider drawing them in such a way that one is slightly in front of the other. When you overlap objects, you create a strong three-dimensional illusion.

In Figure 10-2, the larger child (with lots of hair) is in the *foreground* (the front), the light haired adult and the baby are in the *middle ground,* and the dark haired adult (with the grumpy facial expression) is in the *distant space* (behind the others).

Using lines to your advantage

In the cartoon drawing in Figure 10-1, the lines outlining the family members and objects are *actual lines.* The lines of the steps, on which the largest character is standing, point toward him. But of course, bold black lines, like in this cartoon or a coloring book drawing, do not outline objects in the real world around us.

Figure 10-2:
Creating
depth by
overlapping
your
subjects.

Representational drawings that include realistic three-dimensional subjects can use *implied lines* to strengthen a composition. This means lines that are not really there, but are formed (or implied) by the edges of the shapes of the objects in your drawing.

Following the leading line

Effective *leading lines* can invite and encourage the viewer to enter the drawing space, explore the focal point, and linger to investigate the many facets of the composition.

Either actual lines or implied lines can be used to navigate the viewer around a nonrepresentational drawing. However, in a representational drawing, leading lines are usually implied, rather than actual. For example, in a realistic landscape drawing, a leading line can be a pathway, a river, a row of trees, or a fence. When properly rendered, the eye follows this line (or lines) directly into and through the drawing.

Most viewers begin looking at a drawing in the lower-left hand corner, making this corner the best location for a leading line.

Placing leading lines on the right side of your drawing may take the viewer's eye out of your composition. Also, don't put leading lines exactly in a corner. When a leading line points directly to a corner it forms the shape of an arrowhead, pointing the viewer directly out of the drawing, just as effectively as a big bold neon EXIT sign.

Lining up emotions with composition lines

Various types of lines put diverse emotions and moods in your compositions. Remain conscious of the following effects lines can have in your drawings:

✔ Curved lines reflect beauty, gentleness, and calmness. The s-curve denotes balance and grace.

✔ Horizontal lines create stability, peace, and serenity.

✔ Vertical lines reflect strength, grandeur, and dignity.

✔ Diagonal lines offer a sense of movement and power. When diagonal lines meet to form an arrow, they can direct the viewer's eye.

Balancing subjects in a composition

Most good drawings result from carefully planning the balance of the various subjects. A balanced drawing is more aesthetically pleasing and harmonious. When creating this balancing act, you must take the sizes, placements, and values of the subjects into account.

Playing with the teeter-totter principle

Think of your drawing subjects on a teeter-totter. If your subjects are the same size, then they balance perfectly with both the same distance from the center point, as in the first drawing in Figure 10-3. On the other hand, a tiny object on one side balances a larger object on the other end, by being farther away from the center point, as in the second drawing in Figure 10-3.

Without balance, your drawings may end up visually lopsided and inharmonious. Of course, if you want a particular drawing subject to appear distressing and jarring, using an unbalanced composition can help.

Figure 10-3: Balancing subjects of the same and differing masses.

Choosing the shape of your drawing space

The shape of your drawing space (sometimes called the *drawing format*) helps determine how your composition looks. Most beginners draw within a rectangular format (such as the pages in your sketchbook). Keep your creative mind open; there are many other options. You can even choose a drawing format that closely fits the major shape of your subject.

Arrange your objects asymmetrically. Taller objects usually look better off to one side.

Balancing values and shapes

Masses of light and dark values become shapes. These shapes need to be identified and planned before you begin to draw.

Balance dark and light values in your drawing space, in much the same way as objects. Grouping all the dark objects or all the light objects on one side of your drawing space can create a visually lopsided composition. Sometimes simply moving objects slightly to the right or left in your drawing space, or making them lighter or darker than their actual values, can balance the composition.

Placing an odd number of objects into a grouping (rather than an even number) makes a composition more artistically pleasing. Balancing three objects on one side of a composition and five on the other is much more interesting than a static arrangement of four on either side

Delegating proportions to your subjects

When you plan a drawing, you have to decide how big to make each object in the composition. The proportion of each element relative to the others depends on what you want to emphasize in your composition.

It's completely up to you to call upon your creative mind to help you make decisions about the proportions in your composition. Ask yourself the following questions:

- ✔ **What do I consider to be the most important subject within this composition?** The answer to this question may decide what your focal point (center of interest) should be.
- ✔ **Where should I put my focal point and how much of my total drawing space should my focal point occupy?** Many beginners choose to make their focal point the largest object in the drawing.

> ✔ **How much of my drawing format should be background (negative space)?** Negative space is sometimes thought of as a resting place for the viewer's eyes.

Visiting the Lab: Basic Composition Formulas

The human eye seems to prefer certain compositions more so than others. In this section I introduce a small sampling of classic compositional types to help guide you as you produce your first drawings.

A Golden Rule: The Golden Mean

This one's an oldie and a goody. The *Golden Mean* compositional formula is based on the ancient Greeks' definition of a perfect rectangle. This classic form of composition often brings the viewer's eye directly to the focal point.

Dividing the rule of thirds

If you slept through every math class you ever had, then this may be a bit of a challenge at first. But stick with me — this compositional formula helps you locate some perfect places for your focal points.

This version of the Golden Mean composition is sometimes called the *rule of thirds*. It just happens to be my personal favorite. Find your drawing supplies and follow along with me (and Figure 10-4):

1. **Draw a horizontal rectangular 5 x 8 inches.**

 This small rectangle represents you drawing space, just to make things more manageable.

2. **Divide the rectangle into three equal sections vertically.**

3. **Divide the rectangle again into three equal sections horizontally.**

Look at the four points where the lines intersect in Figure 10-4 (I've drawn circles around them). Any of these points makes a great place for a focal point, but the best two points are the ones on the upper and lower right. Most people read from left to right, so the eye usually enters a drawing from the lower left. By placing a focal point on the right, the viewer comes into a drawing and towards the focal point, from the lower left.

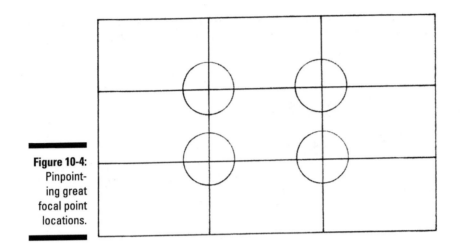

Figure 10-4:
Pinpoint-
ing great
focal point
locations.

Finding more points of interest

Here's another simplified way to use the Golden Mean to help you place sub-jects within your compositions. Start by making another 5-x-8-inch rectangle in your sketchbook:

1. **Draw a line diagonally from one corner to the other.**

 You can see my line in the first drawing in Figure 10-5. It really doesn't matter which set of two opposite corners you choose. This line divides your rectangle into two equal triangular sections.

2. **From one of the other two corners, draw a second line that intersects the first line at a right angle (a 90-degree angle).**

 The place where these two lines intersect, shown in the second drawing in Figure 10-5, makes a great place for a focal point.

 You end up with three triangles of different sizes. Find objects that fit approximately within these three triangles and you have a harmonious composition.

Figure 10-5:
Using the
powers of
triangu-
lation to find
focal-point
placements.

You can vary this formula by turning your drawing paper sideways or upside down, or by drawing it either in reverse or as a mirror image.

Compositions with S-O-U-L

Four of the most popular compositional types are named after letters of the alphabet, for obvious reasons that you will soon discover.

"S" composition

In this type of composition, the subjects form a shape similar to the letter S. An "S" composition is gentle, fluid, and graceful. The double curve of a pathway, river, or line of trees can create this composition.

Check out the Headde family in Figure 10-6 as they walk along an S-shaped pathway. I love the way this compositional type seems to invite the viewer into the painting.

Figure 10-6: "S" compositions are graceful and fluid.

"O" composition

In Figure 10-7, a member of the Headde family snoozes against one of the trees that outline the "O" shape of this compositional type. The peaceful circular movement of the "O" keeps the viewer's eye inside the drawing.

Draw objects, value masses, or lines to form your "O." Then place your focal points within this circle.

Figure 10-7:
"O" comp-
ositions are
peaceful
and serene.

"U" composition

This dynamic compositional type usually has vertical objects or masses on either side with a horizontal line forming the bottom of the "U" shape. The area within the "U" can be either a peaceful place for the viewer's eye to rest or a good location for the focal point. Figure 10-8 shows how you can turn a subject into a focal point by placing it inside the "U."

Figure 10-8:
"U" comp-
ositions
create an
ideal
location
for a focal
point.

"L" composition

A vertical mass on one side of a drawing, balanced by an open area or distance on the other side, with a horizontal base, is an "L" composition. This

dramatic and solid compositional type firmly anchors drawing subjects on two sides of the drawing format.

The open area can provide a "frame" for your focal point. Your focal point can also be the vertical mass, as in Figure 10-9. Baby Headde once again takes center stage, or in this case, center chin.

Figure 10-9: Vertical mass in an "L" composition becomes the focal point.

More composition types

In this section, I share with you a few more of my favorite composition types.

Tunnel composition

A tunnel composition is a view through a doorway, window, or a grouping of trees or mountains in which the focal point is in the opening beyond the "tunnel."

Grouped mass composition

This composition consists of several objects of different sizes, shapes, and values grouped together to form a pleasing arrangement. This composition is very popular with artists who like to draw still-life arrangements.

Radiating line composition

When several leading lines converge to a point, this is called a radiating line composition. The point where the lines meet is a perfect place for a focal point, or simply a place for the viewer to rest his or her eyes. The roof of a building, a road, a fence, or a line of trees can form the implied lines.

Planning with Artistic License and Tools

It's perfectly acceptable to draw your subjects exactly as they are. However, nothing in drawing is written in stone. Several creative doorways open when you understand that artists aren't limited to drawing things exactly as they see them. Many artists use creativity and some sort of drawing tools, such as grids, viewfinder frames, or photographs, to help plan strong compositions.

Often you discover perfect drawing subjects with imperfect compositions. If nature or man has placed an object in a position that you don't like, you can simply draw it in a different place or remove it entirely.

Framing the world

A *viewfinder frame* helps you locate and plan great compositions by helping you filter out some of the world's distractions. The frame also lets you test-drive hundreds of compositions without once picking up a pencil: You simply hold up the frame, look through it at your scene, and move it around (like looking through the lens of a camera) until you see an ideal composition.

Get together some cardboard, scissors or a knife, and two large paper clips, and then follow these steps to make your own viewfinder frame:

1. **Cut out two identical L-shaped pieces of cardboard, any width you want.**

 The wider the frame, the more distracting, unwanted objects are blocked from your view.

2. **Use two large paper clips to join the pieces of cardboard together to form a frame (see Figure 10-10).**

 You can easily adjust the size of the frame to make it in proportion with your drawing paper.

Look at your subject through the frame to choose an ideal composition.

Planning composition from a photograph

Using photography allows you to capture a composition that you want to draw, take it back to your drawing space, and work on it for hours or days until you get it just the way you want it.

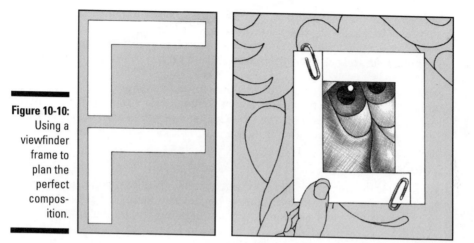

Figure 10-10:
Using a viewfinder frame to plan the perfect composition.

Plotting out your photograph

Working with a grid provides a fun way to set up accurate proportions in any drawing that is based on a photograph (or any other image, for that matter).

First of all you need to draw a grid of squares on your photograph. If your photo is highly detailed, you may want to use lots of small squares (as used in the photo in Figure 10-11). If the subject looks simple, use larger squares.

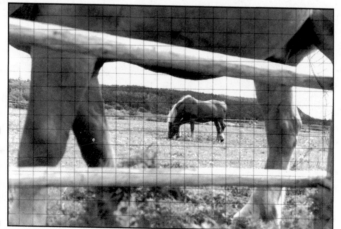

Figure 10-11:
Drawing a grid with small squares.

Draw the grid on your photo (or a copy) with an ordinary, nonerasable ball-point pen. It doesn't smudge as easily as markers and can be seen more clearly than a pencil, which tends to just scratch the surface of the photo. Use your ruler to keep everything straight and tidy.

Label the horizontal rows of squares down the side of your photo with letters. Label the vertical rows of squares across the top of your photo with numbers. That way, you can easily keep track of what square you're working on as you transfer the visual information from the photo to your drawing surface.

Scaling up or down

When you want your drawing to be larger than your photo, you draw the grid on your drawing paper proportionately larger than the one on your photo. If your photo is large and you want a smaller drawing, use a smaller grid.

To decide the final size of your drawing, measure the size of your photo and then multiply (for a larger drawing) or divide (for a smaller drawing).

Preparing your drawing surface

After you decide what size your drawing should be in relation to your photo and you've calculated what size the grid on your drawing surface needs to be (see the previous section), use a ruler and a HB pencil to lay out the grid on your drawing surface. Draw the lines lightly, so that you don't indent your drawing surface and can eventually erase them without tearing up the paper.

Label the horizontal and vertical rows of squares (outside the perimeter of your drawing space) to correspond with each square you marked on your photo. This makes transferring the visual information from the photo to your drawing surface much easier.

Transferring the image

Draw what you see inside each square of your photo in the corresponding square on your drawing surface. Check the positioning of everything in each square before you erase your grid lines.

Modifying Photographs

If you plan to simply draw a photo exactly as it is, you miss out on a lot of creative fun. The photo in Figure 10-11 inspired the drawing of the unicorn in Figure 10-12.

Figure 10-12:
Creatively
changing a
photo of a
horse into a
drawing of a
unicorn.

Project 10: Planning a Composition

In this project, I walk your through the process of planning a composition, from its conception as photos to its completion as an original artwork. Follow along with me as I resolve the following problems:

- ✔ I have two photos (see Figure 10-13) that I like but I'm not fond of the composition in either. I need a balanced, flowing, and serene alternative.

- ✔ There are just too many things in each photo, and I need to find a way to eliminate some of the clutter.

- ✔ The broken and abandoned lobster trap in the lower right of the first photo is my very favorite object, and I need to find a way to make it the primary focal point.

Figure 10-13:
Combin-
ing the
best parts
of two
images
into one
harmonious
composition.

As I examine each photo, I realize that, with a few minor modifications, an "S" composition would work beautifully. The size of this drawing is 4 x 5 inches, but feel free to use any size you prefer.

1. **Roughly sketch an "S" composition.**

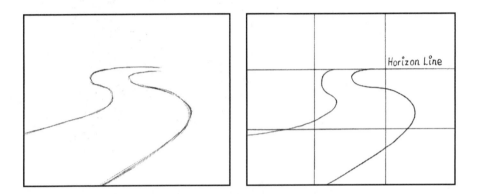

2. **Draw lines dividing the drawing space into thirds, horizontally and vertically.**

 I have chosen the upper horizontal line as my horizon line. The four places where the lines intersect are ideal locations for primary and secondary focal points. Now I need to decide what to include, what to leave out, and where to put everything.

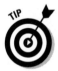

 Scan and print or photocopy your photo(s) in two or three different sizes. Cut out the parts you like in the sizes that best fit your artistic design, and then tape them on your plan. Choose a good place for your focal point(s), and then arrange the other differently shaped sections until they fit nicely within your composition.

3. **Lightly sketch the outlines of the lobster trap (the focal point) and the rocks around it (secondary focal points) in the lower-right corner (the foreground).**

 See my cut and taped plan in the first illustration in the next set of two. The focal point is located on the lower-right point of the intersecting lines of the rule of thirds. I moved a couple of those huge rocks to the front of the lobster trap. I'm reasonably happy with this preliminary composition, but the boat looks awful, spoils my "S" shape, and has to go!

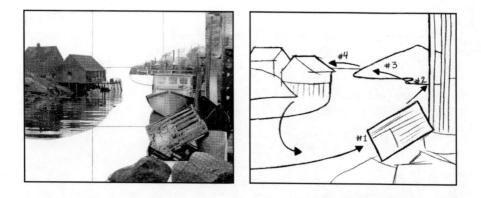

4. **Add the fishing shacks and wharf on the left (the middle ground) and the land and buildings in the background (the distant space).**

Find the vanishing points on the horizon line and use geometric perspective to draw the buildings correctly. (I tell you how to do this in Chapter 9.)

Time to examine the flow of this composition and make sure that everything works. The lobster trap (#1) is my focal point. The eye naturally enters this "S" composition from the lower left and moves directly toward the lobster trap. The tops of the rocks, in front of the lobster trap, are sort of shaped like rounded arrow points, navigating the viewer's eye upward. The upper-right corner of the lobster trap serves as a sharp arrow point, clearly directing the viewer's eye upward and to the right, where you see the edge of a building.

The edge of the building (#2) serves as something I call a *stopper*. In this case, the stopper is meant to stop the eye from moving farther to the right and possibly exiting my composition. Another stopper, a horizontal board jutting out from the edge of the building (which I'll add later), keeps the eye inside the composition as it looks upward.

The end of this section of land (#3) to the left of the buildings, is shaped like another point of an arrow and is pointing directly toward the fishing shacks in the middle ground, on the right side of the composition.

The fishing shacks (#4) will be detailed enough to offer the viewer's eye a place to rest for a second. Now I need to figure out how to keep the viewer's eye inside my composition, rather than exiting to the far left. I plan to emphasize the ripples and reflections in the water so as to navigate the viewer's eye downward and back toward the lobster trap, thereby completing a full-circled composition.

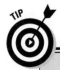

Planning your composition

The more you understand the rules of composition, the better your drawings will become:

- ✔ Place your focal point off center within the boundaries of your drawing space.

- ✔ Use some of the basic elements of composition such as balance, shading, proportion, and overlapping to draw the viewer's eye to your focal point.

- ✔ Include an odd number of objects into a grouping, rather than an even number, whenever possible.

- ✔ Choose a variety of objects of different textures, shapes, and sizes.

- ✔ Arrange your objects asymmetrically. Taller objects usually look better off to one side.

- ✔ Keep it simple! Too many objects in a drawing create overcrowding and disharmony.

5. **Now that the composition is working, add shading to your rough sketch.**

This rough sketch is known as a thumbnail, and allows you an opportunity to work out and balance the light and dark values of the various sections of a drawing. I have the darkest values in and around my primary focal point. The other values, from lights to darks, are on both sides of the drawing, distributing their weights evenly so as to create a balance of values throughout the composition.

6. **Turn your thumbnail sketch into a completed drawing by redrawing each section in detail.**

Use your vinyl eraser to get rid of lines you don't want and use your kneaded eraser to lighten the entire drawing.

Chapter 11

Recording Your Life in a Sketchbook

A basic drawing studio can travel easily with you, wherever you go. In this chapter, I tell you how to put together a portable studio for your outings, and I offer suggestions on where to look for fun drawing subjects. I demonstrate different methods of sketching to show you how to capture your visual memories efficiently and quickly. Understanding that you are not limited to duplicating exactly what you see opens many creative doorways.

Preparing Your Portable Studio

Have a set of drawing materials packed and ready to accompany you on various outings. Some suggestions for preparing a portable studio include:

✔ A hardcover sketchbook is a great alternative to carrying a drawing board. Purchase the best-quality, hardcover sketchbook that you can comfortably afford. Soft-covered sketchbooks become tattered and crumpled very easily, and your sketches can be ruined.

✔ A large zippered pencil case can hold your drawing media and erasers.

✔ If you like to work with charcoal and other messy media, be sure to include some disposable moist wipes or paper towels.

✔ If you draw in a public area, a portable music player, with headphones, helps block out distracting noises. Also, when you wear headphones, curious onlookers are less likely to disturb you!

If you prefer to draw on sheets of paper, rather than in a sketchbook, the contents of your portable studio need to be expanded:

✔ Treat yourself to the luxury of experimenting with a broad range of different types of drawing paper. Drawing paper comes in lots of different colors, textures, and sizes. Go to a good art supply store, purchase as many different types as you can comfortably afford, and then play with sketching on each until you discover your favorites. (My favorite drawing paper is hot-pressed, smooth watercolor paper.)

✔ A portable drawing surface, such as a drawing board, is a must-have if you use sheets of paper instead of a sketchbook. Many art supply stores sell different types in various sizes. If you're handy with tools, you can even make your own. Cut a piece of thin plywood to a size slightly larger than your drawing paper and then sand it until it's smooth.

✔ Hold your drawing paper in place on your drawing board with clips.

Getting Out and About

Your supplies are packed and you're ready to go! Lots of fun subjects are just waiting to be captured in your sketchbook. Exploring your surroundings, as an artist, provides gazillions of opportunities to document many different aspects of your daily life, including the following:

✔ From that quiet, peaceful afternoon, sitting in Aunt Daphne's parlor, to a noisy backyard barbecue party, your sketchbook provides infinite opportunities for a fun time. Most family members and friends feel quite honored when asked to be the subject of one of your sketches. For example, maybe Uncle Ben is wearing an especially loud and silly hat. A sketch can exaggerate it in such a way that it becomes the focal point of your drawing, and provides you (and others) with many giggles!

✔ For centuries "capturing" human beings in artworks has fascinated artists. Sometimes, you spot an incredibly compelling person in a park, on a bus, or at your high school reunion picnic. Don't be caught saying "If only I'd brought my sketchbook."

✔ All events in your life, such as a trip to your local zoo or watching a ball game, provide fascinating drawing subjects. As a unique individual, you see your surroundings from a completely different perspective than anyone else. Capturing scenes, people, animals, and objects in sketches allows you to emphasize specific details that are important to you.

Filling the Pages of Your Sketchbook

Wonderful drawing subjects aren't always cooperative. People and animals tend to move just as the pose is perfect. Or, you may have to abandon an incredible drawing subject before you have time to draw it properly. Quick sketches save those moments as images! You can do other drawings based on your sketches, sometime later, when you have a chance to relax.

Sketches are based on careful observation of your drawing subject, and with practice, they become quick and easy. A thorough visual examination of your subject is the most important ingredient for making great sketches. Squinting, to see the different values, provides you with a map for sketching the shapes you see. (I discuss visually simplifying a subject in Chapter 6.)

I use the following two words to describe sketches:

- **Rough:** Quickly and efficiently illustrates the forms, shapes, and/or values of any scene, object, or living being, with very few details.

- **Gesture:** Uses simple sketching methods to capture the past, present, or potential movement of living beings, from the quick movements of a galloping horse, to something as subtle as a child's facial expression.

Sketching, even though you do it quickly, requires practice and more practice before you can get down all the visual information you want. You may do hundreds of sketches in your drawing lifetime, and each one gets you closer to the results you want.

Sketching your subjects with simple lines

You can sketch lots of information quickly, with only a few strategically placed lines. The two sketches in Figure 11-1 record the shapes that I consider important in these two subjects. In the first drawing of the seated figure, simple lines define the folds in the fabric of his clothing, show the shape of his arms, head, feet, and hands, and separate the light areas on his face and neck from the shadow areas. In the landscape (the second sketch), I outline only the simple shapes I see, rather than intricate details.

In this exercise, you sketch an object with only lines. Find an appealing subject and gather your drawing materials.

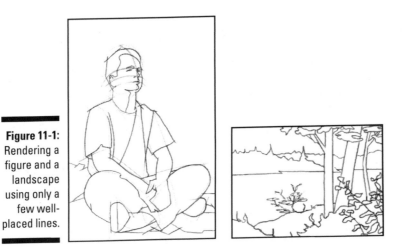

Figure 11-1:
Rendering a figure and a landscape using only a few well-placed lines.

1. **Look closely at your subject.**

 Take note of the areas that you consider important. Observe which objects are in the foreground, middle ground, and distant ground, and note objects that overlap others. Visually break the subject down into shapes and measure the proportions.

2. **Use lines to draw the outlines of the shapes you see.**

 Draw slowly. Accuracy is more important than speed. Your speed automatically improves the more you practice.

 A few simple lines, along with careful observation of your drawing subject, can visually describe anything. For example, sometimes one curved line is all you need to accurately record the curve of a human spine. Fine detail isn't as important as capturing the overall essence of your subject.

Developing your sketching style

Your sketching style develops over time. The method you choose for sketching is completely a matter of personal choice. Some artists prefer lines, more prefer only shading, and others (like me) prefer a combination of values and lines. Take time to experiment with different sketching methods. Whatever method you prefer is right for you.

Combining shading and lines in sketches

My favorite sketching method entails first outlining the objects in the scene with lines and then adding simple hatching lines to shade in the values. This sketching method captures shape, form, light, and shadow, as well as some detail.

Figure 11-2 shows two examples of sketches rendered with a combination of lines and shading. I first outlined the shapes that I considered important with lines (have a peek at Figure 11-1). I then used simple hatching lines to indicate the values created by the light and shadows.

Sketching with spirals or shading

Experiment with lots of different ways of sketching, until you find a style you like.

Sketching with spiral lines lends itself well to drawing the three dimensional forms of a human figure, as shown in the first drawing in Figure 11-3. The second gesture sketch is done in charcoal with only shading. You can make detailed drawings from your sketches. (See the third drawing.)

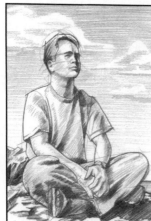

Figure 11-2: Sketching with both line and shading.

Sketching efficiently and quickly

Practicing rough sketches with a timer increases your speed and strengthens your observation skills. You need some sort of timer, your drawing supplies, and any object to serve as a model!

First start with a one-minute sketch, and slowly work your way up to five minutes. Put your sketching subject in front of you, set up your drawing supplies, and get comfortable.

1. Set your timer and look closely at your subject. Identify specific shapes and visually measure the proportions. Note the light source and pinpoint the highlights and shadows.

2. Start sketching the lines and shapes you see in whatever method you prefer.

Remember to look at your subject often, as you sketch.

3. When the timer goes off, stop sketching. Find another subject (or the same one at a different angle), turn to a new page, reset the timer, and do another sketch.

Working efficiently is more important than working fast. But, some sketches need to be done quickly. When drawing a figure from life, some poses become uncomfortable for the model after only a couple of minutes.

Begin sketching with nonliving models until your skills become strong and your speed increases. Then you can enjoy the benefits of both speed and accuracy.

Figure 11-3: Observing two more sketching techniques, and a detailed drawing of the same subject.

Project 11: Teddy Tink

The model for this project was incredibly cooperative. He stayed very still, didn't talk my ear off, and didn't require any coffee breaks!

In this project, I show you how to take a subject, such as Teddy Tink, from a very rough sketch to a detailed drawing. Use a vertical format and enjoy yourself as you follow these steps:

1. **Lightly sketch an oval shape for the body slightly over to the right of your drawing space.**

 See the first rough sketch in the next set of two. Don't press too hard with your pencil. You need to erase these sketch lines later.

 Make sure you leave room to later add his head, arms, and legs.

2. **Sketch a circle for his head.**

 Notice that the circle overlaps the body. At this stage, Teddy Tink looks like a snowman with one ball of snow on top of a larger oval-shaped one.

3. **Add a half-ellipse across his head.**

 This curved line indicates the position of the top of his eyes.

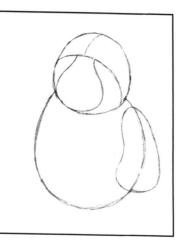

4. **Add a slightly curved line from the half-ellipse to the top of his head.**

 This line meets the half-ellipse at a point closer to the left and identifies the center of his face, which is turned a little to the left of the drawing space (see the second sketch).

5. **Draw a light-bulb shape, which will be his snout.**

 As you soon see, this light-bulb shape maps the location of his eyes.

6. **Draw his left arm.**

 Note that his left arm is wider at the bottom. This is one of his paws.

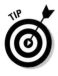

 Break the subject down into shapes and visually measure the proportions. Take note of the areas where parts of his body bend or twist or are extended or outstretched.

7. **Sketch his right arm a little smaller than his left.**

 Check out the first sketch in the next set of two. His upper body and head are rotated slightly back on the left. From this perspective, his right arm seems a little smaller because it's slightly farther away. (I tell you about perspective throughout Chapter 9.)

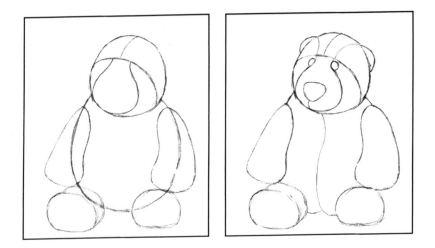

8. **Sketch the tiny section of his right leg that is showing and the bottoms of his feet.**

 His feet seem to be almost directly under each of his arms.

9. **Erase the lines from his body that are inside the outlines of his arms and feet.**

10. **Sketch the outlines of his eyes, ears, and nose.**

 Teddy Tink's eyes rest on either side of the top of his snout. His ears are little. Because of the angle at which his head tilts, his ear on the left seems to be a little smaller and higher that the other, and his nose is a little to the left of the center of his snout.

11. **Add a line down the center of his body with a curve where his tummy will be.**

12. **Add a short curved line connecting the bottom of his nose to the bottom of his snout.**

13. **Lightly pat all your lines with your kneaded eraser to make them a little lighter.**

 Now your rough sketch is complete.

14. **Draw "fuzzy" lines (lines that look like the edge of fur) around all edges except the nose and eyes.**

 See the first drawing in the next set of two. Note that the fuzzy lines are different lengths and curve in many directions.

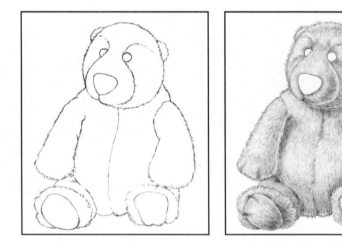

15. **Erase the lines on the inside of the top of his head and draw curved fuzzy lines for his eyebrows.**

16. **Draw the pads on the bottoms of his feet with smooth lines.**

 Now you have a detailed line drawing.

17. **With your 2H pencil lightly shade in the fur, watching very closely the different directions in which the hatching lines curve.**

 The directions in which the fur seems to curve are important, because this helps give the illusion of depth to the bear's form.

 Take note that the light source comes from the left. Identify the location of the highlights and shadows. The fur on the right side of all sections of his fur is darker than on the left.

18. **Use your 2B pencil to shade in the fur-textured darker values, mostly on the right.**

19. **Add the darkest values of his fur with a 4B or 6B pencil.**

 Don't miss the dark values under his nose, snout, and arms, and on his left shoulder under his head.

20. **Map in the details of his eyes by outlining the pupil and the highlight inside the iris.**

 See the close-up drawing of Tink's face in the next set of drawings. The largest circles of his eyes are the irises. The dark circles in the centers of the irises are the pupils. The tiny white circles are the highlights.

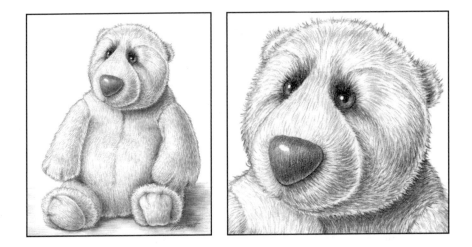

21. **Shade in the lower section of each iris with your HB and the top sections with your 6B.**

22. **Use your 6B pencil to shade in the dark values of the pupil.**

23. **Map out the highlight on his nose and leave it white.**

24. **Shade in the rest of his nose.**

 Note the little section of reflected light on the lower edge of his nose. Use your HB for medium values, and a 4B or 6B to add dark shading.

25. **Add the really dark shading of his fur around his eyes.**

 This shading graduates lighter up toward the center of his forehead, which gives him such an endearing facial expression.

26. **Draw in the shadow below him with hatching lines.**

Chapter 12

Drawing on Your Memories

*Y*ou add a whole new dimension to your artistic skills when you can draw from your memory. Think about the pleasures of drawing anywhere and anytime, knowing that your subject is safely tucked away inside your mind.

In this chapter, I offer tips and exercises to help improve your visual skills and memory. Keep your drawing supplies close by, so that you can follow along with me and practice drawing from your mind. I also provide you with a fun opportunity to try your hand at being a forensic artist.

Capturing an Image in Your Mind

To acquire a visual memory of your potential drawing subject, before you attempt to draw it from your mind, you use the following:

✔ **Vision:** Refers to your sense of sight and is most often thought of in terms of actual objects or scenes that you see with your eyes. Vision also refers to an image from your memory, dreams, or imagination that you see in your mind's eye.

✔ **Perception:** The manner in which you understand and process sensory information.

Fine-tuning the art of seeing

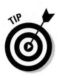

Your five senses — seeing, hearing, feeling, tasting, and touching — feed your memory with sensory information. Most experts agree that of all the senses seeing produces the strongest sensory memory. After all, you can't expect to remember and draw something accurately if you have never seen it properly. Various factors, such as time, perspective, distance, and atmospheric clarity, influence how you see.

Taking the time to focus on your subject

You need to be in a position to take your time, focus your full attention on your subject, and observe it carefully, in order to remember it well enough to later draw it. For example, if you're running down a street trying to catch a bus, you're not likely to accurately recall the shape of its headlights unless you take the time store that specific information in your memory.

Keeping your perspective

The perspective from which you view your subject determines the angle from which you remember it. Most objects look very different from various angles.

Eye level is easiest when trying to remember something. If the object is far below you or high above you, its perspective becomes more complicated. As your skills with memory and perspective improve, you enjoy the challenge of drawing objects from extreme and unusual perspectives.

Don't limit your viewpoint of a subject to only a front, back, or side view. Whenever possible, take the time to view your subject from all sides, and try not to make assumptions about what you see. Have you ever seen a person back on to you, with long beautiful hair and assumed that person to be female? You get quite a surprise when that person turns toward you and "she" has a full beard!

You can draw your potential drawing subject more accurately when you are familiar with it from all sides. In Figure 12-1, I show you two mug shots of the same suspect (oops, I meant "subject") from two different perspectives. Examine these two drawings closely and observe how different something (or someone) can look from the side. Try to imagine what this same subject looks like from behind.

Choosing an ideal viewing distance

Clarity diminishes the farther you are away from something. If you see an object from more than 30 to 40 feet away, it tends to look blurry. On the other hand, if you're too close to something, you can't see its entire outline and structure.

Figure 12-1:
Seeing the
same
subject from
two
different
perspectives.

For ideal viewing, you need to be far enough away to see the entire object yet close enough to make out fine details. Sometimes, you need to see the subject from more than one distance. You can move closer to see details, and then move back to get an overview of its whole shape and form.

The composition you choose also determines how close or how far away from your subject you need to be. (I tell you about composition throughout Chapter 10.) Find a familiar object. Look at it from the other side of the room, the middle of the room, and a few inches from your face. Take note of how much detail you can see from each distance.

In Figure 12-2, please meet Pricilla, the proud owner of my friend Rob. In the first drawing, note that she's too far away for you to see and remember fine details. However, if you want to draw her as a part of a larger scene, you may be able to draw her basic form from this distance.

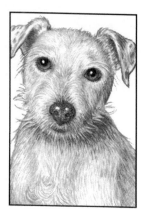

Figure 12-2:
Seeing
more and
more detail
the closer
you get to
Pricilla.

The second drawing is a perfect distance if you want to draw her full body. Observe the forms of her face and body as defined by the shading of her fur.

The third drawing in Figure 12-2 shows you what you need to remember to draw only her gorgeous face! Take note of the fine details, such as the wispy hairs sticking out from her face, the shine in her eyes, the form and texture of her nose, and the spots on her ears.

Taking your perception into account

Several people can view the exact same subject under identical conditions, and yet each person often remembers a completely different image. Your perceived visual image of an object may not be the same as what that object actually looks like. Your eyes may see an object correctly, but your brain records images based on your memories, experiences, and perceptions.

Knowing your subject is as important as storing its image in your mind! Don't worry if drawings from your memory don't look much like the actual objects at first. Keep in mind that your memory is fragile and easily distorted by your current visual perceptions. Sketching and drawing from the actual subject helps you to know lots of important information about it. As you become more knowledgeable about various subjects, you get better at accurately remembering what you see.

Storing Images in Your Mind

You store information in your mind in different formats, including:

- ✔ **Verbal:** Remembering an object in words. A concise verbal description can often provide you with a visual image.

- ✔ **Visual:** Seeing an object in your mind's eye. Some people find it easier to translate a visual memory into a drawing than to put its description into words, and then translate the words into an image.

Everyone's different! Some people are better at remembering verbally, others visually, and many use a combination of both. As you work on improving your overall memory skills, you find drawing from your mind becomes easier.

Your memory is strongest immediately after you see something. Within minutes, you begin to forget some information. Do a rough sketch of a subject

Enhancing your memory with research

You may be walking through a park someday and spot the most adorable dog. You attempt to store as much information as possible in your mind, but you feel a need to know even more to do a detailed drawing. Have another look at Pricilla in Figure 12-2. She's a Jack Russell Terrier, and even though each dog of this breed looks a little different, the basic characteristics and anatomy are very similar. By researching Jack Russell Terriers, you can draw one more accurately.

The Internet or your public library is a great place to begin researching unfamiliar drawing subjects. When you take the time to become knowledgeable about your subject, you may even be able to adjust your visual perception to draw reasonable representations from other angles. For example, think about a frontal view of a human head. When you are familiar with the basic rules of proportion, you can adjust your perception to draw back or side views of this same subject (I tell you about the proportions of the human head and face throughout Chapters 17, 18, 19, and 20).

you want to remember as soon as you possibly can. If you wait more than 48 hours, the image may become increasingly difficult to remember correctly.

This three-part exercise explores your current memory skills, takes you step by step through a simple technique for storing visual images in your mind, and encourages you to draw what you remember.

Part 1: Think about an object in your home that you see every day. Without going to look at it again, attempt to draw it. You may find this difficult if you've never looked at this object with the intent of drawing it.

Part 2: Put away your drawing materials for a few minutes. Go get this object and place it in front of you. Sit comfortably and relax your mind. First of all, imagine there's a clear pane of glass in between you and the object. Then choose a place on the object to begin pretending to draw it on the glass.

With the tip of a pencil or pen (or your finger), begin tracing the object on your invisible pane of glass. After you have traced the entire outline, use the same technique to trace fine details and textures. Now look for light and shadow areas and pretend to draw them.

When you think you have it in your mind, try closing your eyes and see how much information you can recall. If you need to, observe your subject again.

Do this several times until you feel confident that you can translate its image into a sketch or drawing.

Part 3: Time to put the object away and find your drawing supplies again. Draw the same object on a new page in your sketchbook. Take a moment and compare your earlier drawing with this one. You probably found the object a little easier to draw this time.

Project 12: Drawing a Verbal Memory

You've probably seen a composite drawing of a criminal suspect, rendered by a sketch artist, on a TV show or in a movie. During my 25-year career as a forensic artist, I've often been asked, "How do you draw from someone else's memory?" I'd like to say that it's a special talent or magical ability. But it isn't. All I do is draw from the verbal description that I obtain during my interview with the victim or witness. Drawing from someone else's verbal memory isn't much different from drawing from your own (unless, of course, that person speaks a different language).

If my drawing (or yours) happens to look like your next-door neighbor, don't be concerned! My drawing is completely from my imagination and isn't based on a real person. On the last page of this chapter I show you my drawing of the suspect. But wait until you're finished to look!

In this exercise, I'm the witness and you're the police artist. First, I give you my verbal description of the suspect. Then I tell you how to start drawing from this description.

Read the entire description carefully before you begin to draw. As you read each part of the description, take a moment and form an image of it in your mind.

- ✔ The suspect was a white male, 25 to 35 years old, wearing a lightly colored crew neck T-shirt.
- ✔ He had a long, thin, sort of rectangular-shaped face.
- ✔ His cheekbones were high, and he had a square jaw and a large chin.
- ✔ There was beard stubble on the lower part of his face.
- ✔ His hair was medium brown, straight, and thin. It mostly fell forward down on his forehead and was wispy, messy, and looked dirty or wet.

✔ His ears were average size and didn't stick out.

✔ He had a loop earring in his left ear.

✔ He had wrinkles on his forehead.

✔ His eyebrows were dark, thick, and bushy. They were long and almost went all the way across his face.

✔ His eyes were dark, really small, and creepy looking.

✔ He had a wide, fat nose, and his nostrils were big.

✔ His mouth looked mean. His upper lip was small, and his lower lip was big.

Grab your drawing supplies and get ready to "capture" the suspect in a drawing. I'm not showing you any of my drawing steps during this process — I want you to draw using only the written description of the suspect. Choose a vertical format in your sketchbook:

1. **Draw an egg shape.**

 The wide part of the egg shape is his head, and the smaller end is his chin. Keep your drawing light for now, because you need to erase later.

2. **Draw a very light line dividing the face in half horizontally to mark the approximate location of his eyes.**

3. **Draw another line down the center of the face to help keep your drawing symmetrical.**

4. **Draw the outline of the lower half of his face, referring to your verbal description for clues about its size and shape.**

5. **Complete the outline of his head by drawing his hair and ears.**

6. **Draw his facial features.**

 So I don't accidentally smudge my drawing with my hand as I work, I prefer to start at the top of the forehead and work my way down to the chin. (In Chapter 19, I tell you more about adult facial features.)

7. **Add shading to identify the forms of his skull (like the texture of his hair) and face (for example, his cheekbones and chin), textures (such as the beard stubble), and fine details (such as wrinkles).**

 Think about what types of shading (I tell you about hatching and cross-hatching in Chapter 7) can help define the form of his bone structure and the textures of his hair. (Refer to Chapter 8 for lots of information on drawing textures.)

Did you capture the suspect? Of course, I mean "capture" him in a drawing! Figure 12-3 shows my drawing of the suspect.

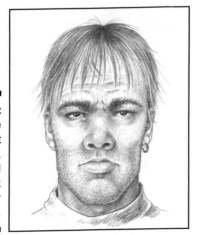

Figure 12-3:
The meanest guy in town. Turn around and walk the other way.

If you enjoy doing this kind of drawing, have someone describe another person to you as you draw.

Chapter 13
Setting up to Draw Still Life

• •

In This Chapter

▶ Choosing subjects to include in a still life drawing

▶ Lighting your composition

• •

When most people think of still life art, they think of a bowl filled with fruit or a vase of flowers. You can choose symmetrical and/or non-symmetrical drawing subjects for still life compositions. Lots of fascinating objects are symmetrical, and rendering them correctly is integral to mastering realistic still life drawings. In this chapter, you discover how to select various still life subjects, accurately draw symmetrical objects, and set up lighting.

Choosing Subjects for Still Life Drawings

With a little creative exploration, you can find an infinite supply of still life subjects. You can choose from various objects you find especially fascinating, or explore the vast labyrinths of your imagination, exercise your artistic license, and discover tons of unique subjects. Combining several objects of different shapes and sizes into a single composition can create an extraordinary still life drawing. (See Chapter 10 for more information on creating a strong composition.)

Traditional and contemporary

Traditional still life drawings include classical subjects, such as fruit, dishes, tools, ornamental objects, and flowers. (I tell you about drawing flowers in Chapter 14.) *Contemporary* refers to anything that is modern. Of course, what's considered contemporary today may be called traditional in a few years! The current twist of retro being considered modern adds to the confusion! Simply stated, choose subjects that personally appeal to you, no matter what category they fit into.

You may find lots of great traditional and contemporary subjects around your home, or in your neighbor's home (thank you Wilma!). Fruits, flowers, and

vegetables still look much the same as they did many years ago, when the great masters of art drew them.

Check out the cool plastic picture frame (the first drawing in Figure 13-1) that simply insisted on being a fun contemporary drawing subject. In the second drawing, have a peek at a delectable traditional drawing of a peach. Note the fuzzy textured shading created with squirkles (I show you how to do shading with squirkles in Chapter 8).

Figure 13-1:
Your home
may offer
a wealth
of both
contempo-
rary and
traditional
still life
subjects.

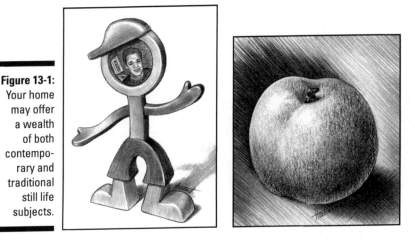

Even your lunch can provide fun drawing subjects. For example, take a nice, shiny apple, place it in front of you, and sketch it. Take a bite and then draw it again. Continue to do a whole series of drawings until you get down to the core!

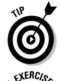

Glass and crystal objects are longtime favorite still life subjects. Their shiny textures need strong highlights and really dark values to look realistic. (See Chapter 8 for more on drawing textures.) Have a peek at the drawings in Figure 13-2 to see what I mean.

The bizarre bottle (the first drawing in Figure 13-2) wasn't an artistic slip! It's really shaped like this! The values I used to shade this unusual bottle were determined by the transparent qualities of the glass:

✔ The darker values from the top section of the background are drawn in the upper half of the bottle.

✔ Lighter values from the surface on which the bottle is sitting are visible in the lower section.

✔ The base of the bottle has the dark values of the shadow under the bottle.

A crystal angel (the second drawing in Figure 13-2) provides an intricate study of a highly detailed transparent subject. Many of the medium values were actually in the background, but I decided to leave the background white to further accentuate the complex texture.

Figure 13-2: Glass and crystal often make great subjects for still life compositions.

Explore garage sales, flea markets, and antique stores, and find some "old" objects to draw. Old, weathered, and worn objects have a lot of personality, which you can identify and incorporate as an integral part of your drawing.

In the first drawing in Figure 13-3, you see a drawing of a weathered and tired, old wooden bucket that I discovered as I was driving along a quiet road beside the ocean. Thankfully, I usually have my camera with me in case I spot an artistic treasure, such as this. The old fishing shack in the background and the wild flowers growing around the bucket provide additional charm to my drawing.

In the second drawing in Figure 13-3, you see three beautiful, old wooden objects, pleasantly arranged and unified in that they are all the same texture.

You can unify a still life drawing by choosing objects that relate to one another in some way. Consider themes such as gardening tools and plants, kitchen utensils and food, table settings, themes based on texture or color (such as all-black or all-white objects), or an arrangement of children's toys.

Way out there and totally zany

An infinite supply of creative, nonrealistic still life objects exists in your imagination. You can invent your very own creations or take a traditional object,

such as an apple or a bucket, and transform it into something totally bizarre (as in the two drawings in Figure 13-4). The face in the second drawing was inspired by the gorgeous texture of wood.

Figure 13-3: Old, weathered objects provide personality for your still life drawings.

Figure 13-4: Transforming ordinary objects into zany drawing subjects.

Drawing Symmetrical Objects

Always look for symmetry in the subjects you choose for still life compositions. In this project, I tell you how to use a few simple tools to help you draw symmetrical objects accurately, quickly, and easily. I show you how to draw a symmetrical vase, but keep in mind that the technique works just as well for any symmetrical subject.

Identifying the shape of a cast shadow

Find several differently shaped objects, place them one at a time near a strong light, and observe their shadows. Move the light around (or move the objects around) and watch how the shadows change shape. Place the objects on gathered fabric and see how the shapes of the shadows follow the folds of the fabric.

The shape and form of an object and the surface on which it sits determine the shape of its cast shadow. For example, if you look at an apple's shadow on a flat tabletop, it is similar in shape to the apple itself. However, if the apple sits on wrinkled or gathered fabric, the shape of the shadow follows the contours of the folds in the fabric. The origin of the light source also affects the shape and size of a cast shadow. (Refer to Chapter 6 for more information on shadows.)

In addition to your regular drawing supplies, you need a sheet of tracing paper.

1. **Draw a rough sketch of the outline of the vase.**

 Or, if you want to draw something else, just follow along with me.

2. **Using a ruler, locate and mark a vertical line down the center of the vase (see Figure 13-5).**

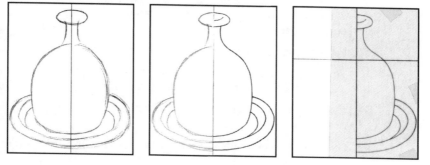

Figure 13-5: Using a line down the center to draw a symmetrical object.

3. **Choose one side of the vase, (whichever you prefer) and lighten your sketch lines with your kneaded eraser.**

4. **Refine this side of your drawing with nice, neat lines.**

5. **Erase the rough sketch on the other side of the drawing.**

6. **Use a ruler to draw a horizontal line across the vase perpendicular to the vertical line (wherever you want).**

7. **Tape tracing paper over the refined side of your drawing.**

 Don't put tape on your actual drawing surface because it may damage the surface when you remove it.

8. **Using a ruler and a 2B or 4B pencil, darkly trace the intersecting vertical and horizontal lines.**

9. **Trace all the curved lines of the vase with dark lines.**

Figure 13-6:
Tracing
paper helps
you draw
the second
half of the
symmetrical
object.

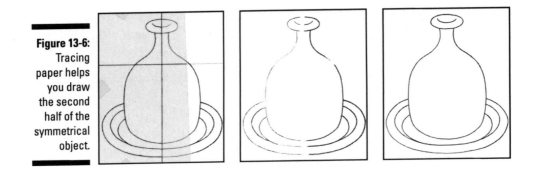

10. **Carefully remove your tracing paper and flip it over.**

 You now have a mirror image of half of the vase.

11. **Position the tracing paper on the missing half of your drawing, so the vertical and horizontal lines overlap one another, and tape the tracing paper in place (as in Figure 13-6).**

12. **Use a pencil or pen to go over each line of this half of the vase.**

 The drawing on the reverse side of your tracing paper serves as a carbon and allows you to transfer the image onto your drawing surface.

13. **Carefully remove your tracing paper and erase the horizontal and vertical lines.**

14. **Outline the lines a little darker to match the first side you drew.**

Lighting Your Still Life

In this section, I show you four photos of a little covered vase sitting in a dish under different lighting options. How you position the light source affects how three-dimensional or flat your subject appears.

If you have a specific artistic reason for wanting still life objects to look flat, instead of three-dimensional, try frontal or back lighting.

Find an object, a flat, white surface, and a portable light source. Place your object on the surface. Set up each of the following four lighting options and see which ones you prefer:

- ✔ **From above and slightly to the right (as in the first photo in Figure 13-7):** This traditional lighting option emphasizes the vase's shadows, highlights, and three-dimensional forms.

- ✔ **From the right and slightly below the object (as in the second photo in Figure 13-7):** This lighting option creates lots of contrast between highlights and shadows and also illustrates the vase's three-dimensional qualities. Look for reflected light on the edge of the shadow side of your object. (I tell you about light, shadows, and reflected light throughout Chapter 6.)

Figure 13-7:
Lighting above and below an object, and from the side, emphasizes the 3D qualities of the form.

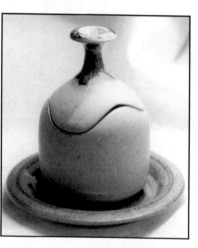
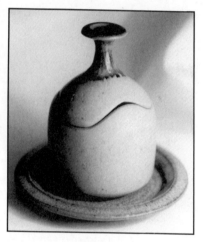

- ✔ **Strong light from behind (see Figure 13-8):** The silhouette presentation of back lighting provides a less detailed image because you see only the shadow side of the vase. Most of the object needs to be shaded with dark values.

- ✔ **Strong light on the front of your object (refer to the second photo in Figure 13-8):** The lack of visible shadows, which are out of your line of vision (behind the object), makes the object appear soft and flat. Frontal lighting is very common in photos where you use a flash.

TIP

Use photos only as reference tools and draw from actual objects, whenever possible. My photograph (the second photo in Figure 13-7) didn't capture the slight rim of reflected light that I could clearly see when I observed the shadow side of the actual vase.

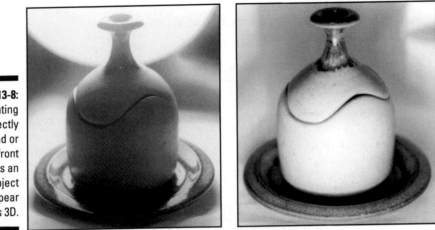

Figure 13-8:
Lighting from directly behind or in front makes an object appear less 3D.

Project 13: Drawing a Still Life

Choose a simple symmetrical drawing subject for this project. Take a tour of your home and see what catches your eye. For example, vases, flowerpots, and wine glasses make gorgeous drawings. Then follow these steps:

1. **Place your object on a flat surface.**

 Keep in mind that reflected light is more visible on most objects when they are sitting on a white or light-colored surface.

2. **Arrange your lighting however you want.**

 I use a high-powered halogen lamp as my light source, but feel free to improvise with whatever you have handy.

3. **Draw your object.**

 See "Drawing Symmetrical Objects" earlier in this chapter to see how you can use tracing paper and a ruler to help you. Refer to Chapters 6 and 7 for step-by-step instructions on drawing light and shadows.

Chapter 14

Saving the Joy of Flowers and Trees

In This Chapter

▶ Capturing flowers in drawings

▶ Appreciating the diverse personalities of trees

*I*n this chapter, you focus on the forms and textures of flowers from different perspectives. Discover the intriguing challenge of capturing the personalities of trees in drawings as you explore a diverse sampling of trees. I encourage you to find flower and tree "models" and try your hand at these sensitive and inspirational drawing subjects.

Making a Flower Last Forever

Plan an outing, find some floral models, and draw them from various perspectives. You can capture the grandeur of a massive sunflower, the delicacy of a simple daisy, and the intricate details of a rose. Do close-up detailed drawings of the textures and forms of the individual petals and leaves, which define their unique qualities.

Portraits of people simply don't look right if you draw the shapes of their noses wrong or put their eyes in the wrong place. Flowers are a little more forgiving. You can slightly modify the shapes of some petals, or position them less precisely, and your drawing still looks like a flower.

Sizing up Sunny, the sunflower

Majestic sunflowers have been longtime artistic models. They can grow taller than an adult, and the flower itself can be up to two feet across! You may be familiar with one of Vincent Van Gogh's most famous masterpieces, which just happens to be of sunflowers.

In Figure 14-1, meet Sunny, a gorgeous sunflower, whose seed decided to jump from a bird feeder into a flowerpot. My mom, Pamela Hoddinott, who is also an artist, took the photo I worked from. Compare the different textures of the bumpy center, the smooth petals, and the veins of the leaves.

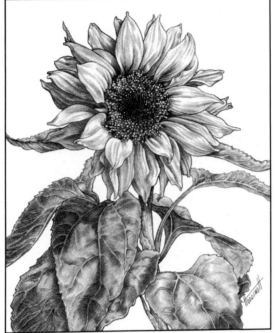

Figure 14-1: Capturing the different textures of the center, petals, and leaves in a sunflower.

Blossoming along with Rose

I think of drawings of flowers as portraits, because of their philosophical similarities to the physical and emotional growth of people. My favorite flower, a white rose, represents innocence, complexity, and benevolence. The outer petals of a rose surround its delicate inner form in an expressive, loving embrace, while the thorns of its stem offer protection.

Time to find your drawing supplies and draw a rosebud. My drawing is 5 x 6 inches, but you can use any size you want.

1. **Lightly sketch the outline of the shape of the rosebud and its leaves.**

 See the first drawing in Figure 14-2. With this light sketch, you want to place the rosebud within your drawing format.

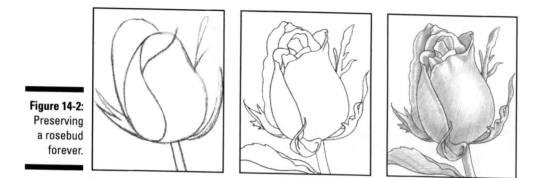

Figure 14-2:
Preserving
a rosebud
forever.

2. **Lighten your sketch lines and draw the rosebud with detailed lines.**

 Keep your lines light, because this drawing needs to be soft and delicate, and heavy black lines just won't do!

3. **Use hatching lines to add some light values.**

 I tell you how to shade with hatching and crosshatching in Chapter 7.

 Add some darker values with crosshatching and an HB or 2B pencil (see the first drawing in Figure 14-3).

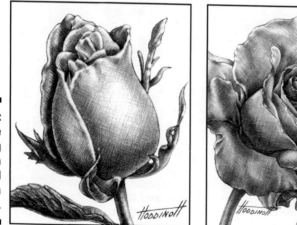

Figure 14-3:
Adding the
finishing
touches to a
rosebud and
examining a
mature rose.

In Figure 14-3, two drawings illustrate the journey of a rosebud to its full bloom as a mature rose.

You need to be familiar with flowers from all sides before you can accurately draw their forms. If you choose to work from photographs, make sure you have good lighting and take lots of pictures from different angles.

Examining and Drawing Trees

Each tree in nature is unique, and with careful observation, you can capture its distinctive personality in a drawing.

Beautiful, emotional, and inspirational drawings document the struggles of nature's miracles. You can bring your drawings beyond technically skilled renderings, toward powerful statements on life, by illustrating imperfections that offer a view into Mother Nature's vulnerability.

I saw the wonderful tree in Figure 14-4 beside a highway several years ago. It inspired me to stop, turn my car around, and go back to take some photos. In spite of its imminent death, tiny branches in the lower-right-hand corner cling valiantly to life. Notice how several branches overlap others as well as the main tree trunk in some places.

Note that the branches are not straight lines at right angles to one another. Examine the curving forms of each branch and the many sizes of V-shaped branches that make up a tree's construction.

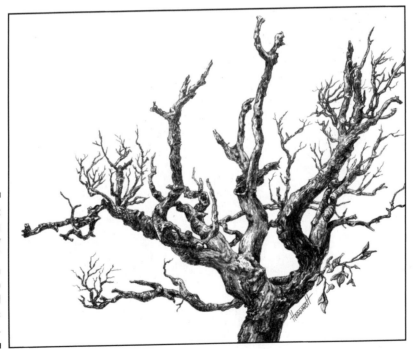

Figure 14-4:
Portraying seemingly "imperfect" trees can lead to powerful artistic statements.

If you can draw the letter *V*, you can draw realistic branches of trees. Grab your drawing materials and draw a simple tree branch.

1. Lightly sketch an outline of the main branches (see Figure 14-5).

The two thick vertical lines in a V-shape represent each of the main branches.

Figure 14-5:
Reducing
the
branches
of a tree to
several
V-shaped
lines.

2. Lighten your sketch lines with your kneaded eraser.

3. Fine-tune your initial drawing by using curved lines to join the branches together realistically, forming the overall shape of the tree.

In the second drawing in Figure 14-5, I adjust the shape of the tree by adding a more detailed outline.

4. Add lots of little V-shapes to represent the tiny branches of the tree.

The V-shaped branches become progressively smaller, shorter, and thinner the farther away they are from the main branch.

As with flowers, trees are very forgiving of needing to be rendered exactly. Be creative and choose certain aspects of a tree that accentuate the specific emotions you want to portray.

Project 14: Lovely Lily

In this project, I show you how to visually simplify the intricate details of a complex flower and draw its most important elements with simple lines. Then you add shading to depict its three-dimensional forms and personality.

1. **Draw a large oval to represent the main part of the flower.**

 Observe its tilted angle in the first drawing in the next set of two. Most flowers are based on circular shapes viewed at various angles.

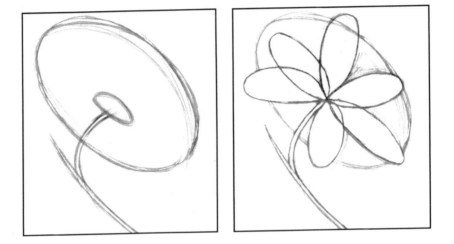

2. **Add a small ellipse inside the large one to mark the center of the lily.**

3. **Draw simple lines to represent the stem.**

 The lines of the main part of the stem angle from the lower right to the upper left. A secondary section of the stem breaks away, curves up and towards the upper-right corner of the drawing format. It connects with the center of the lily.

4. **Sketch in the six petals of the lily, with each one originating from the center of the small ellipse.**

 Some of the tips of the petals end inside the perimeter of the large ellipse, and others extend beyond it. Because you view them from different angles, several seem wide while others appear narrow, and a couple of them are short, whereas others are long.

5. **Use your kneaded eraser to lighten all your sketch lines.**

6. **Draw the shapes of each petal in more detail and add some thin leaves growing from the stem.**

 See the first drawing in the next set of two. Observe that some petals overlap others, which gives your flower a more realistic look. Note that the petals and leaves seem to curve in many different directions. Drawing them with curved lines achieves this illusion.

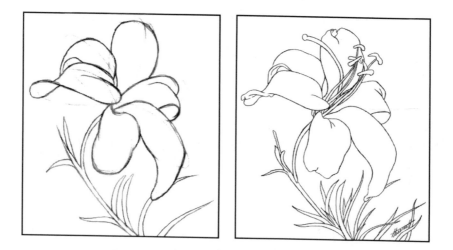

7. **Erase your rough sketch lines again until you can barely see them.**

8. **Draw a detailed line drawing of your lily with fine, crisp lines, using the faint sketch lines as references.**

 Begin by drawing the stamen (the long skinny thing) in the center of the lily. Don't forget to add a few more thin leaves growing from the lower section of the stem.

 The soft light source is from above in this drawing of Lovely Lily. I show you how to shade with hatching and crosshatching in Chapter 7.

9. **Add shading to the petals of the lily with hatching lines.**

 In the first drawing in the next set of two, I shade the petals with simple hatching lines that follow the contour of each petal.

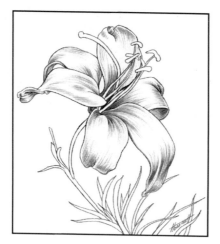 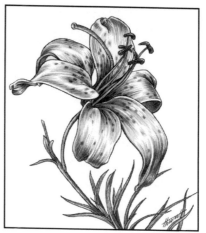

10. **Use crosshatching to shade in the leaves, stem, and stamen.**

 Don't miss those sections that are in shadow and have darker values than most other sections.

11. **Add some adorable little spots on the petals of Lovely Lily to give her extra personality!**

 Vary the shapes and sizes of the spots, and draw them various distances from one another, so they don't end up looking like polka dots. Shade the spots darker in darker areas and lighter in lighter areas.

Chapter 15

Documenting the World Outside

. .

In This Chapter

▶ Appreciating the various moods of the sky

▶ Exploring lands, oceans, and mountains

. .

Combine a love of the great outdoors with a knapsack full of drawing
supplies and you have all the ingredients for many hours of productive
fun. In this chapter, you take a short visual tour beyond your home to see
the world through the eyes of an artist.

Exploring Sky and Land

Many alluring, multifaceted treasures of nature beckon you to step outside
your home. The challenge of rendering intangible subjects has drawn many
artists upward to the sky.

Appreciating the many moods of skies

Each time you go outside, or peek through the windows of your home, take
time to closely observe cloud formations in the sky. Analyze their shapes and
forms and note the range of values in the clouds themselves and in the sky
beyond them.

In the next set of three drawings, I render the moods of three different skies:

> ✔ **Clear and calm:** The illusion of distance in a clear sky is created with
> atmospheric perspective (see Chapter 9). In the first drawing in Figure 15-1,
> the shading graduates from dark at the top of the sky to very light above
> the horizon line, thereby creating the illusion of depth in this warm,
> tranquil scene.

✔ **Stormy and angry:** In the second drawing in Figure 15-1, I illustrate the sky's power to portray ominous or angry emotions. The sky is dark, and lightning, bursting from the clouds, reflects on the surface of the water. A small section of a cloud reaches down toward the land with the potential destructive touch of a tornado.

✔ **Cloudy and picturesque:** The clouds in the third drawing in Figure 15-1 appear soft and gentle. However, the potential power of clouds to create changes in the weather should not be underestimated.

Figure 15-1:
The sky offers many moods that you can capture in your drawings.

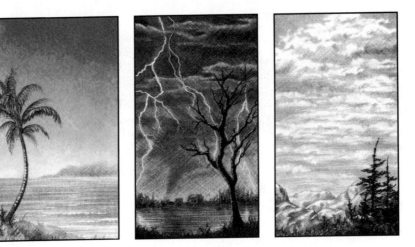

Think of clouds as three-dimensional objects and observe how the light from the sun defines their forms with highlights and shadows. (I show you how to draw three-dimensional forms in Chapter 6.) Of course, if the wind is blowing, you may need to draw quickly, because clouds constantly change their formations.

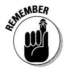

Perspective affects the forms of clouds in the same way as three-dimensional solid objects. (In Chapter 9, I tell you about perspective.) You can create the illusion that clouds near the horizon line are farther away than those directly overhead by drawing them smaller, closer together, and lighter in value.

Wandering throughout many lands

Wherever you live on this planet, the inherent beauties of unique landscapes are available as drawing subjects. You can even combine nature's creations with the structures of humans. You can render a scene exactly as you see it, creatively modify it, or use compelling parts of the scene to inspire a unique imaginary landscape from your mind.

Including people

Many artists choose to include some element of the existence of people in their drawings. You can include subtle references, such as a worn path through a wooded area, or footprints in snow or sand. More obvious objects, such as a birdbath, outdoor chair, buildings, or a canoe, can blend nicely and nonintrusively into many scenes. Actual persons who are absorbed in an activity, such as building a sand castle, can become focal points for your drawing compositions.

When you draw a scene as it is, you visually save wonderful memories for later reflection and enjoyment. During a vacation, I was mesmerized by the beauty of this gorgeous river scene (Figure 15-2), and I saved it as a drawing. The sun was powerful, and bright, as you can tell by the distinctive shadows on the grass under the chair. The presence of this chair invites you, the viewer of this drawing, into this serene landscape.

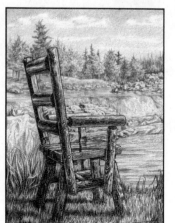

Figure 15-2:
Recording a discovered scene as a landscape.

Always feel comfortable using your creative abilities to rearrange, modify, or even completely change various components of subjects that inspire you!

Project 15: Dreaming of a White Winter

In this project, you draw by taking away rather than adding. You draw the light values with your erasers and the shadows with your charcoal pencil. You need drawing paper, vinyl and kneaded erasers, a stick of charcoal, some tissue or paper towel, and a charcoal pencil.

1. **Draw a rectangle, approximately 10 x 5 inches.**

2. **Shade in the whole space inside this rectangle with your stick of charcoal.**

 Use the side of your charcoal instead of the end — it's faster. Aim for a dark middle value at this stage, but expect this initial shading to become lighter after you blend it (see the next step).

3. **With a piece of paper towel or soft tissue, gently rub the whole surface until you have a solid tone.**

4. **Use your kneaded eraser to begin erasing or "pulling out" light areas.**

 I have "drawn" two hardwood trees on the left, a big one and a little one. On the right are three evergreen trees of different sizes. Because the light source is from the left, the trunks and branches of all the trees are lighter on the left. Don't forget the two light areas (snow) on the right and left covering the bases of the trees.

5. **With your kneaded eraser, draw more snow.**

 Take note, however, that the water and lots of shadow areas have been left the same dark value as the original charcoal shading.

6. **Lighten the sky with your kneaded eraser.**

 As I lighten the sky, I outline some trees in the background. By leaving this section (the line of trees) of the paper dark, the line of trees is well defined against the lighter values in the sky.

7. Switch to your vinyl eraser and use a sharp edge to pull out some whiter, brighter areas, such as the banks of the stream, and some more details on the trees.

8. Lighten the left side of all the trees a little more with the sharp edge of your vinyl eraser.

9. Use your vinyl eraser to lighten the areas of snow (which are not in shadow) on the ground and on the fir trees.

10. Add a third small trunk of a tree on the left.

11. Draw more branches on the hardwood trees with a sharp edge of your vinyl eraser.

12. Add some really bright details on the left sides of the hardwood trees to clearly define the edges of their trunks.

13. Use your vinyl eraser to add a few very white highlights to the snow on the ground and on the branches of the fir trees.

14. **Use a very sharp edge of your vinyl eraser to draw some thin white lines in the stream to look like ice.**

15. **Use your charcoal pencil to add darker details and shadows.**

16. **Add details, such as branches of trees, shadows under the banks of the stream, trees in the distance, and the texture of the tree trunks.**

 Touch up any areas you aren't happy with by adding (or taking away) more details.

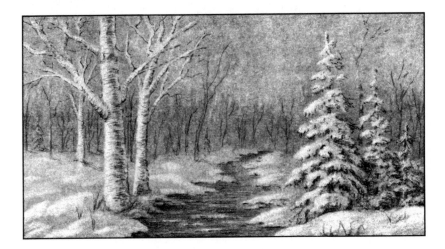

Chapter 16

Capturing Critters in Drawings

· ·

In This Chapter

▶ Shading fur and feathers with values and texture

▶ Bringing life into portraits of animals and birds

· ·

Since primitive man began drawing on the walls of caves, animals have remained a favorite subject for artists of all ages and abilities. You can discover lots of fuzzy friends to draw in your home, your favorite park, the local zoo, or a neighbor's garden.

Animals and birds rarely appreciate having their portraits drawn, so I encourage you to make quick sketches and take lots of photographs of potential subjects. I focus on pets and familiar birds in this chapter, because you are more likely to have access to domestic animals than wild ones.

Fashioning Furry, Fluffy, and Feathered

Most animals, birds, and other fuzzy friends are always fully dressed. Their fashion statements vary from critter to critter, come in a variety of fashionable patterns, and sometimes change with the seasons.

Some points to keep in mind when drawing fur or feathers include:

✔ Observe closely the direction in which the fur or feathers grow and draw your shading lines to follow these directions.

✔ Fur and feathers look much more realistic when the shading lines are different lengths and sizes.

✔ Use curved shading lines to define the form of a bird or animal.

✔ Pay special attention to light and shadows, as well as texture, when shading fur or feathers.

Identifying the long and short of fur

The furry coats of animals can be straight, curly, soft, coarse, shiny, matte, spotted, or striped! Keep the following guidelines in mind when drawing either short or long fur:

✔ To make fur look short, you draw short (mostly curved) hatching lines. Use long, curved hatching lines to create the illusion of long fur.

✔ Hatching is the perfect shading technique for rendering the texture of most types of fur. (I show you how to shade with hatching in Chapter 7.)

✔ Bold, thick lines give the illusion of coarse fur, and gentle, thin lines help fur to look soft.

Short fur

In Figure 16-1, meet Shadow, my daughter Heidi's dog. Shadow's fur is short, soft, and shiny. (I show you how to draw spotted fur in Chapter 8.) She sheds enough fur in one month to make a spotted fur coat for a bald Chihuahua!

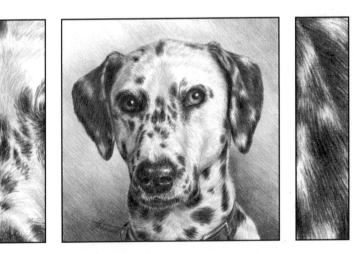

Figure 16-1: Drawing spotted fur involves lots of shading and a full range of values.

Look at how the shading of Shadow's short fur clearly defines the bone structure of her head and face. Observe the close-ups of the patterns of black spots on white fur, and white spots on black fur in Figure 16-1. The fur grows in many different directions. Look at all the different values, from white to medium, used to represent the light fur. A range of values from medium to black depicts the black fur.

In Figure 16-2 you see a combination of fur and feline facial features in a caricature of Riley. Riley is the proud owner of my friend Sherri. Have a look at how soft his fur looks and all the different directions in which it grows. Riley's fur is finer and softer than the fur of a Dalmatian. His eyes are drawn realistically, but I took artistic license with his nose by making it more of a button shape. This gives the drawing a cartoonlike impression, almost as if he were a stuffed toy.

Figure 16-2:
Drawing
short,
soft fur,
growing in a
number of
directions.

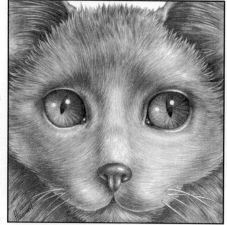

Long fur

Long fur tends to be somewhat more difficult to draw because the individual strands often curve in different directions and overlap one another.

In Figure 16-3 you see Rosey, my Soft-Coated Wheaton Terrier, who now lives at the Rainbow Bridge. She had very soft, slightly wavy fur and looked most adorable when her fur was wild and messy.

Long fur doesn't define the bone structure of an animal as well as short fur. But the contrasting shading of the light and shadow areas identifies the basic form of her head.

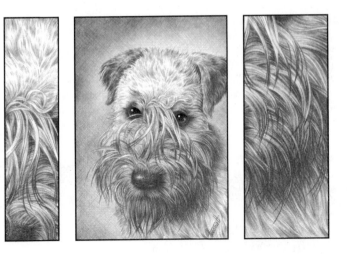

Figure 16-3:
Drawing
long, soft
fur on an
animal.

Drawing form beyond the furry texture

In this exercise, you draw the form of the leg and foot of a puppy with short fur. The same basic principles apply to drawing short fur on any part of an animal's body.

1. Lightly sketch the three shapes you see in Figure 16-4.

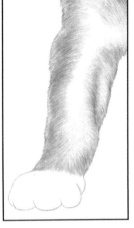

Figure 16-4:
Drawing
the shape
and basic
texture of a
furry leg.

The top shape is a section of the puppy's body, the longer one is his leg, and the horizontal oval shape at the bottom is his paw.

2. **Use your kneaded eraser to lighten your sketch lines and draw a more detailed outline.**

3. **With your HB pencil, begin shading the values you see with hatching lines to represent the texture of fur.**

Watch closely the direction in which the fur grows (see the third drawing in Figure 16-4). On the main part of the leg, it seems to grow downward in the center. As it gets closer to the edges of the leg, it curves outward at a downward angle to the edges of each side of the legs.

4. **Use your 2B pencil to darken the shading in the shadow areas of the leg (see Figure 16-5).**

Figure 16-5:
Adding
detail to the
furry form.

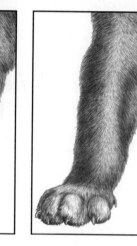
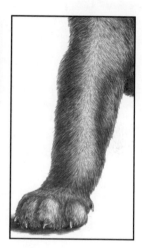

5. **Add the light shading on the paw, and outline the toenails on the toes (see the second drawing in Figure 16-5).**

6. **Add a section of dark fur where the top of the leg meets the chest.**

7. **Use your 2B pencil to add the dark shading to his paw and to draw the shadow under his paw (as in the third drawing in Figure 16-5).**

Flying ahead with winged things

In Figure 16-6, have a look at a drawing of a generic feather that I drew from my mind. Understanding an individual feather's basic shape and construction allows you to draw the many feathers of a wing with increased accuracy. The wide end of the shaft (the long skinny thing in the center) of a feather is called a *quill.* It has a hollow center, and many years ago, people dipped quills into ink and used them as writing tools.

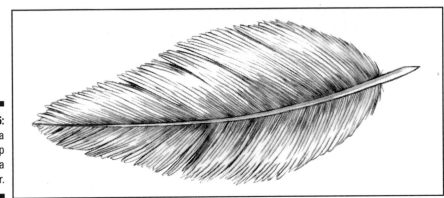

Figure 16-6:
Taking a
close-up
look at a
feather.

Wings come in a vast range of shapes and sizes, from the tiny delicate wings of a hummingbird to the magnificent strong wings of a bald eagle. In Figure 16-7, I show you the outline of a simple wing to provide you with an understanding of its construction. You can adapt the overall shape and construction of this wing to draw anything, from birds to angels, and from ferocious dragons to flying pigs!

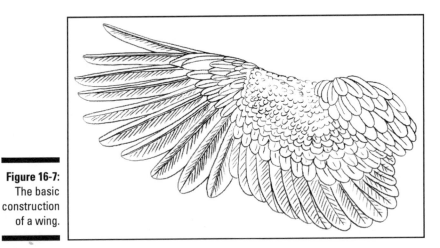

Figure 16-7:
The basic
construction
of a wing.

The texture of feathers can be shaded with a combination of curved hatching lines (helps larger feathers look realistic) and squirkles (works beautifully to illustrate tiny feathers). I show you how to shade with squirkles in Chapter 8.

Bringing Critters to Life in Portraits

With special attention to lighting, contrast, and texture, as well as some understanding of a critter's personality, drawings can become emotional and remarkable portraits.

A strong, dominant light source emphasizes the shapes and textures of birds or animals, defines the forms of their structures, and creates fascinating shadows. A contrasting balance of light and dark values, resulting from strong lighting, creates a powerful dramatic artwork. (I tell you more about contrast in Chapter 6.)

Without contrast, a drawing of a white bird on white paper has the potential of ending up rather boring. In Figure 16-8, I use a dark background behind the bird's white head and neck to make them stand out and become the focal points of the drawing. However, if this were a dark bird instead of a white one, I would use a much lighter background to provide contrast.

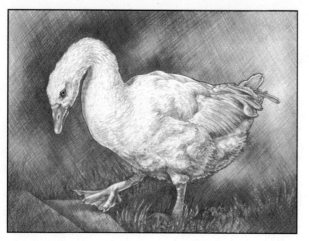

Figure 16-8: Using strong contrast to emphasize the head and neck of a bird.

In Figure 16-9, have a look at a soft, gentle drawing of a kitten named Fluffy, who was the childhood pet of my sister, Karen. Observe the following to see how I utilized contrast, lighting, and texture in this portrait:

✔ The contrasting values, used for the texture of her fur, create the illusion that she is striped.

✔ Diffused, soft lighting provides a peaceful mood and atmosphere. The mellow lighting effect was created by a cloudy day when the only light was from above.

✔ The shadows, created by the kitten and flowers, are in the lower section of the drawing. Her fur looks very soft and fluffy, in contrast to the dark values of the shadows.

✔ Her eyes are strongly emphasized with strong contrast in their shading. The location of the highlights in her eyes tells you that the lighting comes from above.

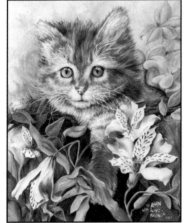

Figure 16-9:
This kitten was rendered with a soft, diffused light source from above.

Dogs seem to speak through their eyes. A special look can tell you that they are hungry, want you to play, or that they love you.

In Figure 16-10, meet Maggie Nexdoor, my neighbors' younger "daughter." Observe that the light source is from the right, and therefore her gorgeous, long fur appears to be darker on the left side of the drawing.

You can add more interest to portraits of animals by drawing them from an angle rather than front on. Maggie's head, shiny nose, and bright eyes are drawn at a slight angle. This perspective emphasizes her playful nature, as you are left wondering what she is looking at and why she is smiling.

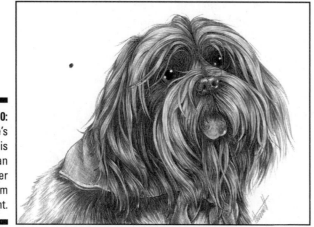

Project 16: Wings on the Water

Which came first, the chicken or the egg? Well, even though this is a swan,
not a chicken, you start this project by drawing an egg shape. Grab your
sketchbook, follow along with me, and draw a swan. Use a square format:

1. **Use a 2H pencil to very lightly draw an egg shape close to the bottom
 of your drawing space.**

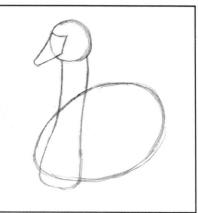

Leave room to add her long neck and head. Note that the smaller end of the egg shape is tipped downward toward the lower-left corner of your space. Keep your lines light, because they need to be erased later.

2. **Draw her neck.**

 Notice that the lower end of her neck (closer to the water) is wider than the top (where the neck joins her head).

3. **Add a small circle at the top of her neck for the head.**

4. **Draw in her bill (you may call it a beak).**

5. **Pat the surface of your drawing with your kneaded eraser to lighten all the sketch lines.**

6. **Use an HB pencil to draw the swan in detail.**

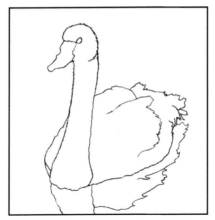 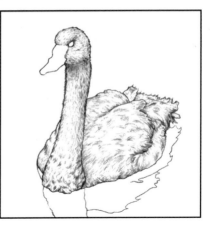

Add the outline of her bill and eye with smooth lines. Use fuzzy lines to draw the outline of her wings, those big beautiful tail feathers, and the reflection in the water. By drawing fuzzy lines rather than smooth ones, you outline the texture of her feathers.

7. **Use an HB pencil to lightly shade in the forms on her body and head with short hatching lines.**

 The light source is from the right, so the shading is darker on the left. Take note of the directions in which the feathers are growing.

8. **Add light shading to indicate the texture of feathers all over her body, wings, and tail.**

 Use squirkles for the areas with tiny feathers, such as her neck and face. Try curved hatching lines for the longer feathers of her wings and tail.

9. **Add more-detailed shading to the feathers on the swan's head (see the next set of two drawings).**

Observe the light areas (highlights) on the front of her head and her cheeks. Notice how the shading on her head defines the form of her head.

10. **Add more shading to the darker areas of her neck and body with a 2B pencil.**

Observe the dark shading on the top section of her neck directly under her cheek and on the right side of her neck. Take note that the feathers at the bottom of her neck (closer to the water) appear larger than those close to the top of her neck. This illusion is created by drawing longer, bolder, and darker curved hatching lines in this area.

11. **Shade in her bill, using a full range of values from light to dark.**

Take time to map out the highlights and the dark values before you begin to draw. (I tell you how to map out values in Chapter 7.)

12. **Draw the shading of her eye.**

The highlight stays white. Note that the shading is darker in the top section of her eye.

13. **Draw lots of very light, straight lines all through the background, parallel to the top and bottom of your drawing space.**

You're welcome to use a ruler. Calm water looks more realistic when the ripples are level, rather than tilted.

14. **Shade in the reflection of the swan in the water (see the next drawing).**

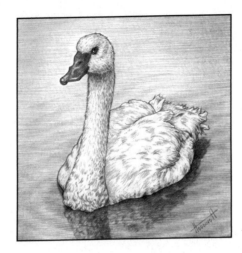

The water is shaded with hatching lines that run parallel to the top and bottom of the drawing space. Focus on the various values used to show the light and shadows. The shading is lighter in value closer to the top of the drawing space, but is a little darker closer to each side.

The ripples close to the swan are shaded to show she is moving through the water. The shading style is still parallel hatching lines, but different values define the circular ripples in the surface of the water.

15. **Use parallel hatching lines to draw in the water around the swan.**

Part IV
Drawing People

The 5th Wave — By Rich Tennant

In this part . . .

Time for dessert! Combine chocolate, vanilla, and caramel, and you have my favorite food, people! No, I don't eat people, but in staying with the food metaphors that I use to describe the other parts of this book, this almost makes sense. People come in all sorts of colors, sizes, shapes, and flavors (metaphorically speaking, of course). And speaking of flavors, you're not limited to thirty-one, as with ice cream. You can choose your drawing subjects from millions of individually beautiful and unique human faces and bodies.

Ice cream is much more fun to eat when it's topped with syrup and sprinkles. Drawing faces becomes even more delectable when topped with exciting extras, such as a hodgepodge of crazy hairstyles, a potpourri of facial expressions, a smattering of caricature ideas, and the investigation of how a human face ages. You can try your hand at drawing individual facial features, and finally put them all together to draw complete portraits.

I love drawing people, and so will you! Once you get past the intimidation element, and realize how simple it is to actually draw people, you're hooked!

Chapter 17

Baby, Look at You Now

· ·

In This Chapter

▶ Identifying the proportions of tiny heads and faces
▶ Sketching the endearing features of babies
▶ Observing the diversity of babies' hairstyles

· ·

From the tops of their heads to their big, innocent eyes, soft features, and tiny chins, infants' faces are fascinating. Babies are the easiest human subjects for drawing portraits, because there isn't a lot of detail in their faces. In this chapter, you discover the distinctive characteristics that define the precious faces of the littlest of people. I show you the simple structure of a baby's head, each of the features, and how to put them all together, like pieces of a puzzle.

Measuring Tiny Proportions

You can draw a baby's head and face with accurate proportions when you understand how to put all the various components in their proper places. Keep in mind however, that the "rules" of proportion are not carved in stone. The placement and size of some babies' features wander a little outside these suggested guidelines.

Looking at babies' heads

A young baby's head is less than half the size of an adult's, and the structure, shape, and proportions are also very different. A couple of terms to become familiar with are

✔ **Facial mass:** Refers to the facial area of a human head.

✔ **Cranial mass:** The main area of the head including the skull.

Many beginners make a baby's face too big in proportion to the size of the skull. An adult face is half the size of the adult cranial mass. However, a baby's face is approximately one-third the size of his or her cranial mass.

The two drawings in Figure 17-1 are by no means an accurate measuring technique. But they illustrate beautifully how tiny a baby's face actually is in proportion to its cranium, when compared to that of an adult.

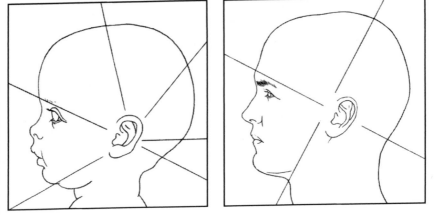

Figure 17-1:
Comparing the cranial and facial masses of babies and adults.

The baby's head (excluding the neck section) is divided into four full sections and another half section (see the first drawing in Figure 17-1). The face is one section and the cranial mass takes up all the rest of the shape. A baby's head is more than three times larger than his or her face.

The adult head (as in the second drawing in Figure 17-1) is divided into three pieces (excluding the neck). The face is one piece, and the cranial mass is two pieces. The adult's cranial mass is twice the size of his face.

Proportions of the face

The next time you see a baby, take time to closely examine the head and the proportions of his or her features. First of all, look at how tiny his or her facial mass is compared to the size of the cranial mass. Check out the locations of the eyes, nose, mouth, and ears. Also note how tiny an infant's neck

is compared to the size of the head. No need to wonder why young infants can't hold their heads up by themselves!

At its widest point, a baby's face is "five eyes" wide. The width of the space between the eyes is a tiny bit more than the width of an eye. Both the nose and mouth are the same width as an eye, or the space between the eyes.

Horizontal proportions

Horizontal facial proportions are easy to remember if you think of them in terms of three halves (and if you are a math major, I expect you are cringing at the thought of three halves!).

Look closely at the two drawings of babies' faces in Figure 17-2. The heads are different shapes, but the same proportions apply to each. I add four horizontal lines, AB, CD, EF, and GH, to better explain what goes where:

- ✔ **Line AB:** Halfway between the top of the head and the bottom of the chin (line GH). Touching this line are the tops of the ears and the tops of the upper eyelids.

- ✔ **Line CD:** Halfway between line AB and the bottom of the chin (line GH). On this line you find the bottoms of the ears and the bottom of the nose.

- ✔ **Line EF:** Halfway between lines CD and GH. Along this line is the bottom of the lower lip.

- ✔ **Line GH:** Identifies the bottom of the bone in the chin (lower jaw), not the bottom of the soft tissue under the chin. Keep in mind that infants often have what is commonly called a double chin.

Figure 17-2:
Laying
out the
horizontal
proportions
of babies'
faces.

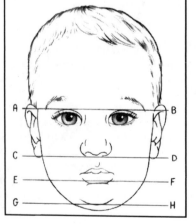
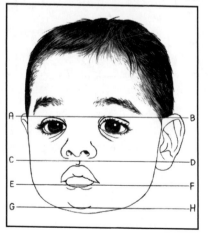

Vertical proportions

Simple guidelines for proportion apply to the vertical placement of a baby's facial features (see Figure 17-3). The face is divided vertically into five equal distances. I illustrate two different babies to show how the same rules apply. Lines IJ, KL, MN, OP, QR, and ST help you understand the following proportions:

- **Line IJ:** Marks the widest point of the right side of the face.

- **Line KL:** Identifies the outer corner of each baby's right eye.

- **Line MN:** Shows the placement of the inside corner of the right eye, the right edge of the nose, and the right corner of the mouth.

- **Line OP:** Identifies the inside edge of the baby's left eye, the left edge of the nose, and the corner of the left side of the mouth.

- **Line QR:** Is the outer edge of the each baby's left eye.

- **Line ST:** Marks the widest point on the left side of the baby's face.

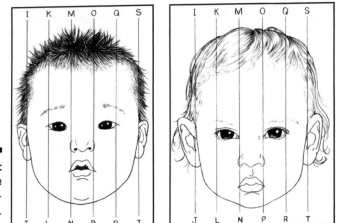

Figure 17-3: Placing the vertical proportions.

As the face matures

During the first two years of life, the human face grows very quickly and undergoes drastic changes, as my daughter Heidi shows in Figure 17-4.

In the first drawing she's a very young infant. Her eyebrows are very light, she has very little hair, and her face is very tiny. By age 1 (the second drawing), the lower section of her face has developed to allow room for a few teeth. By age 2, her jaw has developed to accommodate more teeth. As she becomes older, her eyebrows darken, and her hair grows thicker.

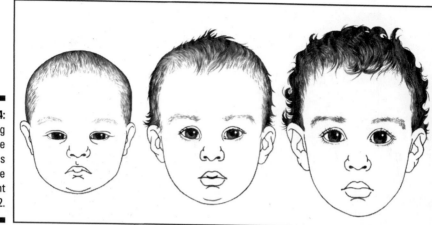

Figure 17-4:
Clocking in the changes of a face from infant to age 2.

Teeny, Tiny Faces and Soft, Fuzzy Hair

If the individual features of babies weren't very different from one another, all babies would look identical! In this section, you explore individual features and unique hairstyles.

Seeing how to draw a baby's eye

The eye of an infant is shaped differently from that of a child, but the shading techniques are the same. Refer to "Drawing the eye of a child," in Chapter 18, for detailed instructions on shading the eye of a child. I show you how to do crosshatching in Chapter 7.

1. **Draw an almond shape (see Figure 17-5).**

 This shape outlines the perimeter of the upper and lower eyelids. Inside this shape are the whites of the eyes, the irises, and the pupils.

2. **Add a tiny half circle to the inner corner of the eye (on the left).**

3. **Draw a curved line that begins on the left, below the inner corner of the eye. Extend it up and to the right, above the almond shape, all the way to the far right.**

4. **Add the iris, pupil, and two (or one if you prefer) tiny circles for the highlights (see the second drawing in Figure 17-5).**

 The iris is not a complete circle because the top and bottom are hidden underneath the upper and lower eyelids.

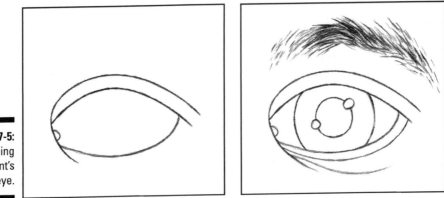

Figure 17-5:
Sketching
an infant's
eye.

5. **Draw the eyebrow.**

 Draw in the same directions in which the hairs in the eyebrow grow.

6. **Draw lines to represent the outside edge of the lower eyelid and a crease under the eye.**

7. **Use crosshatching to add shading around the eye (see Figure 17-6).**

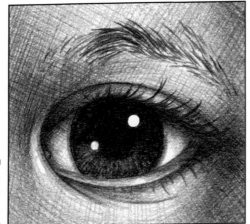

Figure 17-6:
Shading an
infant's eye.

 The shading helps to recess the eye into the eye socket, giving a very realistic form.

8. **Shade the white of the eye under the upper eyelid, the iris, and the pupil.**

 The iris is a little lighter on the side opposite the larger highlight.

9. **Add a few eyelashes, matching the direction in which they curve.**

Measuring the body proportions of babies

Artists use either the width or the length of a person's head (excluding his or her hair) as a unit of measurement for the human figure. The distance from the top of the head down to the chin provides the measurement unit for vertical proportions. Children's heads grow more quickly between birth and three years than at any other time in their lives. Therefore, the measuring unit of a "head" constantly gets larger as the child gets older.

The most noticeable changes in body proportions occur during the first three years of life. At birth, infants usually measure between three and a half and four heads tall. Their legs seem short, and their abdomens look big because their organs are disproportionately large. By the time infants reach one year of age, they measure approximately four heads tall. They appear rather chubby, with large abdomens, long torsos, and short bowed legs. At two, babies are around four and a half heads tall, and their legs have grown considerably. By three, toddlers reach a height of five heads. Their legs are the fastest-growing part of their bodies.

Drawing an adorable, little button nose

The form of a baby's nose is simply a large ball in the center, with two small overlapping balls on either side. In this exercise, have a ball(s) drawing a baby's nose.

1. **Draw a large circle with two smaller ones on both sides of it (see the first drawing in Figure 17-7).**

 The smaller circles overlap the large circle and are slightly below it.

Figure 17-7:
Rendering an infant's nose, which is a series of circles.

2. **Add the outline of the shape of the nose and the nostrils (see the second illustration in Figure 17-7).**

3. **Lighten your lines with a kneaded eraser, and use the third drawing in Figure 17-7 as a guide, to shade in the nose with crosshatching.**

REMEMBER

Drawing babies' facial proportions

At its widest point, a baby's face is "five eyes" wide. The width of the space between the eyes is a tiny bit more than the width of an eye.

Both the nose and mouth are the same width as an eye, or the space between the eyes.

The bridge of an infant's nose is barely noticeable. Note the positions of the highlights, reflected light, and the dark shadow areas. See Chapter 6 to see how I shade in spheres with highlights and reflected light.

TIP

SKETCHBOOK

Sketching the precious mouth of a baby

The upper lip of a baby's mouth can be simplified as three circular shapes, and the lower lip is divided into two circular shapes.

1. **Draw the five circular shapes that you see in the first drawing in Figure 17-8.**

 Keep your lines light, because you need to erase them later. In the upper lip, the circle in the middle is a little larger, and the two smaller circles are a little lower than the bigger one.

Figure 17-8:
Circling
in on the
upper and
lower lips.

In the lower lip, the circles don't touch the top center circle, leaving a space in the center of the five circles.

2. **Use your kneaded eraser to lighten the lines of your five circles.**

3. **Very lightly outline the upper and lower lips, touching the perimeter of the circles as shown in the second illustration in Figure 17-8.**

 The two upper circles (on both sides of the bigger one) are cut into by the line that defines the lower edge of the upper lip.

4. **Use your HB pencil to shade the forms of the five circles (see the first drawing in Figure 17-9).**

Figure 17-9:
Shading the
mouth.

Assume the light source comes from the right and take note of the highlights on each circle. Refer to Chapter 6 to discover how to transform a circle into a three-dimensional sphere.

5. **Shade in the areas of the lips that are not part of the circles a little darker.**

6. **Use a darker pencil to shade the opening of the mouth (the space between the lips).**

7. **Erase the lines around the perimeter of the lips with your kneaded eraser until they are barely noticeable (see the second drawing in Figure 17-9).**

 If you can still see the lines around the five circles, pat them gently with a pointed tip of your kneaded eraser until they are very faint.

8. **Use graduated crosshatching to smooth out the shading of the lips.**

 I show you how to shade with graduated crosshatching in "Graduating values with crosshatching," in Chapter 7.

9. **Shade in the forms of the face around the mouth.**

 I use a variety of different values, and I leave the highlight areas white. The light comes from the right, so the shading is darker on the left.

Drawing a baby's ear

The ears of babies come in all shapes and sizes and often appear too large for their tiny faces. But as babies get older, and their faces mature, they do grow into them!

Ears are the hardest part of a portrait to draw. The ear is complex, but if you break it down into four parts, it's somewhat easier to understand. Follow along with step-by-step instructions to draw a three-quarter view of an ear:

1. **Draw a long oval shape slightly tilted to the left at the bottom (see the first drawing in Figure 17-10).**

2. **Lightly sketch the four sections of the ear (as in the second drawing in Figure 17-10).**

 The *ear canal* is the opening to the inner ear. I discuss it in this project, but because of the angle of this ear, you don't draw it.

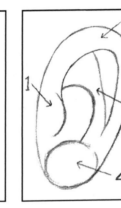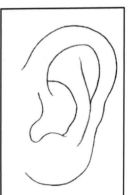

Figure 17-10:
Simplifying the complex shape of a baby's ear.

In the second drawing in Figure 17-10, I number the four sections of the ear that you draw. Each has a fancy name, which I won't bore you with, but you need to remember the simple terms that I use:

- **Small lobe (1):** The little round form where the ear joins the face. You find it over the opening to the ear canal. It joins the earlobe at the front of the ear.

- **Outer rim (2):** The wide rim along the outside edge of the ear that joins the earlobe at the back of the ear.

- **Inner rim (3):** The smaller rim that circles the back of the opening to the ear canal.

- **Earlobe (4):** The soft, fleshy part of the ear, to which lots of people like to attach earrings.

3. **Lighten your sketch lines, by patting them with your kneaded eraser, and redraw the shapes of the ear with neat lines (see the third drawing in Figure 17-10).**

 I give the ear some personality by refining most of the shapes of the lines. For example, the inside edge of the outer rim curves toward the opening to the ear canal in the front; the outer edge of the inside rim overlaps the outer rim close to the earlobe. I also join the small lobe to the earlobe with a curved line.

4. **With patience and an HB pencil, complete the shading of the ear.**

 Have a look at the first drawing in Figure 17-11, which shows some nice highlights on the outer and inner rims, the small lobe, and the earlobe. Observe how dark the shading is behind the small lobe. This is the location of the opening to the ear canal.

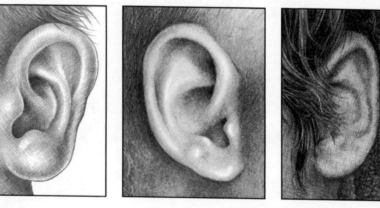

Figure 17-11:
Adding
highlights
and shading
to the ear.

In Figure 17-11, the first and third drawings show three-quarter views. Note their different shapes. Some experts believe that ears are as unique as fingerprints and that no two look exactly the same. In the second drawing, I show you a frontal view of a baby's ear, so you can more clearly see the location of the opening to the ear canal.

Babying hair, less is more

The diverse hairstyles of babies range from completely bald to a full head of thick, curly, or straight hair. Take a moment and look at all the different hairstyles of babies in the drawings throughout this chapter.

Resist the temptation to make a baby's hair too thick or full. When it comes to babies, the old expression "less is more" applies nicely. Too much hair in a drawing can make the baby look older than his or her actual age.

In Figure 17-12, you see six cartoons of babies, each modeling a different hairstyle. Pull out your drawing supplies and have some fun drawing more cartoon babies. Try and come up with a completely different hairstyle for each little face you create.

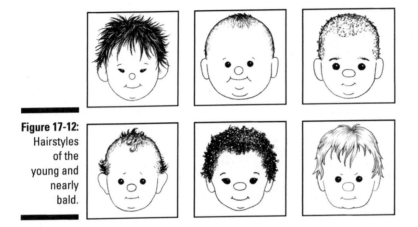

Figure 17-12:
Hairstyles
of the
young and
nearly
bald.

Putting the features and hair together

In Figure 17-13, I show you a profile drawing of my nephew, Colin, so you can see all the different parts of a baby's head and face combined in a portrait.

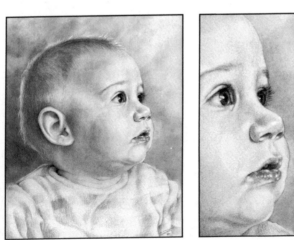

Figure 17-13:
Eyes, nose,
mouth, ears,
and hair
come
together to
become
a portrait
of a baby.

Soft lighting works best for portraits of young children. This drawing is done from a photograph taken without a flash, as he looked toward a bright, sunny window. This choice of lighting illuminates his face and accentuates an intro- spective facial expression. Although most of the shading ranges from light to medium, I make his eyes stand out by using really dark values.

Project 17: Baby Brandon

Time for you to draw a complete portrait of a baby's face! In this project, you draw my beautiful grandson, Brandon. Feel free to use the instructions to draw another baby in a similar pose.

1. **With your HB pencil and your ruler, draw a rectangle and divide it into 24 squares.**

 If you draw 2-inch squares, your drawing ends up 8 x 12, which is a great size for this drawing. Remember to press very lightly with your pencil, because some lines need to be lightened or erased later.

2. **Drawing one square at a time, lightly sketch the perimeter of the head and ear with your HB pencil.**

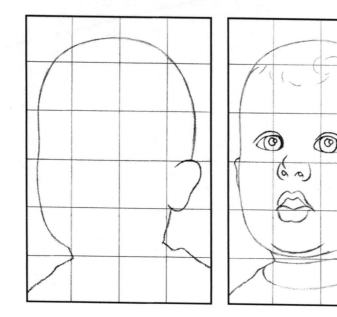

3. With your HB pencil, draw the outlines of the perimeter of the eyes and the upper eyelids.

4. Draw in the three circular shapes for the irises, pupils, and the highlights of the eyes.

5. Draw in the outlines of the nose and mouth.

6. Add the details of the ear on the right and the small visible section of the ear on the left.

7. Draw the two curved lines which indicate a double chin.

8. With your HB pencil draw light lines to indicate the hairline.

9. Draw the outline of the clothing.

10. Erase the grid lines on your drawing.

11. Beginning at the forehead and slowly progressing down the face to the chin and neck, draw the shading on the face.

12. Add shading to the side of the nose and the nostrils.

13. Add a little shading to the white of the eye and eyebrows.

Note the shadow under the upper eyelid and that the shading is darker on the eye on the left (further away from the light source).

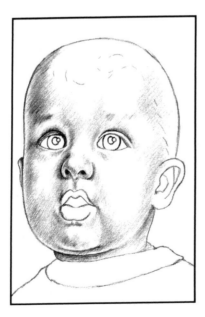 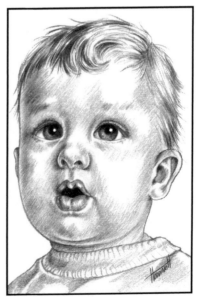

14. **Shade in the iris with your HB, and use a 6B to shade in the pupil.**

 The iris is darker on the side with the highlight and directly under the upper eyelid.

15. **Shade in the lips with your HB pencil, and the shadow area of the inside of the opening of the mouth with your 2B pencil.**

 Drawing lines around lips is acceptable for a beginner, but is not technically correct. In "Sketching the precious mouth of a baby," earlier in this chapter, I show you how to draw lips without lines.

16. **Add shading to the ears.**

 I simplified the ears for this project. To draw an anatomically correct ear, go to "Drawing a baby's ear," earlier in this chapter.

17. **With your kneaded eraser, lighten the outline of the skull and then draw the hair.**

 Less is more when drawing the fine, thin hair of babies. Take note of the wispy strands of hair that overlap the top of the ear. Note that the hair is darker on the left side. Remember to keep white areas throughout the hair as highlights.

18. **Draw very lightly the ribbing of the neck of the sweater, and add shading mainly to the left side of the clothing.**

Chapter 18

Celebrating Childhood's Innocence

In This Chapter

▶ Exploring a child's growing face

▶ Portraying the distinctive features of children

▶ Planning creative portraits of young people

Many artists struggle with getting a portrait of a child to look the right age. By using adult facial proportions, you end up with a portrait of a miniadult, rather than of a child. With careful observation of children, you begin to notice distinctive differences.

In this chapter, I discuss the changes in facial anatomy that occur as a child grows from a toddler to an adolescent, and I tell you how to apply this information to your drawings.

Growing Faces from Toddlers to Teens

Getting portraits of children to look young enough tends to be the most common frustration of portrait artists. You can draw children more accurately when you understand the changing structure of their faces at different ages.

Measuring children's facial proportions

From toddlers to adolescents, children's facial masses grow proportionately more quickly than their cranial masses. (I tell you about facial and cranial

masses in Chapter 17.) Children don't reach the adult proportions of the cranial and facial masses until their early teens.

In Figure 18-1, you see four simple line drawings of children, from a toddler (age 2 to 4) to a young teen (age 13 to 14). I draw three lines to help you understand how a child's face grows:

- ✔ The upper line marks the top of the head.
- ✔ The centerline indicates the placement of the eyes.
- ✔ The bottom line shows the location of the bottom of an adult face.

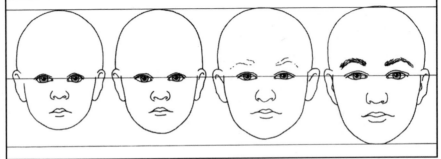

Figure 18-1: The growing face of a child changes in proportion with age.

Children's faces follow slightly different rules of proportion at different ages, but some guidelines loosely apply to all ages. Have another look at Figure 18-1 and take note of the following:

- ✔ The upper half of the irises is on, or slightly below, the halfway point between the top of the head and the chin. Beginners often place the eyes too high on the head.
- ✔ The nostrils of a child's nose are above the halfway point, between their eyes and chin.
- ✔ The bottom edge of the lower lip lies above the halfway point between the nostrils and the chin.
- ✔ The width of a child's head, at its widest point, is "five eyes" wide.
- ✔ The nose is approximately the width of the space between the eyes.

The facial proportions of young children, ages 5 to 7 (the first drawing in Figure 18-2) are closer to those of babies than adults. By the time a child approaches his or her teens, ages 11 to 12 (the second drawing in Figure 18-2), the facial proportions are closer to those of an adult. (I tell you about adult facial proportions in Chapter 19.)

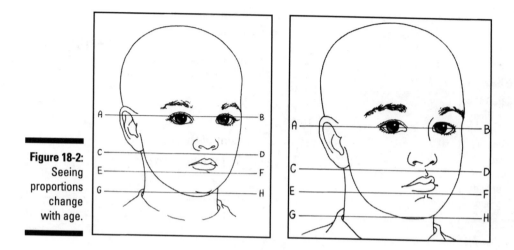

Figure 18-2:
Seeing
proportions
change
with age.

In Figure 18-2, please note the following:

- ✔ **Line AB:** Halfway between the top of the head and the bottom of the chin (line GH). The tops of the ears touch this line. A large portion of the eyes of younger children lies below this line. In a preteen, the eyes are closer to the center of this horizontal halfway point on the face.

- ✔ **Line CD:** Halfway between line AB and the bottom of the chin (line GH). Slightly above this line you find the bottoms of the ears and the bottom of the nose. However, the nose is lower on the face and closer to this line in a preteen than in a young child.

- ✔ **Line EF:** Halfway between lines CD and GH. Slightly above this line is the bottom of the lower lip. The preteen's mouth is lower on his face than the younger child.

- ✔ **Line GH:** Identifies the bottom of the chin. The "baby fat" below the chin is almost gone in the preteen, and the face is more clearly defined.

Comparing distinctive characteristics

Have a look at the three illustrations of my son, Ben, in Figure 18-3, when he was little. The irises are close to the same size in all three drawings. The toddler's eyes may even look larger, because the eye opening is smaller (not much of the white of the eye is showing), and the facial proportions are smaller.

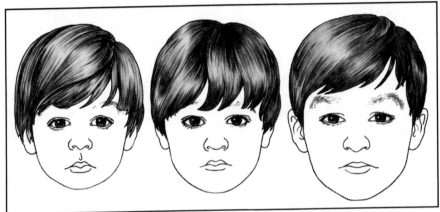

Figure 18-3: Defining physical characteristics in three different age groups.

In addition to children's eyes seeming larger, and their facial masses being smaller proportionately than adults, other characteristics help define age:

✔ **Toddler (age 2 to 4):** Toddlers' eyelashes seem long and their eyebrows are still light. Their cheeks are full and rounded, and their chins are very tiny. The facial proportions are similar to those of babies.

I find the eyes to be the most valuable feature for depicting the accurate age of a child. The irises of human eyes grow very little after age 2. The iris of a toddler is almost as large as that of an adult. In portraits of children, I always draw the irises a little larger than they actually are to exaggerate this characteristic.

✔ **Young child (age 5 to 7):** The individual features grow larger, and more of the whites of the eyes become visible as the child gets older (see the second drawing in Figure 18-3). Both the nose and mouth appear lower on the face.

✔ **Older child (age 8 to 12):** In the preteen years, the nose continues to grow longer, and as the jaw develops, the mouth also appears lower on the face (see the third drawing in Figure 18-3). The chin becomes longer, and the overall structure of the face is more defined.

✔ **Adolescent (age 13 to 14):** When a child reaches adolescence, his or her facial proportions are close to those of an adult. In Figure 18-4, two portraits (frontal and profile), of my former student and current friend, Mike, demonstrate the facial characteristics of a typical 14-year-old.

The proportions of his facial mass to cranial mass are the same as an adult's. His nose tip is still rounded, like a younger child, but the bridge of his nose is now well defined. His jaw and chin are still rounded and will continue to develop for a few more years, but his Adam's apple is now visible, and facial hair will soon become noticeable.

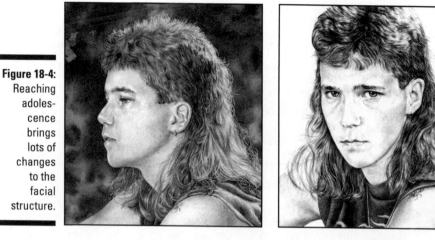

Figure 18-4: Reaching adolescence brings lots of changes to the facial structure.

Focusing on Children's Facial Features

When you understand the construction of the individual facial features of a child, they easily come together to form a whole face.

Drawing the eye of a child

The iris is almost round in this drawing, but keep in mind that an iris visually changes shape from a circle to an oval (an ellipse) with the changing angle of the head; the iris is rarely perfectly round.

1. **Draw the outline of the upper and lower eyelids, the iris, and the inner corner of the eye (see the first drawing in Figure 18-5).**

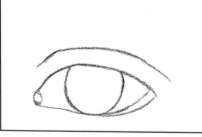 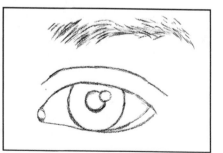

Figure 18-5: Drawing the first few lines of a child's eye.

The top of the iris is hidden under the upper eyelid. Draw your lines lightly, so they can easily be lightened later.

2. **Sketch the eyebrows lightly (see the second drawing in Figure 18-5).**

 Children's eyebrows are usually very light.

3. **Draw the pupil and the highlight.**

 Make sure the distance between the outline of the iris and the outline of the pupil is equal on both sides and the bottom. Note that the pupil is closer to the upper eyelid.

4. **Use your kneaded eraser to lighten all your lines.**

5. **Very lightly begin shading the areas around the eye.**

 Look very closely at the shading in the first drawing in Figure 18-6. Carefully placed shading with crosshatching fools the observer's eye into thinking that there's a line defining the upper-eyelid crease.

Figure 18-6: Shading the eye and surrounding area and adding the lashes.

 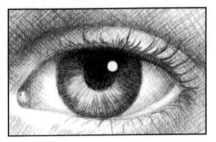

6. **Shade in the iris and the pupil (refer to the second drawing in Figure 18-6).**

 The shading lines on the iris all seem to point toward the center, and they are darker under the upper eyelid and on the highlight side.

7. **With your HB pencil, draw only half as many eyelashes as you think there should be.**

 Drawing eyelashes incorrectly can ruin your drawing. Many beginners make the lashes too long, too straight, or too thick. Look closely at the eyelashes in the second drawing in Figure 18-6. Note that they grow in many different directions, are different lengths, and are curved. They also appear thicker closer to the eyelids and grow from the outer edges of the upper and lower eyelids, and not the white of the eye.

8. **Add shading to the white of the eye in the corners and under the lid.**

 Very light shading in the white of the eye under the upper eyelid and toward both corners helps make the eye look three-dimensional.

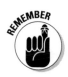

To make an area lighter, pat gently with the pointed tip of your kneaded eraser. To make an area darker, add more lines with your pencil.

Rendering the forms of a child's nose

The basic shape of a child's nose is a large oval in the center, with two smaller ovals on both sides.

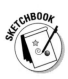

1. **Draw a large oval with two smaller ones on both sides of it, as you see in the first drawing in Figure 18-7.**

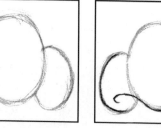
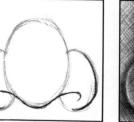
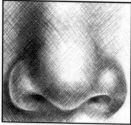

Figure 18-7: Making a child's nose take shape.

The smaller ovals cut into the larger one and are slightly below it.

2. **Add the outline of the shape of the nose and the nostrils (see the second illustration in Figure 18-7).**

3. **Lighten your lines with a kneaded eraser, and use the third drawing as a guide, to shade in the nose with crosshatching.**

Note the positions of the highlights, reflected light, and the dark shadow areas. Check Chapter 6 to see how I shade in spheres with highlights and reflected light.

Structuring the developing mouth

In the next two drawings of a child's mouth, note that the upper lip is defined with three oval forms, and that the lower lip is divided into two oval forms.

1. **Draw the five oval shapes you see inside the lip line in the first drawing in Figure 18-8.**

Keep your lines light because you need to erase them later.

2. **Use your kneaded eraser to lighten the lines of your five ovals.**

As the body grows from childhood to adolescence

Individual children experience different rates of growth, and their body proportions change at various stages of development. When you observe groups of children of the same age, you see very diverse body structures, including short, tall, chubby, thin, muscular, and slender.

The length of a child's head (excluding hair) is used as a unit of measurement for the height.

Keep in mind that the measuring unit of a "head" constantly gets larger as children grow older. By three, toddlers reach a height of five heads. (See Chapter 17 to find out more about the body proportions of infants and young children.) By adolescence, children's body proportions closely resemble those of adults. (I tell you about adult body proportions in Chapter 19.)

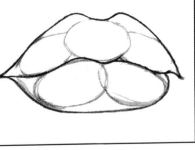 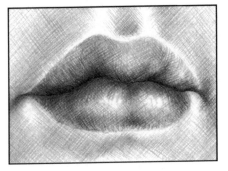

Figure 18-8: Drawing a child's mouth in a series of shaded circles.

3. **Outline the upper and lower lips so your lines touch the perimeter of the ovals.**

4. **Use your HB pencil to shade the forms of the five ovals (as shown in the second drawing in Figure 18-8).**

 Assume the light source is from the right. Take note of the highlights on each circle. Refer to Chapter 6 to discover how to transform a circle into a three-dimensional sphere.

5. **Shade in the areas of the lips that are not part of the ovals a little darker.**

 This darker shading makes the oval forms stand out more clearly.

6. **Use shading (not a hard line) and a darker pencil to shade the dark values of the opening of the mouth.**

7. **Erase the lines around the perimeter of the lips with your kneaded eraser, until they are barely noticeable.**

If you can still see the lines around the five ovals, pat them gently with a pointed tip of your kneaded eraser until they are very faint.

8. **Use graduated crosshatching (or hatching if you prefer) to smooth out the shading of the lips.**

9. **Shade in the forms of the face around the mouth.**

 Observe closely the different values and the areas that are left white. The light is coming from the right, so the shading is a little darker on the left.

Portraying a child's ear from the front

The ears of children come in all shapes and sizes. Ears are the hardest part of a portrait to draw, but when broken down into four parts, it's somewhat easier to understand. Most portraits are frontal views of faces. Gather your drawing supplies, and follow along with my step-by-step instructions to draw a child's ear as viewed from a frontal facial perspective:

1. **Draw a long oval shape (see the first drawing in Figure 18-9).**

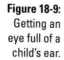

Figure 18-9: Getting an eye full of a child's ear.

2. **Lightly sketch the four sections of the ear (as in the second drawing in Figure 18-9).**

 Refer to Chapter 17 to become familiar with the names of each part of the ear.

3. **Lighten your sketch lines with your kneaded eraser and redraw the shapes of the ear with neat lines (as in the third illustration in Figure 18-9).**

4. **With patience and an HB pencil, complete the shading of the ear (refer to the fourth drawing in Figure 18-9).**

 The highlights on the outer and inner rims, the small lobe, and the ear-lobe remain white. Observe the dark shading behind the small lobe that marks the opening to the ear canal.

Planning a Portrait of a Young Person

Taking the time to get to know your subject before you begin a portrait opens many creative doorways. You can bring a portrait beyond a skillful rendering of physical forms to include unique aspects of the child's personality, or original concepts from your imagination. Planning a successful portrait and creating a strong likeness of your subject depends on:

- ✔ Accurately rendering each feature in relation to the overall shape and size of his or her head.

- ✔ Having the size and shape of each feature proportionately correct in relation to the spaces on the face.

- ✔ Identifying and rendering the distinctive and unique characteristics of your subject's face.

- ✔ Choosing a light source that best defines the physical presence, the personality, and the age of your subject. For example, a young child may need to be rendered within a very soft lighting environment.

- ✔ Taking note of the subtleties of the natural facial expressions and posture of your subject, such as the way he or she tilts his or her head when sitting or standing comfortably.

- ✔ Choosing props, such as clothing, favorite hair decorations, or toys, which represent the child's interests and personality. By adding objects that define an individual child, your drawing has the power to transcend into an emotional work of art.

- ✔ Correctly rendering the texture and style of the child's hair, taking into consideration such things as whether it is long or short, light or dark, or straight or curly. Keep in mind that even straight hair must be drawn with curved lines that follow the contour of his or her head.

Have a look at the precious little face in Figure 18-10. I did this drawing from my memory of a little girl I saw shyly peeking out at me from behind her mom in a store (I discuss drawing from your memory in Chapter 12). It's unlikely that I captured her features accurately, but this wasn't important. I wanted to capture her expression of shy investigation. I remember the tilt of her head, her big, beautiful, innocent eyes, and her adorable hairstyle, with its shiny bows. Oh, and when I smiled at her she did smile back!

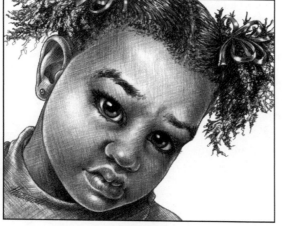

Figure 18-10:
Planning a
successful
portrait
involves
many
factors that
help you
depict a
specific
individual.

Project 18: Portrait of Annie

Mix together eyes, nose, ears, hair, and a mouth and you have all the ingredients for a portrait! Time to try your hand at drawing Annie, who is approximately 7 years old. Use a vertical format and whatever pencils you prefer. Remember to press very lightly with your pencil, because you need to erase some lines as you go along.

1. Very lightly draw the outline of her head and ears.

The shape of her head is similar to that of an egg, but a little shorter. Her ears are a little lower than the halfway horizontal point between the top of her head and the bottom of her chin.

2. **Draw the outline of Annie's eyes, nose, and mouth.**

3. **Draw the details of her ears.**

 An ear is very intricate and is even more difficult to draw than an eye. I show you how to draw an ear in "Portraying a child's ear from the front," earlier in this chapter.

4. **Draw a pupil and highlight inside each iris.**

5. **Sketch in her eyebrows, matching the direction in which they grow.**

6. **Draw the outline of her hair.**

 The outline of the hair lies outside the outline of the skull. The sections of hair are different lengths to give the hair a natural appearance. Some strands appear to cut through her eyebrows and ears. The outside edges of the hair show a few untidy hairs to keep it looking soft and natural.

7. **Erase any sections of the skull, eyebrows, and ears that you want hidden behind or underneath the hair.**

 You now have a line (or contour) drawing, and if your goal is to draw a cartoon or comic book face, you are finished. To add shading and do a more realistic portrait, read on.

8. **Add shading to her ears, nose, chin and face with crosshatching.**

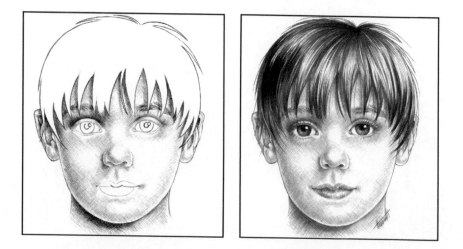

The dominant light source is from the right. Note the shadows under the strands of hair at the top of her face. Darker shading with crosshatching in these shadow areas gives the illusion of depth (I tell you how to do shading with crosshatching in Chapter 7). The shading on her cheeks and chin doesn't extend completely to the edge of her face.

9. **Draw in her neck and shade under her chin with crosshatching.**

10. **Shade in Annie's eyes.**

 Refer to "Drawing the eye of a child," earlier in this chapter, for detailed instructions for drawing a child's eye.

11. **Draw the details of her lips and mouth.**

 No noticeable lines outline her lips. The shading follows the natural creases in each lip and is also directed perpendicular to the opening. The darkest shading is next to the line that indicates the opening of the mouth and on the side in shadow. Note the lighter shading and areas left white on the lips, which gives the illusion of form.

12. **Draw her hair.**

 The hair contains many different values — from white for the highlights, to black for the areas of darkest shadows. The darker areas of hair are drawn with unevenly spaced hatching lines of different lengths.

13. **With your HB pencil draw light, wispy, individual hairs around the perimeter of the head and in between the strands of hair on the forehead.**

 Check over your drawing carefully for any changes you may still want to make. Sign your name, put today's date on the back of your drawing, and give yourself a big hug!

Chapter 19

The Many Faces of Adults

*I*f all earthlings looked the same, we would be an awfully dull-looking species! Thankfully, each person looks unique, inspiring artists' fascination with drawing faces.

This chapter provides you with insight into a vast array of adult facial structures. Drawings of both male and female adults encourage you to compare anatomical differences. Be prepared to have some fun while exercising and challenging both your mind and drawing skills.

Celebrating Differences

Almost everyone has the same facial components — two eyes, two ears, one nose, and one mouth! Yet, even though individual head designs are very similar, most people look very different from one another. You can even find subtle differences between identical twins, if you examine their faces closely.

When seeing someone for the first time, you may notice unique facial characteristics to help you identify that person by their physical appearance, such as the size and shape of the head, face, and features, and the color of the hair, eyes, and skin. From an artistic perspective, other aspects of a person's head and face are equally important, such as the spaces and distances between the different parts, the angles of the lines that outline the various shapes, and the relationships of different facial parts to one another.

Examining diverse shapes of adult heads

In forensic art and anthropology, a complete human skull reveals many things about a person. Gender, life style, cultural origin, and occasionally identity are only a few of the secrets waiting to be discovered.

Figures 19-1 and 19-2 show four examples of frontal half-views of some different shapes of adult heads. The fascinating thing is that the top (skull) and bottom (face) halves can be put together to come up with tons of complete variations! The vertical lines you see illustrate the imaginary lines of symmetry. Dig out your drawing materials and have some fun mixing and matching skulls with faces. Then add some facial features and hair, and voilà, you have a whole bunch of very different looking people.

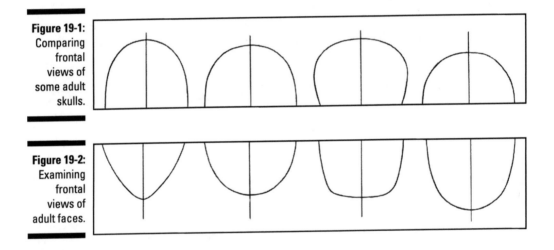

Figure 19-1: Comparing frontal views of some adult skulls.

Figure 19-2: Examining frontal views of adult faces.

To see the vast differences in various human head structures, you could shave your head, and the heads of all your neighbors, friends, and family, and compare the shapes of their skulls. Or, if you encounter some resistance to that idea, examine the drawings of human heads in this chapter and throughout this book. Try to figure out which of the four shapes of skulls and faces (see Figures 19-1 and 19-2) are closest to each of them.

Human heads and faces also look very different from one another when viewed in profile. *Facial slope* refers to the angle of the lower section of a person's head (excluding the nose) when viewed from the side, from the forward projection at the base of the upper teeth, upward to the forehead.

In Figure 19-3, three profile drawings illustrate a sampling of the multiplicity of the shapes of human heads. I identify their different facial slopes with angle lines. Take note that in the first drawing the facial slope looks almost vertical, whereas the other two facial slopes are more slanted.

Figure 19-3:
Exploring
diverse
shapes
of heads
and facial
slopes.

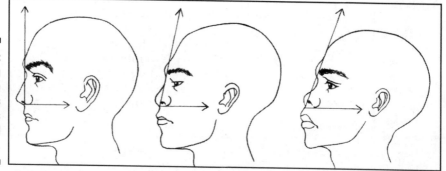

The next time you watch TV or a movie, or are surrounded by people in a public venue, observe peoples' faces and heads in profile. Take note of their different facial slopes and the various shapes of their heads and skulls.

Comparing differences of gender

Males and females generally look very different from one another, both from the side and front on.

Compare the generalized side views of the heads of a male and female in Figure 19-4 and take note that

- ✔ The overall head size and the individual features of a female are smaller.

- ✔ A female has a smoother, rounder, and more vertical forehead.

- ✔ The *brow ridge* (the bulge created by the bone above the eyes on which the eyebrows grow) is more pronounced on a male head.

My son, Ben, is 6 feet and 2 inches and over 200 pounds, and my daughter, Heidi, is 5 feet and 6 inches and petite. As brother and sister, they share some facial likenesses. So, I challenged myself by using them as models to show you some typical facial differences between men and women.

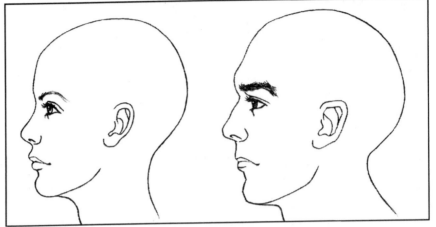

Figure 19-4:
Finding some differences between profiles of adult males and females.

Take note of the following as you compare the two drawings in Figure 19-5:

- ✔ The overall size of a male's face and each of his facial features, including his ears, tend to be larger.

- ✔ The lower half of a female face is proportionately smaller than that of a male, because the jawbone tends to be more petite.

- ✔ The individual features and the overall shape of a female face are more rounded, because there is generally more fat covering her muscles and bones. A male face appears more angular, because less fat covers the bones and muscles, making them more visible under the skin.

- ✔ The male neck is generally larger and more muscular, and he has an Adam's apple in the front of his neck, below the chin.

- ✔ Females usually have fuller lips than males.

- ✔ The eyebrows of males tend to be fuller, thicker, and darker.

- ✔ Male chins tend to be larger, more squared, and more pronounced.

Remembering adult facial proportions

Artists have established several variations of rules for remembering adult facial proportions. My favorite happens to be the one I find easiest to remember. If you're a math major who cringes at the thought of three halves for the facial proportions of babies and children (refer to Chapters 17 and 18), prepare to become really distressed at the thought of two halves and three thirds for adults' facial proportions!

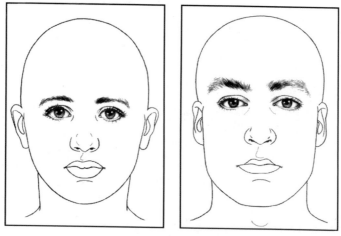

Figure 19-5: Comparing facial differences between my son, Ben, and my daughter Heidi.

Before you attempt to draw individual features on faces, it helps to know how to plan a place for everything, sort of like a blueprint. The following guidelines apply to the facial proportions of both men and women. Draw along with me, refer to Figure 19-6, and prepare a head and face for some features:

1. **Draw an egg shape (see the first drawing in Figure 19-6).**

2. **Add the outlines of the ears approximately halfway between the top and bottom of the face.**

3. **Draw horizontal, parallel lines to mark the top of the head and the bottom of the chin.**

4. **Mark the line at the bottom of the chin as GH.**

5. **Measure and then draw another horizontal line halfway between the top of the head and the bottom of the chin. Mark it AB.**

6. **Measure the total vertical distance between lines AB and GH, divide it by three, and mark these two points on your drawing.**

7. **Draw two more horizontal lines, CD and EF, at these points, parallel to lines AB and GH.**

8. **Identify the widest (horizontal) section of the cranium and draw vertical parallel lines, IJ and ST, to mark the outside edge on each side (see the second drawing in Figure 19-6).**

9. **Measure the horizontal distance between lines IJ and ST.**

10. **Divide this total distance by five and mark the four points on your drawing.**

11. **Add four vertical, parallel lines, KL, MN, OP, and QR, at each of the four points to complete your blueprint.**

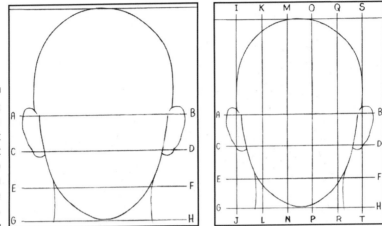

Refer to the drawings of a man and a woman in Figure 19-7 as I show you what features go where on their faces:

- ✔ Line AB indicates the horizontal position of the eyes and the tops of the ears, halfway between the top of the head and the bottom of the chin (Line GH).

- ✔ The lower section of the nose and the bottoms of the ears touch the horizontal line CD.

- ✔ The bottom edge of the lower lip lies on or slightly above line EF.

- ✔ The right eye is between vertical lines KL and MN, and the left is between vertical lines OP and QR.

- ✔ The nose sits approximately between vertical lines MN and OP.

Observe the following on each face in Figure 19-7:

- ✔ The ears are approximately the same length as the nose.

- ✔ The widest section of the cranium is five-eyes wide.

- ✔ The width of an eye is equal to one of the five horizontal spaces.

- ✔ The corners of the mouth line up vertically with the irises of the eyes.

The next time you are among a group of adults, examine how their facial features fall within these guidelines.

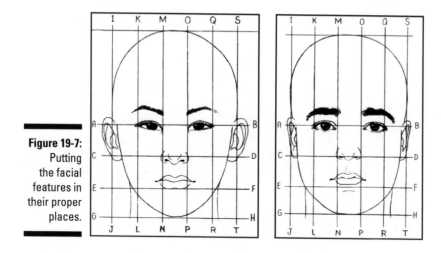

Figure 19-7:
Putting the facial features in their proper places.

Putting Together an Adult Portrait

Drawing individual features correctly is crucial to capturing a likeness of someone. An ideal portrait also has a creative composition in which hands and arms (and often entire bodies) can play an important role. (I tell you about composition throughout Chapter 10.) With careful observation, you can even bring aspects of an individual's personality into your drawing.

Planning a portrait

Your first major decision, when planning a portrait, is to determine how much space within your drawing format to allocate to your model's face.

In the two drawings in Figure 19-8, compare the size of each face to the total space it occupies within the drawing format. In the first drawing, you see a figure drawing of my friend Claudette. In order to draw her entire body, I needed to make her beautiful face proportionately small within the drawing format. By tightly cropping part of Rob's hat, (the second drawing) his face proportionately occupies most of the drawing format.

Hats, glasses, clothing, and other personal articles belonging to your model can add more interest to your portrait drawings. For example, in the second drawing in Figure 19-8, my friend Rob not only wears a nice, warm smile, but also a hat and jacket.

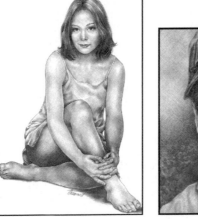

Figure 19-8:
Deciding
how much
space to
allocate to
a subject's
face within
the drawing
format.

Something as simple as the tilt of a head can enhance your composition, and even tell something about the personality of your model. You can also use the background of a portrait to inject some of the subject's individuality.

In Figure 19-9, meet Benny, my longtime friend and fellow artist. The turmoil of the background contrasts with his facial expression, but offers a reflection into the complex mind beyond his physical being.

Exploring faces, arms, and hands

Adult features are larger than those of children. More of the whites of adult eyes are visible, creating the illusion that their irises are much smaller. (I show you how to draw an eye in Chapter 18.) The shapes of adult noses are more defined than those of children, but the basic shading is the same (refer to Chapter 18.) The shading of adult lips is also similar to children's. (I show you how to draw lips in Chapter 18.)

Have a look at the facial features of my former students and current friends, Claudette and Philip (Figure 19-10). The bright light on the front of her facial profile highlights and draws attention to the shapes of her forehead, nose, mouth, and chin against the dark shadow on the side of Philip's face. The strong light also provides high contrast in the shading of Philip's features, especially the eyes, which seem very animated. One dominant light source, a full range of values, and an unusual composition create the illusion that the forms of their features are three-dimensional.

Figure 19-9:
Using the tilt of the head and the background to lend power to a portrait.

Figure 19-10:
Seeing how creative placement of facial features and strong contrast can enhance a portrait.

Even if you draw faces perfectly, you can't get away for long without having to draw necks, hands, or arms. Excluding parts of a body from your drawings, because you can't draw them well, limits your creative and artistic options.

In the first drawing in Figure 19-11, meet my former student and longtime friend Philip. In this portrait, the arms were an integral aspect of achieving my artistic goal. I wanted to contrast his gentle nature, as shown in his facial expression, with the tough guy illusion created by the positioning of his arms and the tattoos adorning them. Also, take note of all the forms of his neck, and how his neck attaches to his head.

Figure 19-11:
Observing how creatively positioned arms in a drawing can express emotions.

In the second and third drawings in Figure 19-11, the two views of a male's arm show the many forms (usually less visible in a female's arm) created by bones and muscles. Take note of how the hands are attached to the arms.

Many years ago I did fashion drawings for an advertising agency. I tried to pose my models so their hands were hidden, but I soon realized this was stifling my creativity. So, I finally decided to teach myself how to draw hands. I'm so glad I did! Hands can say as much about a person as his or her face.

A drawing of a violin player sure would be boring if hands weren't included! In Figure 19-12 observe two hands making music. My goal was to show the tension and the intricate details that define movement. I emphasized the tips of the fingers and exaggerated the contrast between light and dark values in an attempt to pull the viewer's eyes toward the hands.

Figure 19-12:
Creating a musical mood with hands and fingers playing a violin.

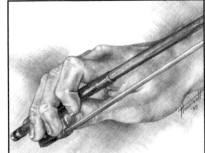
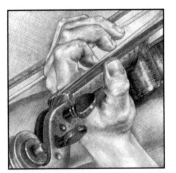

Drawing a portrait of two or more people

Portraits tend to become more complex when you include two or more people because you need to find a way to creatively define each person. (Refer to Figure 19-10 to view a portrait of two individuals.)

Explore creative ideas to illustrate their individual faces from different perspectives. Play with unusual lighting options to create strong contrast and exaggerate the forms of their faces. In group portraits, you can overlap various people, and draw them from different angles, to help characterize each individual and create a strong composition. As you plan your composition, remember that placing someone in the exact middle of the drawing space makes your portrait less dynamic.

Figure 19-13 shows the owner of the hands in Figure 19-12, who just happens to be the best violin player in the whole world (I may be just a tad biased)! Meet my friend Chris! In this drawing, his hands are almost as expressive as his mischievous facial expression.

Figure 19-13: Appreciating the contribution of expressive hands to a portrait of a musician.

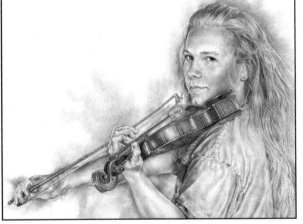

Project 19: Drawing Manisha

Meet Manisha, also known to her many friends as Anne. The three-quarter view of her face in this drawing is much more fascinating than either a frontal or a profile view. From this perspective you can better see the three-dimensional forms of her face. Drawing the light and shadows becomes a really fun exercise in shading various forms.

The proportions of adult bodies

I can't possibly say that one specific adult body type or size is ideal. To do so would be to negate the vast beauty inherent in all human bodies. Women and men come in diverse shapes and sizes, primarily determined by their genetics and life styles.

The horizontal width of an adult, across his or her shoulders, is approximately three heads. The height of average adult females is between six and a half and seven and a half heads tall. Average adult males are between seven and eight heads tall.

The bone structures of adults have completely formed by the time they reach their mid-twenties. Women's bone structures are generally smaller than those of men, and females tend to have more body fat, which gives a rounder and softer appearance to their bodies. The overall bone structures of men tend to be larger than those of women, and the muscles and bones of male bodies are more visible, because they tend to have less body fat than females.

You get no grid as a guide for this project and you make your own choices about which pencils to use. The process is the same as if you were drawing from life rather than this book. Don't panic! I take you through the process step by step:

1. **Lightly sketch the outlines of her face, hair, shirt, and features.**

 To accurately sketch a face from this perspective, carefully observe the angles of all the shapes and how they relate to one another (see the first drawing in the next set of two). For example, the line that indicates her forehead is vertical, while the one between her cheekbone and chin is at an angle. Note that the lines indicating her features are parallel to one another but also at a slight angle to the vertical line of her forehead.

2. **Lighten your sketch lines with your kneaded eraser and redraw more detailed outlines of her face and features (see the second drawing).**

3. **Lighten your lines again with your kneaded eraser.**

4. **Refine your drawing of her face and add the rough outlines of the individual sections of curly hair around her face (see the first drawing in the next set).**

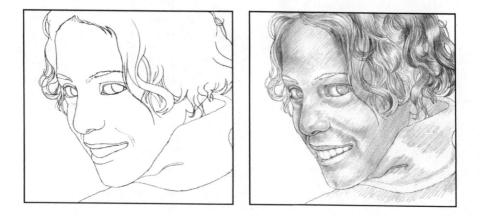

5. **Lighten your fine lines again (thank goodness for kneaded erasers!).**

6. **Use hatching lines and an HB pencil to shade in the light and medium values of some curls in her hair (see the second drawing).**

 Pay close attention to the directions in which the lines curve and continually adjust your drawing as necessary. I show you how to use hatching lines to draw hair (and fur) in Chapter 8.

7. **Use hatching lines to add the light values to her face and clothing.**

 I tell you how to map out your values and apply shading in "Applying Shading to Your Drawings" in Chapter 7.

8. **Use crosshatching and your 2B and 4B pencils to add medium and dark values to her face, hair, and clothing (see the final drawings).**

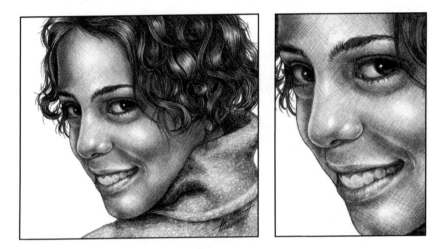

I show you how to do shading with crosshatching in Chapter 7.

9. **Add shading to her eyes, nose, and mouth.**

Refer to Chapter 18 for tips on how to shade these areas of the face.

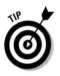

To draw teeth well, you hardly draw them at all! Simply allow the shading of the lips, the upper and lower gums, and the shadows created by the light source to define them. Teeth farther back in the jaw need to be shaded darker because they are in the shadows of the mouth.

Never draw lines between the individual teeth or else they end up looking like a checkerboard! Drawing teeth properly sometimes presents a challenge to even very accomplished artists. Don't be concerned if your drawings of teeth don't turn out well at first. With practice you do get better.

Chapter 20

Enjoying the Lighter Side of Faces

- -

In This Chapter

▶ Having fun with crazy hairstyles, facial expressions, and fuzzy faces

▶ Time-traveling with a face through 70 years

▶ Cartooning with gigglecatures

- -

*I*f a spaceship full of aliens landed on earth today, I suspect they'd be very amused by humans. No science-fiction television show has ever depicted a more diverse species of beings, with so many different faces and hairstyles.

In this chapter I show you some of my favorite creative hairstyles, as well as a humorous collection of facial expressions. I demonstrate how facial hair can drastically change someone's appearance. I also reveal some simple characteristics of human faces that define various ages and explain how you can draw a caricature of someone. You won't be able to resist some of the fun faces in this chapter, so keep your drawing supplies handy!

Exploring Artsy Hair and Fun Faces

The next time you go shopping, to a park, or any other place with lots of people, take the time to examine and enjoy the faces and hairstyles of the people around you. Pretend you're an alien seeing this species for the very first time. Observe all the creative ways humans have found to show off their individuality. Try to remember some of their faces and hairstyles to later record in your sketchbook.

More hair, less hair, and no hair

Just when you think you've seen it all, you spot a new innovative hairstyle! Hair designs are a fun way to exhibit individuality and creativity. Figure 20-1 shows you some of my favorite creative styles from three generations.

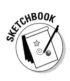

Dig out your drawing supplies and draw your favorite hairstyles from Figure 20-1 in your sketchbook. Keep the faces supersimple and focus on the hair (or the lack thereof). Observe hairstyles of people around you and draw as many as you possibly can. Invent some new hairstyles from your imagination and add them to your sketchbook collection. The more you draw different textures and styles of hair, the more skilled you become!

Letting the face say it all

Believe it or not, you are an expert on analyzing the faces of your family and friends. By simply looking at their facial expressions, you can often tell how they feel. When you meet a stranger, the key component of your first impression is often a facial expression. You instinctively search people's faces for clues about who they are and how they may interact with you.

The next time you are with a group of people, watch how their facial muscles create their different expressions. Try translating what you see into drawings. You can also draw some cartoon faces from your imagination and give them unique expressions.

Here's a list of nine facial expressions. Compare each description to its corresponding drawing, and try to analyze the visual components that define that particular expression:

- ✔ **Terrified:** The eyes open very wide, the eyebrows lift up and curve upward in the center, vertical and horizontal creases form on the forehead, and the mouth sometimes opens (see the first drawing in Figure 20-2).

- ✔ **Angry:** The eyes open wide, the brow lowers and covers part of the upper eyelids, the eyebrows lower in the center, vertical and horizontal creases appear on the forehead, the mouth is closed but stretches taut, with the lower ends folding downward, and the chin is tight and bulges upward (see the second drawing in Figure 20-2).

- ✔ **Sad:** The upper eyelids fold upward toward center, the eyebrows bend upward and toward the center, forming vertical and horizontal creases on the forehead, and the corners of the mouth curve downward (see the third drawing in Figure 20-2).

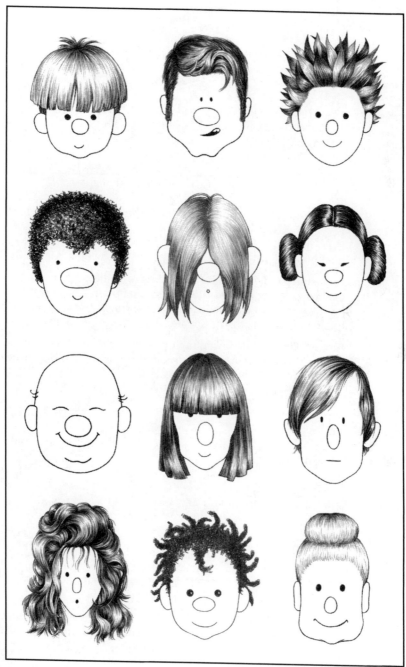

Figure 20-1: Combing through 12 different hairstyles from 3 different generations.

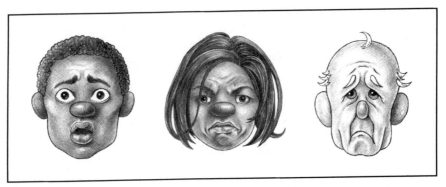

Figure 20-2:
Expressing fright, anger, and sadness in the face.

✔ **Disgusted:** The eyes partially close, the eyebrows lower in the center, vertical folds form on the brow, horizontal creases appear between the eyes, one side of the upper lip raises in a sneer, and the lower lip and chin push slightly upward (see the first drawing in Figure 20-3).

✔ **Devastated:** The eyes close and crease at the outer corners, the eyebrows lower toward the center, the upper lip widens downward on the open mouth, vertical creases form on the lowered brow, and the chin is tight (see the second drawing in Figure 20-3).

✔ **Happy:** The eyelids lower, the upper teeth show, the eyebrows relax, and the mouth widens with the corners curving up and back toward the ears (see the third drawing in Figure 20-3).

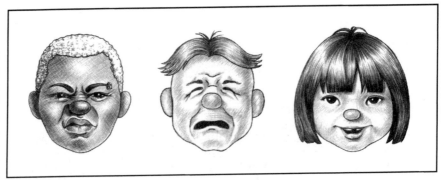

Figure 20-3:
Letting the face convey disgust, devastation, and happiness.

✔ **Ecstatic:** The eyes shut, the eyebrows relax, the mouth opens wide, and most of the upper teeth are visible (see the first drawing in Figure 20-4).

✔ **Seductive:** The upper eyelids close slightly, the eyebrows raise, and the mouth muscles push the lips forward (see the second drawing in Figure 20-4).

✔ **Mischievous:** The eyes narrow, the brow and eyebrows lower toward the center and partially cover the upper eyelids, and the mouth widens back toward the ears (see the third drawing in Figure 20-4).

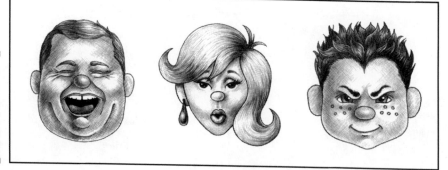

Figure 20-4: Showing ecstasy, naughtiness, and mischief.

Masking a face with hair

Adventurous individuals from every generation exhibit creative hairstyles. Young people seem to become increasingly imaginative with their hair as each decade passes. Many persons even have hairy faces with which they can exhibit their individuality and drastically alter their appearance.

In case you can't tell, all four drawings in Figures 20-5 and 20-6 show the same man, my friend Rob, an incredible human being, currently working on his fifth university degree. Through the magic of drawing, he models four different hairstyles and facial hair designs. Just a wee insight into how a person's physical attributes can be misleading for accurately determining who he or she really is.

A penny for your thoughts

For centuries, artists have used facial expressions to integrate emotions into their art. You may know the painting *Mona Lisa* by Leonardo da Vinci. Her unusual facial expression has been the catalyst for many fascinating theories as to the meaning behind her smile. Find a photo of the *Mona Lisa* and try your eye at deciphering what she is thinking or feeling.

At your library, or on the Internet, take time to research portraits by numerous artists. Study the various expressions and observe the facial characteristics that the artists use to portray each emotion.

In the first drawing in Figure 20-5, you see a rather casual hairstyle and a natural-looking beard. In the second drawing, a polka-dot bow tie, thick glasses held together with tape, a little mustache, and a change in hairstyle create a whole new persona!

Figure 20-5:
Creating
new
personas
with
different
hair designs.

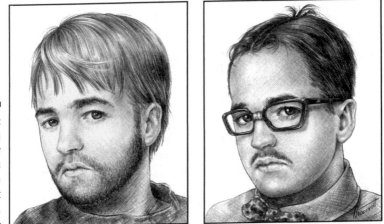

Figure 20-6 illustrates popular hair and beard styles from two different generations. In the first drawing you see a young man with long blond hair and a full thick beard, who looks like he just time-traveled here from Woodstock. The second drawing shows the same person with an incredibly creative style of hair and beard. Of course, to maintain this look he may need to spend two hours a day grooming in front of a mirror!

Figure 20-6:
A person's
hair can
help define
their age
and per-
sonal style.

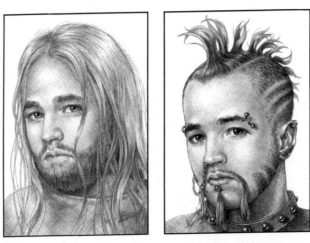

As you can see in Figures 20-5 and 20-6, a little creative thinking goes a long way in making traditional portrait drawing into a fun experience. Find willing models or good photos of family and friends and draw their basic likenesses. (I tell you about drawing portraits in Chapters 17, 18, and 19.) Then experiment with altering their appearance with unusual hairstyles or beard designs. But, keep in mind, Auntie Mary may not remember your birthday next year if you draw her with a full, thick beard!

Watching a Face Travel through Time

It's a lot of fun finding out what you, or someone you know, will look like in 20 years, or even 50 years, almost like traveling into the future.

In this section, a series of drawings takes the face of my friend Rob from 14 to age 85 (his actual age is somewhere in between, but closer to 14). I use *age regression* techniques to make him younger and *age progression* techniques to age him.

I use a male face for this demonstration but the basic principles also apply to females. Of course, you may want to leave out the Adam's apple and facial hair in portraits of females. These drawings also serve as a reference for portraits you do, and you may find them especially helpful if you have difficulty depicting an accurate age of an adult portrait subject.

From 14 to 20

Figure 20-7 shows the facial changes as a child of 14 matures into a young man of 20. By age 14, the proportions of facial mass to cranial mass reach those of an adult. (Refer to Chapter 17 for more information on these terms.)

Some facial hair (peach fuzz) may be visible around age 14, but you may need a magnifying glass to see it! After age 14, he begins to lose the soft "baby fat" that hides some of the forms of the facial bones and muscles.

By 20, his jaw and chin appear firm, and the forms of his skull become more visible, especially the brow ridge. His nose tip is less rounded, and the bridge of his nose becomes well defined. His neck becomes a little heavier, and his Adam's apple is increasingly noticeable. The novelty of having facial hair starts to wear off, as he realizes that shaving every day isn't fun.

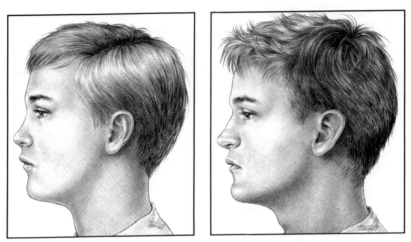

Figure 20-7:
Developing
from a boy
into a young
man.

At 30

By age 30, Rob's face has fully matured into a very nice-looking young man. Compare Figure 20-7 to 20-8 and take note of the following:

- The curve under his brow ridge is more pronounced, and, therefore, his eyes appear slightly deeper set.
- The first signs of lines appear on the forehead and around the eyes.
- His mouth, jaw, cheekbones, and chin are firm and well defined.
- His neck becomes thicker and more muscular.

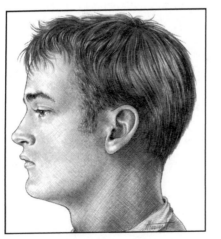

Figure 20-8:
Reaching
age 30.

At 45

By 45, with middle age approaching, Rob's hair becomes a little thinner, recedes slightly at the temples as he gains more forehead, and some gray hairs appear. Also note the following, as shown in Figure 20-9:

✔ Wrinkles form on the forehead, around the eyes (crow's feet), and the corners of the mouth.

✔ The bone structures around the eye sockets are more pronounced.

✔ The flesh around and under the jaw area becomes softer and is more pronounced.

✔ The neck becomes heavier with a slight fleshy bulge at the back.

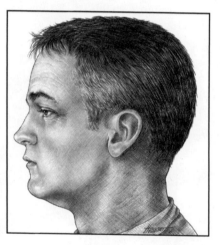

Figure 20-9: Showing the changing face at 45.

You can't accurately depict the aging process by drawing lines on a person's face. You age-progress a person by illustrating the changing three-dimensional exterior forms of the skeletal structure and by transforming the outward appearance of the skin, fat, and muscles pulled downward by gravity.

Practice drawing wrinkles by using a piece of soft, thick, wrinkled fabric as a model. Think of a wrinkle as a soft fold or crease in the skin. Examine the faces of older friends or family and study the forms of their wrinkles.

At 60

During middle age, the changing forms of his face transform Rob's youthful appearance to that of a mature man (see in Figure 20-10):

- ✔ His graying hair thins and recedes at the front and the temples. Many men are quite bald by age 60.

- ✔ The eyes are deeper set, and the wrinkles (crow's feet) around his eyes and the forms under his eyes become increasingly pronounced.

- ✔ The curve under the brow ridge between his eyes deepens, and the understructure of his nose is clearly defined.

- ✔ Facial flesh is softer, and the upper eyelids, cheeks, and ears begin to sag.

- ✔ Because the bones of the skull are more visible, the structures of the brow ridge, cheekbones, and chin are more prominent.

- ✔ The sides of the jawbone become less defined as the flesh at the sides of his mouth, chin, and jaw droops downward toward the neck.

- ✔ His neck is less firm, deep wrinkles appear on the sides, and the bulge at the back of the neck becomes more pronounced.

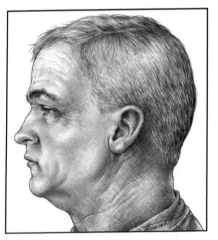

Figure 20-10:
Advancing
the face
to 60.

At 85

By 85, Rob won't need to show an ID to get seniors' discounts at the movies! Observe the beauty of full maturity in Figure 20-11 and note the following:

✔ He has a lot more face to wash these days, as his now-white hair farther recedes and becomes thinner and finer.

✔ Some hairs in his eyebrows have become longer, unruly, and white, and some ear hair is visible.

✔ The eyes are more deeply set, and the upper eyelids droop considerably.

✔ The understructure of the skull becomes more noticeable, and his cheeks appear sunken.

✔ Deeper folds and wrinkles appear, especially on his neck and around his mouth and eyes.

✔ When sitting, his head tilts back on his neck.

✔ The forms of the understructure of his nose are more pronounced, and the nose appears longer.

✔ His lips look thinner, and vertical wrinkles emerge around his mouth.

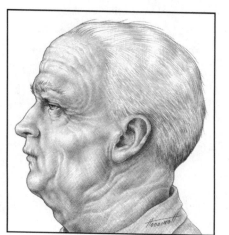

Figure 20-11:
Arriving at
full maturity
at age 85.

Cartooning with Caricatures

A *caricature* is a cartoon that exaggerates the distinctive and unique facial features of an individual. Political cartoonists have a really fun job capturing less-attractive characteristics of celebrities and other famous people. You can find examples of tons of different styles of caricatures in various news magazines and newspapers.

You need strong drawing skills and a good knowledge of facial anatomy to draw cartoons of people. Check out the 12 cartoons in "More hair, less hair, and no hair," as well as the 9 drawings of facial expressions in "Letting the face say it all," earlier in this chapter. The eyes in all these cartoons appear approximately at the midway point on the face, the same proportions as in realistic portraiture.

My curiosity to know what certain people would look like as puppets or dolls gave birth to my unique style of caricatures, which I affectionately refer to as *gigglecatures* (a word you won't find in a dictionary).

In Figure 20-12, I show you two examples of this zany cartoon style. The first drawing is loosely based on one of my favorite child movie stars. I had a lot of fun creating this unique hairstyle and designing her clothing. The second drawing is my witty artist friend Daniel, wearing a mischievous grin.

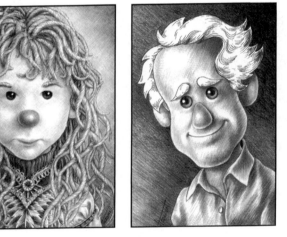

Figure 20-12: Gigglecatures let you have fun with portraits.

Find your drawing supplies and draw a caricature of an actual person you know, such as one your family members or a friend! Choose a good photo or find a patient model. If you work from life, you discover why I call them Gigglecatures. Be prepared for a few giggles! Grab your model (or photo) and your drawing supplies, and follow these easy steps to try your hand at drawing a caricature:

1. **Observe the overall shape of the head and face, and exaggerate it as you draw it.**

2. **Lightly sketch the location of each individual feature.**

In a realistic portrait, accuracy in drawing the proportions of five crucial spaces on a face enhances a recognizable likeness to your subject. These same five spaces, when exaggerated, serve as guidelines for rendering a caricature that looks like the person you're drawing. Pay really close attention to:

- The vertical distance from the hairline down to the eyebrows

- The horizontal distance between the eyes, from one inside corner to the other

- The width of the face from the outside edge of one cheekbone to the outside edge of the other

- The vertical distance from the bottom of the nose to the top of the upper lip (the most important distance on the face)

- The length from the edge of the bottom lip to the bottom of the chin

Constantly refer to your model for unique or unusual aspects of their features that you can exaggerate in your drawing. Remember that this person may draw your caricature someday, so be nice!

When drawing a caricature, exaggerate prominent features. If the eyes are far apart, draw them even farther apart. If his or her eyebrows are heavy, thick, and dark, draw them heavier, thicker, and darker! If he or she has big ears or a big chin or nose, draw them even larger! If the hair is thin, make it thinner, and if it's thick, draw it thicker.

3. **Continue adjusting and changing until you are happy with your drawing.**

Project 20: Gigglecature of Kay

This project demonstrates how I draw a gigglecature based on the face of my wonderful artist friend Kay. Warm up your drawing hand and follow along with me. You may prefer to draw freehand, but I provide a grid anyway. Use whatever pencils you want, but remember to press lightly because you need to lighten or erase some lines later:

1. **Use a ruler to draw a rectangle and divide it into 30 squares, 5 squares wide by 6 squares down (see the first drawing in the next set of two).**

 My drawing of Kay is 5 x 6 inches. I use 1-inch squares, but you can draw a grid with larger squares. If you use 2-inch squares, your drawing becomes 10 x 12 inches.

2. **Lightly sketch the strands of hair covering much of her forehead.**

3. Sketch the outline of the perimeter of her face.

4. Add the eyes, eyebrows, and the lower sections of her ears.

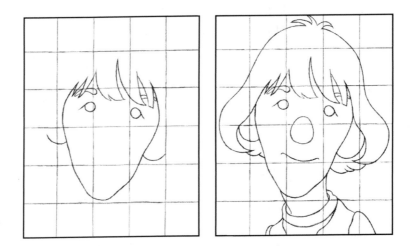

5. Lightly sketch the nose and mouth, observing closely the proportions in my drawing (see the second drawing).

6. Draw the hair on the top and sides of the head.

7. Observe her neck and the details of her clothing and draw them.

Compare the placement of everything in my drawing with your drawing. This is the best time to make any changes or add something you forgot.

8. Carefully erase any grid lines on your drawing.

9. Use hatching to shade the upper half of the background.

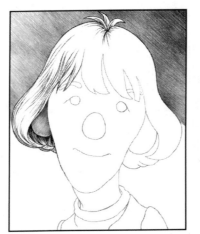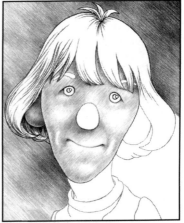

Check out the negative space (also known as the background) in the first drawing in the next set of two. Note that the shading is darker in the upper-right corner. (I demonstrate how to shade with hatching in "Hatching Shades of Gray" in Chapter 7).

10. Draw the light lines in her hair on the left.

Observe the slightly curved lines, which indicate the texture of the hair; they give the illusion of the hair having a slight curl.

11. Add shading to her ear on the left.

The shading on her ear creates the illusion of the ear being under the hair and set further back than the edge of her face.

12. Draw in the hair on her bangs (see the second drawing).

13. Add more shading to the background, noting that it gets progressively lighter closer to the bottom.

14. Add shading to her face with hatching lines.

The light in this drawing comes from the right. The shading on the left is darker than on the right. Look at the cast shadow on her face created by her nose. The shading gives form to her cheekbones, chin, and the areas around her mouth.

15. Draw the outlines of the pupils and highlights in the iris of each eye.

16. Shade the iris of each eye (see the first drawing in the next set).

The shading on the iris of each eye is darker on the side where the highlight is drawn.

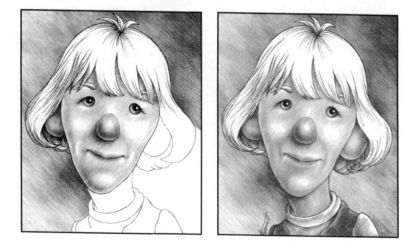

17. With your 6B pencil, shade the pupil of each eye.

18. Add some lines to each eyebrow.

19. **Shade in her nose.**

 I leave an area totally white for the highlight.

20. **Draw the line for the opening of her mouth and add shading to represent her lips.**

21. **Draw the lines to indicate the texture of the rest of her hair.**

 Refer to the final drawing and note that, because the right side of the drawing is closer to the light source, the hair is lighter than the left and is mostly left white.

22. **With your HB pencil add the shading to her other ear.**

 The shading on the ear is darker closer to the hair, which gives the illusion that it is under the hair and partially in shadow.

23. **Add a little more shading under her lower lip.**

24. **Closely observe her neck and clothing and add the shading.**

25. **Finish the shading in the background.**

 The shading becomes progressively lighter as I draw diagonally toward the lower-right-hand corner.

Part V

The Part of Tens

In this part . . .

Put your feet up and get comfortable! It's time to sit, relax, and savor an after dinner drink (ginger ale, of course) and some casual conversation. Shhhhhh! Don't tell anyone, but do I have a secret for you! Actually I have lots of secrets to share, as well as tons of other artsy tidbits of information.

Even perfect little old me (cough and grin) has been known to make an occasional mistake or two (or hundreds). Of course, if you happen to love making mistakes, and damaging or even accidentally destroying (gasp) your drawings, you can simply ignore this part of the book.

I share some of the most embarrassing incidents of my artistic career, in hopes that you can benefit from my experiences. I offer several ideas for saving time, preventing frustrations, and expanding your current artistic horizons. You even have the opportunity to walk step-by-step through the entire process of making an original artwork.

Dinner is over and now it's time to play! You meet a diverse group of playmates, including Harry, Riley, Shadow, Dodo, and Dolly. The ten additional fun projects (of various skill levels) expand your artistic experiences, and leave you with an even greater appetite for drawing. I also include a chapter that tells you a couple of ways to enhance your new-found love of art and drawing.

Chapter 21

Ten Tips, Hints, and Secrets

As the old expression says, "An ounce of prevention is worth a pound of cure"! Protecting your drawings from accidents, problems, and catastrophes is a heck of a lot easier than doing damage control after disaster has struck! I've learned lots of stuff the hard way, by making mistakes. Of course, some accidents are an inevitable part of mastering a new skill, but hopefully some of my negative experiences can benefit you.

In this chapter, I share several hints for protecting your drawings from time, unknown enemies, and accidental damage! You also find an eclectic collection of tips on diverse topics such as signing your name as an artist, drawing with grids, using erasers efficiently, drawing with symmetry, and a secret method for rendering unfamiliar textures.

Erecting Your First Defenses

I've lost drawings to lots of easily preventable and silly mistakes! Thankfully, I haven't made the same blunder twice. I can't guarantee that you won't come up with a few unique mistakes of your very own, but if you heed my advice, at least you won't make the exact same mistakes as me.

 Put your drawings away in a safe place when you are finished working! Red and black crayon marks are impossible to get off an almost completed graphite drawing, which a 2-year-old has used as a coloring book (and I'm speaking from experience)!

Have a special surface for cutting your drawing papers and boards. Make sure you don't ever lay a completed drawing on this surface, even if you are cutting a backing for it. A beautiful, completed drawing that has been accidentally cut in half becomes two pieces of scrap paper for the recycling bin.

Never rest a cup of coffee (or any other beverage) on your drawing surface. When a 55-pound dog hears the doorbell, runs across the room, and bumps into your drawing table, you end up with a soggy brown mess instead of a beautiful drawing.

Protecting Your Drawings from Hands

Human hands are a drawing's worst enemy! Nothing is more frustrating than trying to clean up a drawing that has been smudged, or has dirt or oil on it. After many ruined drawings, I now take steps to prevent this from happening, which I now share with you.

Always place a piece of clean paper under your hand as you draw. Each time you work on a new section of your drawing, remember to move your paper, so that it's always under your hand. This prevents you from smudging your own drawing and protects your paper from the oils in your skin.

Handle your drawing paper by the edges. Don't touch (or let anyone else touch) the surface of your drawing paper, unless absolutely necessary (even before you begin to draw). The natural oils in human skin or dirt on someone's hands can damage your paper. You may not even notice it right away, but after a few months (or sometimes years), yellowish patches may show up on your drawings.

Before you show a drawing to another person, let him or her know that the drawing is very delicate and can be ruined if they touch it. Then watch them VERY closely, in case they forget! You'd be amazed by how many people, during a conversation about a drawing, simply reach out to point to something, and run their fingers down the drawing. These big, ugly smudges are darn near impossible to fix.

Understanding Preservation

Using conservation materials protects your art from decay and deterioration. In my experience, it's well worth paying a little extra for high-quality art supplies, especially papers.

 When you're out shopping for drawing paper or sketchbooks, take the time to read about or ask about the qualities of the paper. If it isn't acid-free, don't buy it. Newspaper, for example, isn't acid-free, and it quickly becomes brittle and yellow when it's exposed to light.

Don't store your drawings with either clear tape or corrugated cardboard touching them. Either of these items can discolor your drawings and do permanent damage after only a few weeks.

If you frame one of your drawings, make sure that both the mat and the backing are acid-free. Drawings always need to be framed behind glass. If you're framing a drawing you're really fond of, use conservation glass, available at most reputable framing shops. Better still, if you can afford it, have your drawings professionally framed.

Never place or hang drawings in direct sunlight, no matter how well protected you think they are. Better safe than sorry!

Using a Spray Fixative

When your drawing is completely finished, a spray fixative can protect it from being accidentally smudged. I've used the same product, called a workable fixative, for over 20 years. Even after all these years, my drawings are still crisp, and the surface of the paper has not become yellowed with age (of course, I use only acid-free papers and boards).

Use fixative only in a well-ventilated place. I almost always go outside to spray my completed drawings.

 Wait until your drawing is completely finished before you spray. The instructions on the can say you can erase after using this spray, but erasing hasn't worked well for me. They also say that you can work over the spray. However, I find the spray changes the texture of the paper, and graphite especially won't adhere to the surface as well after it's been sprayed.

Read the directions carefully. Two or three thins coats of workable fixative, sprayed on the drawing over a period of ten minutes, is better than one thick coating applied all at once.

Drawing Difficult or Unfamiliar Textures

The textures of some three-dimensional objects are difficult to translate into a two-dimensional drawing — for example, a seashell or a highly textured piece of driftwood.

Photocopy (or scan and print) a black-and-white image of the actual object. When you see the texture on a flat piece of paper, it's easier to figure out how to draw it.

Using Two Erasers Efficiently

There are lots of different types of erasers, but a vinyl eraser and a kneaded eraser can do anything you need done.

A vinyl eraser works perfectly for erasing large areas, and sometimes even dark lines, without heavily damaging the surface of your paper.

A kneaded eraser is an absolute joy for lightening rough sketch lines. It can also be molded to a point and used to lighten or erase tiny areas in your drawing. If you work in charcoal or conte, a kneaded eraser works like a charm for pulling out light areas.

Together, a vinyl and a kneaded eraser are a great team, especially for erasing the lines of a grid. Use a sharp edge of your vinyl eraser to erase the lines and gently brush away the eraser crumbs with a clean, soft paintbrush. Then use your kneaded eraser to gently pat the paper surface (to pick up any remaining eraser crumbs) and lightly redraw the sections of your drawing that were erased.

Protecting a Photo from a Grid

If you like drawing with a grid but hate having to draw grids on photos, this tip is for you! Most art supply stores sell clear sheets of acetate. You can draw grids of different sizes on separate sheets of this acetate (I prefer the clear rather than the frosted). The best part is that you can reuse your grids over and over again!

When the time comes to grid your photograph, you simply place the clear grid over the photo and you are ready to draw. This is especially handy when you are working from a photo that you don't want to damage.

Never draw a grid directly on a valuable photo! Make a photocopy, or scan and print it, and work from the copy.

Using Graph Paper to Grid Photographs

Try taping a photograph in the center of a piece of grid paper to draw the grid lines. Rather than using a ruler to measure the squares, you only need to connect the lines on the opposite sides of the photo with the ruler. Voilà! A very accurate grid! Oh, and I prefer using a fine ballpoint pen to draw lines on photographs.

Drawing with Symmetry

You'd be surprised by how many drawing subjects need to look the same on both sides (symmetrical). If you need anything to look symmetrical, from a vase to a face, draw a faint line down the center of your drawing space before you begin. Visually measure the spaces on both sides of this line to guarantee that your final drawing is symmetrical. You can even use a ruler to measure different sections if you want to be very precise!

Signing Your Name as an Artist

You can have a lot of fun developing a creative and unique signature for your drawings. The first thing you need to decide is what name you want to use — just your first name, only your last name, your middle name, maybe all your names, or even a pseudonym. I use only my last name, Hoddinott, because it's uncommon, and I like the way it looks in a signature. When you decide on a name, you need to apply it to your completed drawings.

Spend some time experimenting with the letters in your name and come up with a creative signature that will be easy to use.

The best place to sign your name is in either the lower-right or lower-left corner of your drawing. Sketch your name very lightly first, and then if you like its position, you can then draw it darker.

Be careful not to make your signature too large, because it will distract from the artwork. On the other hand, if you make your signature too small, it will be difficult to read.

Sign your name in the same medium that the drawing is done in. For example, if the drawing is in charcoal, sign your name in charcoal.

Chapter 22

Ten Steps to Completing a Drawing

In This Chapter

▶ Planning, organizing, and starting the creative process

▶ Setting up the initial sketch and working out the details

▶ Taking your drawing from shading through completion

Some artists complete a drawing in a few minutes. Others, like me, may spend several days on one project. Eventually, the process of creating a drawing from beginning to end becomes instinctual. Until then, here's a handy list of steps to help you through your first few masterpieces.

Deciding on Your Plan of Action

First things first — make your plan! As bizarre as this may sound, taking some time to carefully plan your drawing before you begin prevents lots of frustrations and problems later.

✔ **Choose a subject that appeals to you.** Otherwise, you may get bored halfway through your project.

✔ **Choose a subject that you feel is very, very simple.** You set yourself up for a frustrating experience by taking on a project beyond your skill level.

✔ **If you want to work from photos, plan a photo shoot of your subject.** Take lots of photos from many different angles and perspectives.

✔ **When working from life, think about factors like weather, lighting conditions, time of day, and the angle from which you want to capture your subject.** Thinking about these details before you begin to draw can help you capture these aspects of your subject on paper.

- ✔ **Plan your drawing format and size.** Decide if your completed drawing should be horizontal or vertical, and whether a rectangular, square, oval, circular, or another shaped format fits your subject.

- ✔ **Decide which medium and type of paper best suits your subject.** If you are uncertain at first about making these choices, ask a clerk at the art store where you shop for some suggestions.

Setting Up Your Stuff

Okay, so setting up and getting organized isn't the most exciting element of anything. But as with most activities and projects, it's a necessary evil! Just follow these tips as you work through this stage:

- ✔ **Make plans with your subject.** If your subject is a person, his or her schedule needs to be coordinated with yours.

- ✔ **Find a comfortable space with good lighting and set up your subject and drawing materials.** Make sure that you feel comfortable in the space before you begin to draw so that you don't have to shift everything around after you begin.

- ✔ **If your drawing subject is outside your home, check your portable studio and make sure you have everything you need.** I tell you how to prepare a portable studio in Chapter 11.

- ✔ **Arrange to begin your drawing project when you have peace, quiet, and lots of time.** Nothing is more frustrating than being deeply involved in your drawing just as the kids come home for lunch!

Starting Your Creative Engines

Before you can put your pencil into motion, you need to put your brain into gear and work out the fine details of your project.

Arrange your drawing subjects, or yourself, so that you see a pleasing composition. (I tell you about composition throughout Chapter 10.) If you are working from a photo, decide if you want your drawing to be smaller or larger than the photo.

If you plan to use a grid, work out the proportions of the grids for both your photo and the drawing surface. Draw your grid lines on both your photo and drawing surface, and carefully work out the composition.

Sketching the Composition

Study your subject. Look at the contours and the proportions. Observe how all the parts in your scene interact with one another.

Now look at your drawing paper and imagine this subject on your paper. Very lightly sketch (you may need to erase later) a loose map of where different parts of your scene are in relation to each another.

Choose a focal point and decide how to emphasize it within the composition. (See Chapter 10 for more on composition.) With simple sketch lines, indicate the basic shapes and outlines of the objects in your scene in proper proportion to one another. Look for ways to define depth with overlapping and perspective.

Planning Perspective

Your preliminary sketch is complete, everything is where it should be, and you're happy with your composition. Time to focus on a really important element that could make or break your drawing — perspective!

Look at the objects in your composition and decide which would benefit from geometric perspective, such as buildings, fences, or still life objects. Choose a viewpoint for the viewer of your drawing and work out the position of the horizon line. (I tell you about perspective, and how to find the horizon line, throughout Chapter 9.) Plot the vanishing points and draw objects according to the rules of perspective.

Checking Spaces and Relationships

Turn your drawing around in different directions and double-check for obvious problems. Find some friends and family and encourage them to critique your initial sketch. You'd be surprised by how insightful a 4-year-old is (not to mention how brutally honest).

Confirm that objects, spaces, and perspective elements are drawn correctly. Pay close attention to the shapes created by the negative space. Check the relationships of objects to one another, ensuring that angles, sizes, and proportions are accurate.

Mapping Your Values

This is the part where your eyes are your most important drawing tools.
(I tell you about mapping values in Chapter 7).

✔ Take note of your dominant light source and map out all the highlight
 areas in your composition.

✔ Look for areas of reflected light and mark those on your drawing.

✔ Map out your light, medium, and dark values.

✔ Identify cast shadows in foreground objects, as potentially having the
 darkest values.

Planning Your Shading Strategies

Choose the areas you want to draw in detail, such as your focal point, and
plan strategies to best represent their various textures with shading (you
explore creating textures with shading in Chapter 8).

Experiment on a piece of scrap paper before incorporating any textures into
your actual drawing.

Decide what type of shading, either hatching or crosshatching, best repre-
sent the secondary focal points and background textures (I tell you about
shading throughout Chapter 7).

Getting Down to Some Serious Fun

When you are finally happy with your sketch, start shading a section that has
a full range of values from the lightest light to the darkest dark. Continue to
refer to this section as you follow your shading map.

Begin to add shading to define the forms of the objects in your drawing. Add
stronger lines for some areas of the contour of the various components of
your subject.

Step back from your drawing from time to time and have a look at the overall
values. You may need to make some areas lighter and others darker.

Take your time. If you begin to tire or feel frustrated, take a break. When you
return, have a fresh look at your drawing and touch up anything you're not
happy with.

Completing Your Masterpiece

Your drawing is finished! Or is it? This is the time when you need to critically review your work, make any final adjustments, and plan for its preservation.

- Use a mirror to view your work from a different perspective.

- Set up your drawing in a safe place in your home, where you see it frequently throughout the day. Each time you look at your drawing and see something that needs to be touched up, fix it, or jot down the problem area on a notepad and go back to it later. Encourage friends and family to offer critiques as well.

- Give some thought to what you want to do with your completed drawing. You may want to have it framed or simply store it away in a safe place.

- Sign your name, put today's date on the back, put a smile on your face, and go find another exciting project to draw!

Chapter 23

Ten More Fun Projects

• •

In This Chapter

▶ Getting some fun practice

▶ Stretching your mind and exercising your drawing supplies

• •

*W*arm up your drawing supplies! You find all the techniques used in these ten projects discussed in this book. I include a variety of different subjects as well as projects with varying degrees of difficulty.

Use whichever pencils you prefer for these projects. Let your different pencils do some of the shading for you, by referring to the chart of different values, in the Cheat Sheet at the beginning of this book.

The Egg-actly Right Dragon Egg

In this project, you magically transform a simple chicken egg into a wonderful spotted dragon egg! Use your sketchbook horizontally.

1. **Draw the outline of an egg slightly to the left of your drawing space (see the first drawing in the next set).**

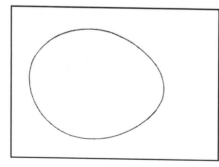
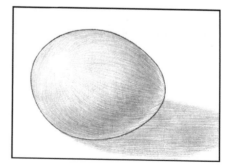

Leave room to add a shadow underneath the egg later. The wider end of the egg is on the left.

2. **Use graduated hatching lines to add the light shading on the egg and in the cast shadow (as in the second drawing).**

 Note the location of the highlight, which is left the white of the paper. Don't forget to use really light shading for the reflected light on the egg.

3. **Graduate the shading into the darker areas on the egg and add some spots (see the first drawing in the next set).**

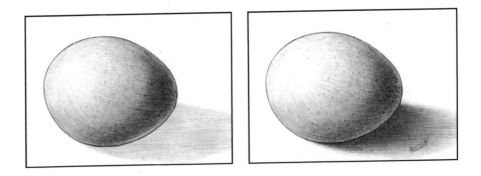

The spots are lighter in value in the light areas, and darker in the shadows. Now the egg is complete. On to the cast shadow!

4. **Add the light values of the cast shadow on the surface under the egg.**

 This shading is darker closer to the bottom edge of the egg.

5. **Graduate the shading of the shadow darker back toward the lower edge of the egg (see the second drawing).**

 The reflected light on the bottom edge of the egg visually separates the egg from the darkest part of the shadow.

Before Harry Met Scissors

My son, Ben, came home from kindergarten one day rather annoyed and complaining that his classmates were calling him "Harry." "But why?" I asked. "Because my 'har' (hair) is too long!" he replied. Needless to say, his next haircut shortened his beautiful John Kennedy, Jr.–styled hair! I giggled as I drew this next project and wondered if this is what his hair would look like if he still wore it long today.

Check out Chapter 20 to see more fun hairstyles! Turn your sketchbook vertically for this project.

1. **Draw an egg shape with the smaller end close to the bottom of your drawing space (see the first drawing in the next set of two).**

 Note the very lightly drawn vertical line down the center of his head (or "her" head, depending on whether you want your drawing to represent a boy or a girl!). This helped me draw the symmetrical shape of the head.

2. **Draw two large ears.**

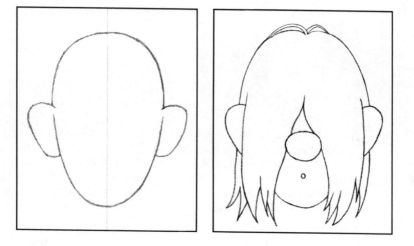

 The ears sit halfway between the top of the head and the chin.

3. **Draw the outline of a circular shape that is his (her?) nose (see the second drawing).**

4. **Add a tiny circle under the nose to represent the mouth.**

5. **Use your kneaded eraser to lighten the outline of the skull and the sides of the face.**

6. **Draw the outline of his/her hair.**

 With the hair added, the upper half of the head is now much wider and higher. Note the two little cowlicks on top of the head. Some sections of hair appear to be behind the ears and more is in front, covering the eyes and most of the face.

7. **Draw the textured shading of the hair with graduated hatching.**

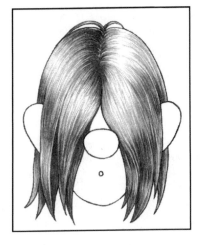

The hatching lines on the top half of the hair are all curved and follow the contour of the skull. From the part in his/her hair (at the top of the head), the shading begins dark, graduates to light, and then goes back to dark. The shading appears light in some places and dark in others, creating the illusion of depth and accentuating that some sections of hair are in front of other sections.

Riley, the Regal Rebel

This is a caricature of Riley the cat, who owns my friend Sherri Flemings. The light source is from the right, so the shading is lighter on the right.

1. **Draw a square grid any size you want, with five squares across by five squares down (see the first drawing in the next set of two).**

2. **Draw (very lightly) the outline of the fur on the top of the head and around his cheeks and chin.**

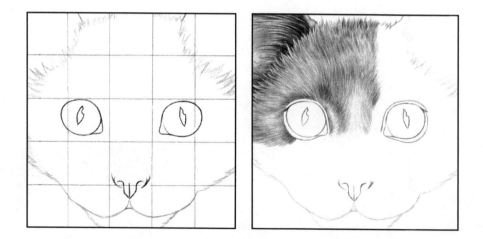

3. **Draw the outline of his eyes and the pupils.**

 The tiny C-shapes in the pupils will become the highlights in his eyes.

4. **Draw the outline of the nose and mouth.**

 Observe closely the individual lines that make up his nose. Also, note that the nose is almost the exact same width as one of your squares!

5. **Erase your grid lines and redraw any sections of the sketch that you erased (see the second drawing).**

6. **Draw the fur on his ear and the top half of his head (on the left) with short hatching lines.**

7. **Accentuate a few darker areas until you are happy with the values and the texture of the fur.**

8. **Draw the outline of the rims around his eyes.**

9. **Finish shading the fur of his other ear and on the top of his head (as in the first drawing in the next set).**

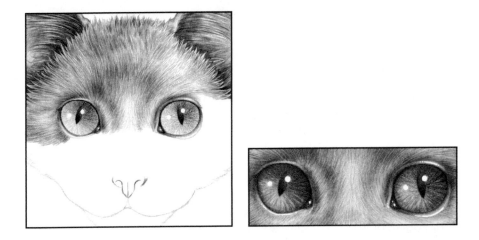

10. **Add the shading to the rims around his eyes and shade in the pupils.**

 Don't forget to leave the highlights white!

11. **Add the shading and detail to the inside corners of his eyes.**

12. **Lightly shade in the light values on the irises.**

 The irises of the eyes are darker under the upper eyelid and on the right side where the major highlight is.

13. **Draw in more fur on the right section of his face and neck.**

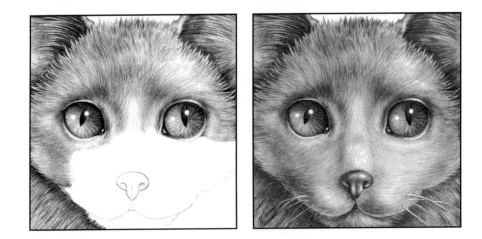

14. **Shade in the darker areas on the iris of each eye.**

 Leave a white area for the major highlight and a lighter area on the side of the iris opposite the highlight.

15. **Draw a darker circle around the irises and add some lines from the edges to the center of the irises.**

 Keep the lines lighter on the side opposite the major highlight.

16. **Shade in the nose.**

 Leave the highlight areas white to make his nose appear shiny!

17. **Draw the fur on the rest of his face and neck, and add his whiskers.**

 His neck is shaded darker, because it is in shadow under his face. Also note the directions in which the fur grows. Use a pointed end of your kneaded eraser to "pull out" some whiskers, and outline them lightly.

Dolly, the Sheepish Sheep

You draw this cartoon sheep using all three families of lines. (I discuss different types of lines in Chapter 5.) Remember to keep your lines very light in the beginning. Most of them need to be erased before you finish. First draw a large square in your sketchbook and then follow these steps:

1. **Draw a large rectangle (as in the first drawing in the next set).**

 Draw the rectangle closer to the top right of the paper than the lower left so you have lots of room for her legs.

2. **Draw the triangle.**

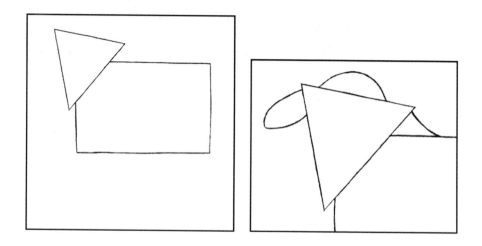

Notice that the triangle, which will be her head, tips slightly to the right. It also cuts into the rectangle.

3. **Draw the half circle sitting on top of the triangle, which will be the top of her head (see the second drawing).**

4. **Draw the curved line that joins the triangle to the rectangle.**

 This is a section of one of her ears.

5. **Draw the partial oval shape on the left side of the triangle to make her other ear.**

6. **Draw the lines that you see inside the triangle which show the shape of the face (see the first drawing in the next set).**

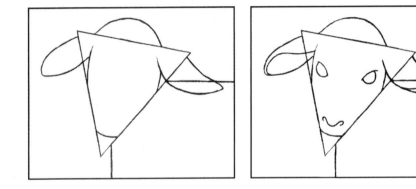

7. **Add the curved line inside the large rectangle.**

 The line curves inside the rectangle. This line completes the outline of this ear.

8. **Draw the lines that form the shapes of the inside section of her ears (see the second drawing).**

9. **Draw her eyes (which are really far apart) and her nose.**

 The nose is simply a curved line with a C-shaped line on each end to represent her nostrils.

 Keep your lines very light — you erase them later.

10. **Draw the curved backwards C-shaped line that indicates her rear end (see the first drawing in the next set).**

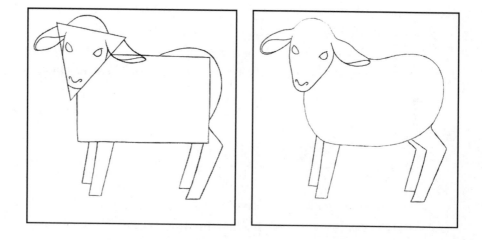

This curved line is outside the rectangle. It starts on the top of the rectangle and ends almost at the bottom of the right side.

11. **Add her legs.**

Note the angle line of one of her back legs.

12. **Draw three more curved lines to round off the other three corners of the rectangle (see the second drawing).**

13. **Erase the original lines of both the rectangle and triangle.**

14. **Extend the lines that outline the shape of her legs upward to touch her body.**

I add two other angle lines to the insides of her back legs. Remember to still keep your lines light!

15. **Lighten the straight lines of her legs with your kneaded eraser, and then redraw each leg with curved lines.**

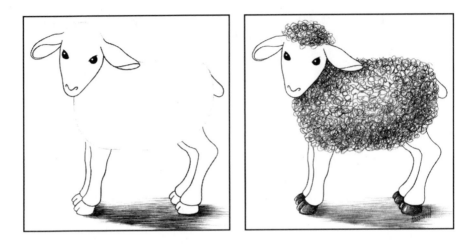

16. **Draw her four hoofs and her tail.**

17. **Shade in her eyes, leaving tiny white circles for the highlights.**

18. **Draw a shadow under her with horizontal hatching lines.**

19. **With you kneaded eraser, lighten the lines around her body and the top of her head.**

20. **Draw squirkles (see Chapter 8) on the top of Dolly's head and all over her body.**

21. **Add darker squirkles under her face, along the body, and on top of her head.**

22. **Shade in her hooves.**

 Note that I leave tiny places white to make the hooves look shiny.

Bad to the Bone

Cartoons are always fun to draw. Use a square format for this little darling!

1. **Draw the outline of the shape of his head (see the first drawing in the next set).**

 His head is almost a rectangular shape, with rounded edges at the top of his skull, chubby cheeks, and a chin.

2. **Add his ears.**

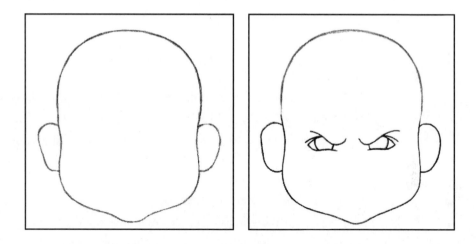

His ears are a little lower than halfway down from the top of his head.

3. **Draw two curved lines for his brows (see the second drawing).**

 These lines curve downward, more toward the center of his face.

4. **Add the outline of his eyes, the upper eyelid crease, and his irises.**

 The upper sections of his irises appear to be hidden under his brows, and the lower part is hiding under his lower eyelids.

5. **Draw his eyebrows.**

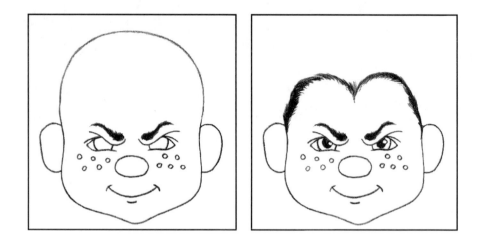

The eyebrows follow the shape of the lines you drew for his brows.

6. **Add an oval shape for his nose.**

7. **Draw two lines for his mouth, one long and the other short, curving upward and back toward his ears.**

8. **Add two tiny, curved lines at the ends of the longer line of his mouth.**

9. **Add some tiny circles on his cheeks for freckles.**

10. **Use your kneaded eraser to lighten the outline of his skull until you barely see it.**

11. **Draw his hairline on the top of his forehead with short hatching lines.**

 The hair comes down on his forehead to a point in the center.

12. **Add the outlines of the pupils of his eyes and the highlights.**

13. **Shade in the pupils very dark, leaving the highlights and irises white.**

14. **Draw the outlines of several leaf-shaped peaks in his hair, beginning with the ones in the front, closest to his forehead.**

15. **Shade in his hair with graduated hatching lines, leaving lighter areas for the shiny sections.**

16. **Use crosshatching to shade in his face.**

 The light source is from the right, so the shading is lighter on this side. The space between his eyes and on his upper eyelids is dark under his brow. Also note the shadow created on the side of his nose.

17. **Add shading to his nose, leaving a white area for its highlight.**

18. **Shade in the irises of his eyes.**

 The shadow on the upper section of his irises is cast by his lowered brow.

Dodo on a Swing

The subject of this project proves that you can turn absolutely everything into a fun drawing. I found this tiny Dodo as a prize in a candy pack. Use whichever pencils you prefer and turn your sketchbook vertically. The ideal format for this drawing is about 7 x 11 inches.

1. **Draw a circle for his head and an oval for his body (see the first drawing in the next set).**

 Keep your sketch lines light at this stage so you can erase them later.

2. **Add the two sections of negative space, the large one above Dodo's body and the tiny one below.**

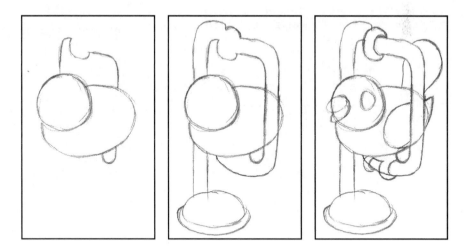

3. **Sketch in the rest of the swing (as in the second drawing).**

4. **Add his beak, eyes, wings, tail, and feet (see the third drawing).**

5. **Use your kneaded eraser to lighten your sketch lines, and then redraw Dodo and his swing with neat lines (see the first drawing in the next set).**

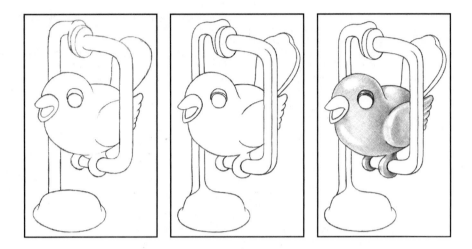

6. **Add lines to the vertical parts of Dodo's swing and to his tail.**

 Observe how the post of his swing joins the circular base. Notice how these new lines give a three-dimensional look to your drawing.

7. **Begin shading his body, head, wings, and feet very lightly (see the third drawing).**

 The white areas are the highlights.

8. **Shade in his eyes and beak.**

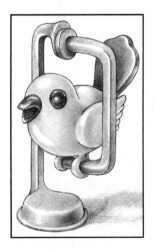

 Take note of the highlights and very dark shading, drawn very close to one another. This high-contrast shading gives a shiny texture.

9. **Add shading to his tail.**

The values are dark on the tail except for the bright highlights. I use crosshatching for most of the shading.

10. **Darken the shading slightly on some shadow areas of Dodo's body.**

11. **Add shading to his swing.**

 Take your time and look closely at each section before you draw.

12. **Draw the cast shadow.**

A Droplet of Water

How can you put a drop of water on a piece of paper without the paper getting wet? Well, you draw it of course!

Many factors contribute to the shape, form, and shading of a droplet of water sitting on a surface, such as the texture, color, and incline of the surface on which it is sitting, the lighting, the perspective from which you are viewing it, and the speed at which it is (or isn't) moving. Experiment by pouring a little water on various surfaces and see the vast array of droplets waiting to be captured in your drawings.

Imagine a raindrop falling from above and landing, ever so gently, on the slanted surface of a white rose petal. This droplet represents that fraction of a second before the drop fully touches the petal and begins flowing downward on its soft surface. Use a vertical format to sketch this tiny droplet.

1. **Draw the outline of this droplet of water (see the first drawing).**

2. **Map in the highlight, the reflected light, and the cast shadow.**

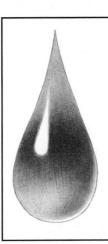
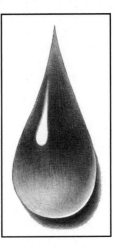

You see my map in the lower-right section of the drop.

3. **Use crosshatching to shade in the light and middle values (see the second drawing).**

 The shading is light at the top of the droplet, becomes darker in the middle sections, and then becomes lighter again. The light shading along the bottom edge of the droplet is the reflected light from the surface.

4. **Add darker shading to the shadow areas and shade in the cast shadow.**

Shadow, the Dalmatian

Shadow is my daughter Heidi's dog. The light source is from the right, so the shading appears slightly lighter on the right and darker on the left.

1. **Draw a square grid any size you want, seven squares across by seven squares down (see the first drawing in the next set).**

2. **Very lightly draw the outline of her head, ears, and muzzle.**

3. **Draw the inside sections of her ears.**

4. **Outline her neck, collar, and the small section of her back that is showing.**

5. **Draw the outline of her eyes indicating the circular outline of the irises (refer to the second drawing).**

6. **Draw the smallest circles that will be the highlights of the eyes.**

7. **Draw the partial circle that indicates the pupil of the eyes.**

8. **Add the nose, the mouth, and the details of her collar.**

 Take a moment to check carefully that everything is in the correct place. Erase your grid lines and redraw the sections of the actual sketch which you may have accidentally erased.

9. **Shade in the background on the left with hatching (see the first drawing in the next set).**

 The shading graduates from light at the top to dark at the bottom.

10. **Very lightly draw an outline of the spots on the ear on the left.**

11. **Add shading to this ear.**

 This ear (on the left) will be very dark because it's farther away from the light source than her other.

12. **Add the shading to the top of her head and add some spots.**

13. **Draw the fur around her eyes, between her eyes, on her cheeks, and down toward her nose.**

 Look closely to see the direction in which the fur grows. The white fur and the black spots are lighter on the right side of your drawing.

14. **Add shading to her other ear (see the second drawing).**

 Observe the shading on the ear on the right. Note that the darker areas give the illusion of a fold in this ear.

15. **Shade in the iris, leaving a white area for the primary highlight and a lighter area on the side of the iris opposite the highlight.**

 The irises are darker under the upper eyelid and on the side where the highlight is drawn.

16. Shade in the sections of the pupil that are dark.

17. Add the shading under the upper eyelid in the whites of her eyes.

18. Draw the fur on the rest of her face.

19. Add the shading on the nose.

20. Add lots of dots to represent the texture of a dog's nose.

21. Draw the fur around her mouth and chin.

22. Draw the white fur on the left section of her neck under the chin, watching closely the direction in which it grows.

23. Finish the shading on her mouth and chin.

24. Finish shading the background on the right side of your drawing, noting that it becomes darker closer to the bottom.

25. Draw in the fur on the center section of her neck, watching closely the direction in which it grows.

26. Draw in the fur on the right side of her neck and the small section of her back.

27. Add shading to her collar.

Mug on a Mug

This mug is a challenging and fun exercise in drawing a shiny object. Remember to keep your lines light in the beginning in case you need to erase. Use your sketchbook horizontally.

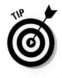

Many of these instructions focus on the face, rather than the actual shading of the mug. In Chapter 7, I take you step by step through drawing a simple mug. Refer to this project if you need more-detailed instructions for the basic outline and the shading of a mug.

1. **Draw an oval in the upper-left section of your page.**

2. **Draw a straight line down from each end of the oval to make the sides (see the first drawing in the next set).**

3. **Add a curved line along the bottom to complete the "U".**

4. **Draw the two ends of the handle inside the right edge of the mug.**

5. **Draw two backwards C-shapes, which complete the handle of the mug.**

6. **Draw a smaller oval inside the other one, on the rim of the mug.**

7. **Draw two big ovals for the eyes that are closer together at the bottom (see the second drawing).**

8. **Add curved lines through the middle of each oval to separate his eyelids from the rest of his eyes.**

9. **Sketch in the eyes, leaving little white circles for the highlights.**

10. **Draw the outline of the nose slightly outside the edge of the mug and then erase the line inside the nose.**

11. **Sketch in the mouth.**

12. **Map in the outlines of the highlights, the shadow area, and the reflected light on the nose.**

 The light source in this drawing is from the left. The shading is darker on the right side of the drawing. Shade all the lighter values first, and then draw the crosshatching lines gradually darker toward the dark values.

 To make the mug look shiny, you need to leave the highlights white. In addition to the highlights on the nose and in the eyes, don't forget the ones on the rim and handle of the mug.

13. **Shade in the nose (refer to the first drawing in the next set).**

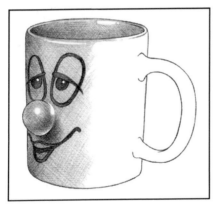 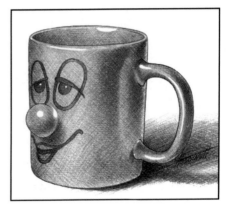

14. **Add the shading to the remainder of the face side of the mug.**

 Remember to leave the highlights white.

15. **Finish the shading of the mug (see the final drawing).**

 Don't forget the dark shading on the right edge of the handle and inside the rim on the left.

16. **Shade in the cast shadow.**

 The shadow areas closest to the mug are very dark. Graduate your shading lighter as the shadow becomes farther away from the mug.

Corny, the Corn-Belly Rattler

With simple step-by-step instructions, you draw a fun cartoon of an adorable snake.

1. **Draw a grid, six squares long by two squares high (letter and number your squares if you want).**

2. **Draw what you see in each square to make a sketch of the rattler.**

3. **Erase your grid lines and draw the lines more precisely.**

4. **Draw the eyelids, the pupils, and the highlights.**

5. **Draw two comma shapes to represent his nostrils.**

6. **Add a line for his mouth with a little oval for the place where it opens.**

7. **Draw the lines that divide the top of his body from his underbelly.**

 See how his body becomes thinner closer to the end of his tail.

You now have a simple cartoon of "Corny." If you want to add shading, continue with the following.

8. **Note the short vertical lines between the tiny sections of his belly and draw these lines before you begin shading.**

9. **Shade in his eyes and face with crosshatching (the light source is from the left).**

10. **Shade in his body.**

Note the shiny spots along his body that I have left white.

11. **Draw the shadow under him.**

Its position creates the illusion that the end of his tail is raised.

Chapter 24

Ten Tidbits of Artsy Info

Many years ago, I visited an art gallery run by a friend. I enjoyed looking at the various artworks and reproductions on exhibit. One very primitive abstract piece caught my eye. I whispered to my friend, "That looks like it was drawn by a monkey." My friend raised his eyebrows, rolled his eyes, and stuck his chin forward. "My dear" he replied, "That's a Picasso."

That little, embarrassing experience was the catalyst for my wanting to become more familiar with art history, techniques, styles, and artists. In this chapter, I share with you snippets from a diverse collection of information I've gathered during my artistic career.

Stepping into Art Appreciation

Sometimes you hear the media hailing such things as random blobs of paint on a canvas as great works of art. If you're anything like me, you struggle to understand these artworks. You're often left scratching your head, amused yet puzzled. The critics encourage you to believe that these artworks are the result of extraordinary talent. No wonder so many people believe that talent itself is magical, elusive, and not within the grasp of mere mortals! However, even the bizarre or zany stuff is usually great for a few giggles.

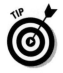

Art has become very accessible in recent years through galleries, art books, and the Internet. With careful observation of the drawings of other artists, you gain invaluable information, which you can apply to your own drawings. Take time to examine and appreciate a diverse range of art and artists.

There will always be artists who prefer to rely on "shock" to achieve recognition. But, the general population seems to respect artists whose representational, impressionistic, or abstract artworks demonstrate strong technical skills.

As an artist, you need to be true to yourself and trust your own instincts and personal artistic likes and dislikes. Within a climate of mutual respect, all art ideas can exist peacefully.

Feeling Like an Alien in an Art Gallery

When I first began exploring art galleries, I felt like an alien in a strange, unfamiliar world. However, I soon recognized that the benefits of observing the actual works of other artists, rather than just pictures, far outweighed my discomfort. It wasn't long before I felt completely at ease and totally enjoyed the artists, as well as the art.

Watch your local newspapers and media for art exhibitions and plan to attend as many as possible. You can usually meet and chat with artists in your community by attending the openings of these shows.

Keep your mind open and enjoy the diversity of creative concepts being explored by contemporary artists. When you first listen to a group of artists and critics discussing art, you may think that they are speaking in a foreign language. Don't be intimidated. I still find this language of "Artspeak" rather confusing sometimes. But I've learned as much from quietly participating in a conversational circle as I have from viewing the wonderful art.

Investigating Historical Styles of Drawing

Some traditional labels of drawing styles, based in art history, include:

- **Abstract** (sometimes called Expressionism or Nonrepresentational) art focuses on form and values. Appreciation of abstract art sometimes requires understanding and patience because there may be no recognizable subjects.

- **Impressionism** tends to be an "impression" of a subject rather than a depiction of the way the object actually looks. Impressionistic drawings are often bold and vibrant and with very little fine detail.

- **Realism** (also known as Representational) is the style of drawing most persons understand. The artist's subjects are drawn (or represented) the way they actually are rather than the way the artist imagines them to be.

- **Photorealism** is a style in which the drawings look more like photographs than drawings. Photorealists prefer to work from photographs rather than life or their imagination. They often use grids or projectors to properly set up accurate proportions for their drawings.

- **Surrealism** occurs when realistic subjects are influenced by the artist's imagination. Objects are usually recognizable but transformed by creative imagery. Some artists feel their images surface from their subconscious and are rooted within the emotional impacts of their life experiences.

Developing Your Own Drawing Style

Some individuals try to fit all art into neatly labeled little categories. I prefer to not be constricted or limited by labels, and I don't pay much attention to current styles or trends in "the art world."

As with clothing, styles of art tend to go in and out of fashion. I just draw what I want and how I like, and I try to stay true to myself. My constantly developing drawing style is unique to me.

You are a unique individual, with distinctive likes and dislikes. You need to introspectively explore yourself to gain insight into your artistic strengths and preferences. Your drawing style emerges based on:

- The subjects that you find most appealing and love to draw.

- Your unique way of viewing the world around you.

- The styles of drawings that you prefer.

- The drawing techniques that you enjoy and the media that you use.

- An acceptance of the challenge to deviate from the "norm" and be true to yourself.

- Your personal needs to communicate through your art.

- Your unique storehouse of life experiences and personal values.

Your style continues to evolve and change for as long as you draw. Maintain your sketchbook and save some of your drawings. Reflecting on your personal journey as an artist is inspirational and self-affirming.

Choosing Your Favorite Drawing Media

Keep an open mind and experiment with different media. In time, your favorites make themselves known to you. Here's a little information on a few of my favorites:

- **Graphite:** Graphite (sometimes called *lead pencil*) comes in various grades and lends itself beautifully to all styles of drawing. Used as an artistic medium for centuries now, graphite has withstood the test of time for permanence.

- **Charcoal:** This medium works beautifully for sketching and boasts beautiful, rich, intense blacks. Charcoal is somewhat messy, easy to smudge, and slightly abrasive (not as smooth to draw with as graphite).

 A little bit of extra work is needed to keep your drawing clean. Charcoal blends beautifully because of its soft texture and is fairly easy to erase.

- **Conte:** While sharing many of the same characteristics as charcoal, conte (also called *conte crayon*) comes in a wonderful range of earth tones that are a joy for portraiture or figure drawings. A basic set of conte includes black, a couple of grays and sepias (browns), and a white.

- **Chalk pastel:** Pastels come in an infinite range of colors and can be layered and blended to build up a paintlike quality of color and values.

- **Colored pencils:** Colored pencils (also called *colored crayon pencils* or *crayons*) have been around for artistic use for more than 75 years. Over the last couple of decades, "painting with colored pencils" has become a highly respected drawing medium.

 Vast ranges of colors are available, and they can be purchased individually or in sets at art supply stores. Colors can be dry mixed by layering colors on top of one another. Colored pencils don't smudge easily and are very clean to work with, but they don't blend well and are difficult to erase.

- **Ink:** Today's inks come in a wide range of colors and can be applied to paper with various tools, including brushes and technical pens. Disposable pens and markers have become popular in recent decades and are much more convenient to use. A thin wash of ink provides gorgeous abstract backgrounds for drawings.

Many artists use their fingers to blend soft media such as charcoal, conte, and chalk pastels. This is perfectly fine if you are drawing for practice or working

on sketches of little importance. However, if you end up loving one of your drawings and want to save it, the oils from your skin may cause deterioration.

To protect drawings from damage, use facial tissues or paper towels to blend.

Taking Art Classes, Lessons, and Workshops

You can always benefit from drawing classes and workshops. Not only do you meet others who are also wanting to improve their drawing skills, but you are exposed to different techniques and drawing styles. If you can access life-drawing classes, you have the highly rewarding opportunity to draw from live models.

As you uncover local art resources, you meet other artists and have opportunities to become involved in art groups. Many art groups organize incredible workshops, taught by prominent artists, and the camaraderie and enjoyment is well worth your time. Check out your local community-based educational facilities and recreational centers for programs in your area.

The Internet is a vast resource for drawing lessons. I have free art classes available on my web site at www.finearteducation.com, and through my site, you can also explore an extensive list of other artists who provide online lessons.

Take time to investigate and participate in some of the wonderful drawing e-groups, where international artists share tips, critique one another's works, and openly discuss various art techniques and art resources.

Working from Life or Photographs

Whether you ultimately choose to draw only from life, only from photographs, from your imagination, or a combination of any of these options is a personal preference.

Don't let anyone tell you that working from photos is wrong. However, it can never replace the infinite benefits of drawing from actual three-dimensional subjects.

Putting Your Drawings on the Internet

Maybe you'd like to share your new drawing skills with friends and family. Anyone can have a free Web site, and you don't even need to know how to build a site.

Simply type "free personal web pages" into any search engine and choose a home for your site. Most of these resources offer easy-to-follow instructions for setting up your page and getting it online.

Answering Ten Copyright Questions

All artists need to understand and respect the laws of copyright as they pertain to art. The easiest way for me to explain copyright is to answer ten of the questions I'm most often asked.

- **What is copyright?** Copyright is a form of protection which grants artists the exclusive right, to sell, reproduce, or exhibit their original drawings. *Exclusive* refers to the artist who originally created the work. He or she is the owner of the copyright.

- **What is an original work of art?** An original artwork is one that an artist creates completely from its conception to the final drawing. No aspect of the work is derived from an already copyrighted image or idea.

- **When is an artwork not original?** An artwork is not original when the art is copied from an idea or image that is copyrighted. This includes most cartoon characters, artworks by other artists, pictures in books or on the Internet, or photographs taken by someone other than the artist (unless you have the permission of the photographer).

- **What can be copyrighted?** Anything that you can touch, see, or hear can be copyrighted.

- **Can I draw from copyrighted images?** You can draw a copyrighted image if you have the permission of the person who owns the copyright. In most cases, the copyright still belongs to the person who conceptualized and physically created the original work.

- **Can I draw from the illustrations in this book?** I own the copyright to all illustrations in this book. You have my permission to draw from any of these drawings. However, you can't claim copyright to drawings based on the creations of another artist. This would be considered plagiarism.

✔ **How do I claim copyright to my original art?** If you live in a country that has signed the Berne Convention (Berne Union for the Protection of Literary and Artistic Property), claiming copyright is simple. From the moment your art is completed, you automatically own the copyright.

✔ **Is there a way to prove that I own copyright?** All you need is proof that you created your work before anyone else.

An old method of guaranteeing ownership of a work of art is to simply mail a copy of it to yourself. When you receive it, do not open it or break the seal on the envelope. Simply file it away with the title of the work and the date of its completion. The postmark on the envelope is proof of the date it was mailed, so obviously the work was completed prior to this date.

✔ **Can I put a copyright © symbol on my original art?** This is your right as the original creator of an artwork. Unless your art is copied and you are not the true creator, you should use the copyright symbol.

✔ **How do I use the copyright © symbol?** A statement of copyright needs three things: the copyright symbol, the date the artwork was created, and the name of the artist. An example is: **Copyright © December 19, 2003, Brenda Hoddinott.**

Copyright laws depend in some cases on where you live and work in the world. If you have any questions about copyright issues regarding your work, consult a lawyer who is familiar with the laws in your specific region.

Crossing Over from Drawing to Painting

If you are thinking about taking up painting, first take a couple of years to develop strong drawing skills before you begin.

Understanding how to implement a full range of values into a painting is much more important than the colors you use. After all, painting is simply drawing with paint!

Igniting Your Sparks of Creativity

Accumulating strong technical drawing skills ignites that spark of creativity lying dormant within you!

You possess the freedom to draw whatever you want, after you are freed of the chains created by lack of knowledge. You see objects beyond reality and acquire an ability to draw subtle and subliminal images within your drawings to create or exaggerate a specific mood. Your skills become your wings, allowing you to fly and soar freely through the infinite creative channels of your mind.

Relaxing Your Eyes

When you really get in the moment of drawing your subject, you can sometimes ignore your own physical situation to the point that when you break out of the spell, you find that you have given yourself a mighty powerful headache from eyestrain.

Try these tips to help relax your eyes so that you can resume your drawing:

- Sit comfortably in your chair. Or, get up and stretch a couple of times in several different directions.
- Rub your hands together rapidly until the palms of your hands feel warm.
- Close your eyes lightly.
- Cover each of your eyes gently with the palm of a hand. Your fingers should be resting on your forehead, and the heels of your palms can rest on your cheekbones. Relax your body and stay in this position for at least two minutes.

Setting Up Your Own Artist's Studio

If you have adequate space in your home, you can enjoy customizing a small home studio for your own personal needs.

My studio is my favorite room in my home and has everything I need to work, relax, and make art. It is located on the lower level of my home, away from my noisy family and the distractions of everyday living. Some items to consider including are

- A special wall on which you can display and enjoy your drawings
- A storage area for your drawings, drawing materials, and portfolio cases
- A worktable for cutting your drawing papers and working on large projects
- An adjustable drawing table with flexible lamps

- A comfortable chair in which you can sit, read, and research your drawing projects

- A file cabinet, in which you can keep reference materials and files

- A shelf for storing your art books

- A computer, printer, and scanner

- A digital camera and photo supplies

And finally, the most important element of all, YOU! Drawing is a journey, not a destination.

The day that you are totally happy with your drawings is the day you pack up your supplies and quit. Learning to draw is an infinite quest.

Index

• *D* •

• *G* •

• *M* •

FOR DUMMIES®

A world of resources to help you grow

HOME, GARDEN & HOBBIES

Feng Shui
0-7645-5295-3

Gardening
0-7645-5130-2

Guitar
0-7645-5106-X

Also available:

Auto Repair For Dummies
(0-7645-5089-6)

Chess For Dummies
(0-7645-5003-9)

Home Maintenance For
Dummies
(0-7645-5215-5)

Organizing For Dummies
(0-7645-5300-3)

Piano For Dummies
(0-7645-5105-1)

Poker For Dummies
(0-7645-5232-5)

Quilting For Dummies
(0-7645-5118-3)

Rock Guitar For Dummies
(0-7645-5356-9)

Roses For Dummies
(0-7645-5202-3)

Sewing For Dummies
(0-7645-5137-X)

FOOD & WINE

Cooking
0-7645-5250-3

Cookies
0-7645-5390-9

Wine
0-7645-5114-0

Also available:

Bartending For Dummies
(0-7645-5051-9)

Chinese Cooking For
Dummies
(0-7645-5247-3)

Christmas Cooking For
Dummies
(0-7645-5407-7)

Diabetes Cookbook For
Dummies
(0-7645-5230-9)

Grilling For Dummies
(0-7645-5076-4)

Low-Fat Cooking For
Dummies
(0-7645-5035-7)

Slow Cookers For Dummies
(0-7645-5240-6)

TRAVEL

Italy
0-7645-5453-0

Hawaii
0-7645-5438-7

Las Vegas
0-7645-5448-4

Also available:

America's National Parks For
Dummies
(0-7645-6204-5)

Caribbean For Dummies
(0-7645-5445-X)

Cruise Vacations For
Dummies 2003
(0-7645-5459-X)

Europe For Dummies
(0-7645-5456-5)

Ireland For Dummies
(0-7645-6199-5)

France For Dummies
(0-7645-6292-4)

London For Dummies
(0-7645-5416-6)

Mexico's Beach Resorts For
Dummies
(0-7645-6262-2)

Paris For Dummies
(0-7645-5494-8)

RV Vacations For Dummies
(0-7645-5443-3)

Walt Disney World & Orlando
For Dummies
(0-7645-5444-1)

Available wherever books are sold. Go to www.dummies.com or call 1-877-762-2974 to order direct.

FOR DUMMIES®

The advice and explanations you need to succeed

[S]ELF-HELP, SPIRITUALITY & RELIGION

Sex FOR DUMMIES
0-7645-5302-X

Parenting FOR DUMMIES
0-7645-5418-2

Religion FOR DUMMIES
0-7645-5264-3

Also available:

The Bible For Dummies
(0-7645-5296-1)

Buddhism For Dummies
(0-7645-5359-3)

Christian Prayer For Dummies
(0-7645-5500-6)

Dating For Dummies
(0-7645-5072-1)

Judaism For Dummies
(0-7645-5299-6)

Potty Training For Dummies
(0-7645-5417-4)

Pregnancy For Dummies
(0-7645-5074-8)

Rekindling Romance For Dummies
(0-7645-5303-8)

Spirituality For Dummies
(0-7645-5298-8)

Weddings For Dummies
(0-7645-5055-1)

[P]ETS

Puppies FOR DUMMIES
0-7645-5255-4

Dog Training FOR DUMMIES
0-7645-5286-4

Cats FOR DUMMIES
0-7645-5275-9

Also available:

Labrador Retrievers For Dummies
(0-7645-5281-3)

Aquariums For Dummies
(0-7645-5156-6)

Birds For Dummies
(0-7645-5139-6)

Dogs For Dummies
(0-7645-5274-0)

Ferrets For Dummies
(0-7645-5259-7)

German Shepherds For Dummies
(0-7645-5280-5)

Golden Retrievers For Dummies
(0-7645-5267-8)

Horses For Dummies
(0-7645-5138-8)

Jack Russell Terriers For Dummies
(0-7645-5268-6)

Puppies Raising & Training Diary For Dummies
(0-7645-0876-8)

E[DUCATION] & TEST PREPARATION

Spanish FOR DUMMIES
0-7645-5194-9

Algebra FOR DUMMIES
0-7645-5325-9

The ACT FOR DUMMIES
0-7645-5210-4

Also available:

Chemistry For Dummies
(0-7645-5430-1)

English Grammar For Dummies
(0-7645-5322-4)

French For Dummies
(0-7645-5193-0)

The GMAT For Dummies
(0-7645-5251-1)

Inglés Para Dummies
(0-7645-5427-1)

Italian For Dummies
(0-7645-5196-5)

Research Papers For Dummies
(0-7645-5426-3)

The SAT I For Dummies
(0-7645-5472-7)

U.S. History For Dummies
(0-7645-5249-X)

World History For Dummies
(0-7645-5242-2)